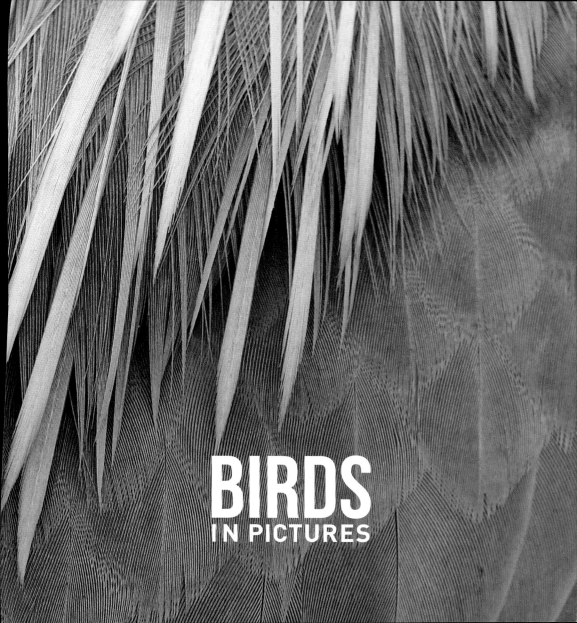

BIRDS
IN PICTURES

BIRDS
IN PICTURES

Markus Varesvuo

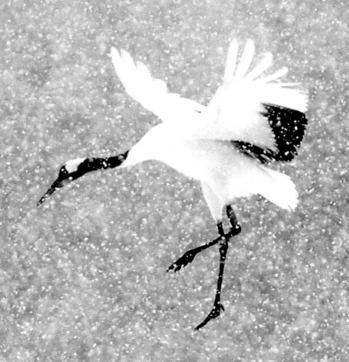

RED-CROWNED CRANE

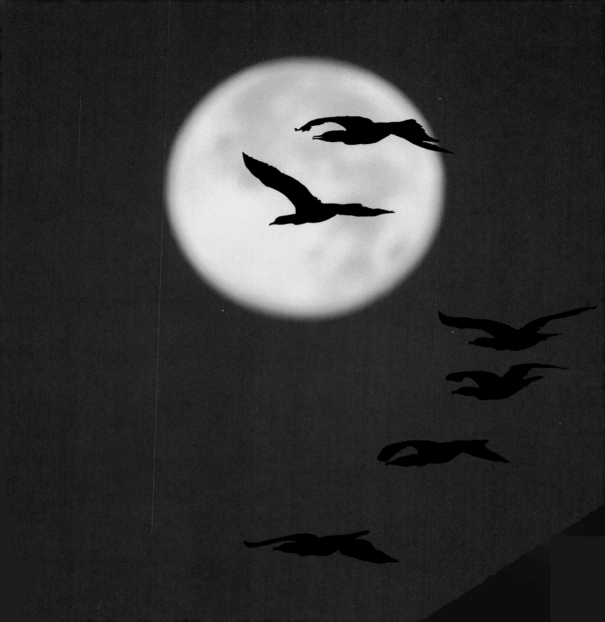

Contents

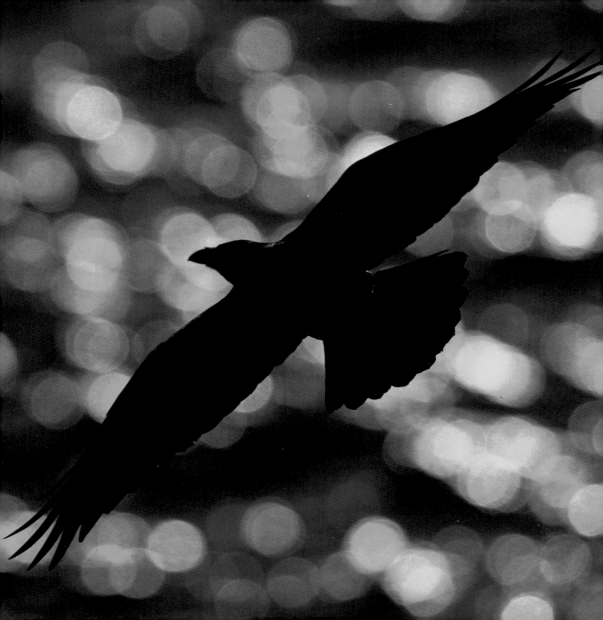

Introduction

We live in the age of the photograph. We are flooded with pictures, inundated and swamped by our own pictures, pictures by our friends, in the social media, the newspapers, books and magazines.

To me as a wildlife photographer, this means raising the bar with every photograph that I publish. For a picture to get noticed in this upswelling of photos, one has to aim high, every time. As ever, it has to be technically good. As ever, there should be a story, either evident in the picture itself, or by the picture evoking strong feelings that transport the viewer to a memory, a dream, an idea.

Having taken bird photos for just over 40 years, I have become my most ardent critic. I have seen so much, either myself or in bird pictures by others, that if you think you are overwhelmed by the pictures out there, I can probably outdo you…

This doesn't mean that this collection of bird photos would surpass all others. But I can promise that is has filtered through several layers to reach you, and what is on these pages, without an ounce of conceit, is worth your time.

You may disagree with my choice of composition or use of camera techniques, but I am quite confident that we will share an appreciation of the objects. The wide range of diversity, an almost infinite extent of imagination shown by evolution, is more manifest in birds than in most other wildlife. Apart from the human kind perhaps. Where the human animal is a species with an incredibly diverse set of individuals, the bird kind have, relatively, a similar scope of variation in species, if not in individuals.

Yet, a bird is not just a repetition of its species description. Each bird is an individual, which is easy to understand if you spend any given time with a specific individual. They have their unique sets of skills and preferences; even if you think you know a species' behaviour, an individual can always surprise, and teach you something new. A lifetime is not long enough to grow tired of our feathered friends. Quite the opposite – the more one learns, the more interesting they become.

With *Birds in Pictures*, I hope to lure you into the world of birds, should you not already be here.

Markus Varesvuo

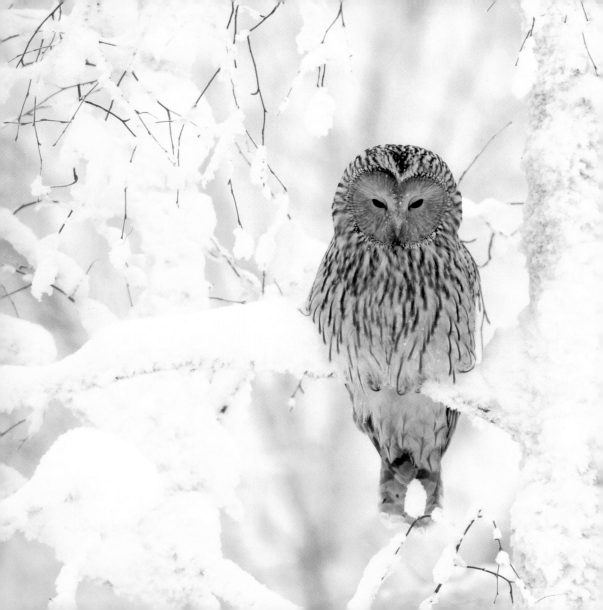

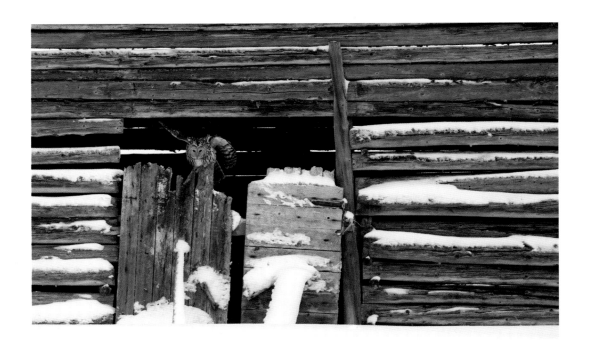

Ural Owl

Strix uralensis

This species is well adapted to extreme cold but less so to deep or hard-packed snow. A Great Grey Owl (*Strix nebulosa*) can catch prey from beneath snow up to half a metre deep but such conditions, especially when prolonged, can prove fatal to a Ural Owl.

When vole populations decline in the woods, Ural Owls move closer to people, near hay barns and fallow fields.

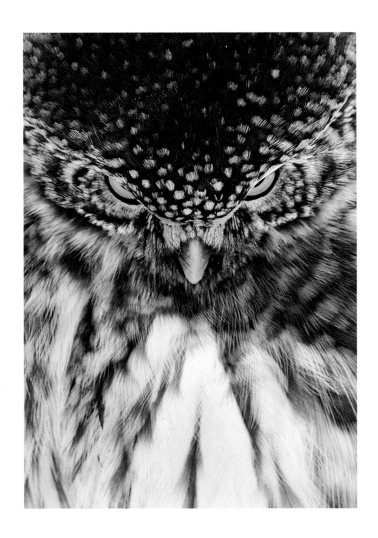

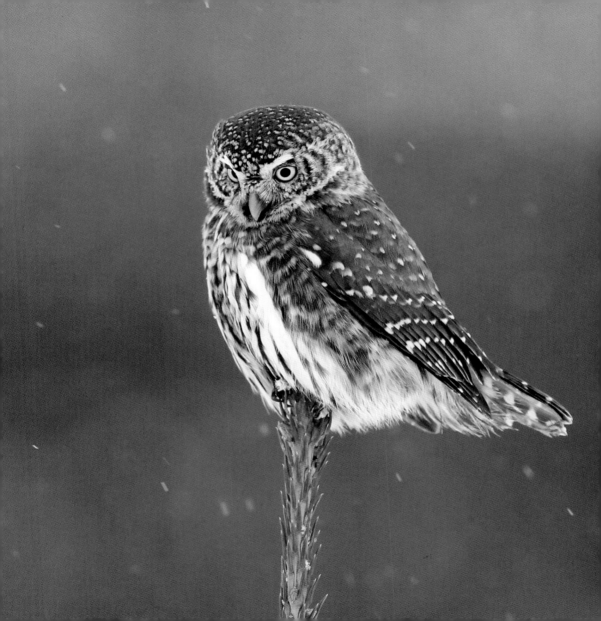

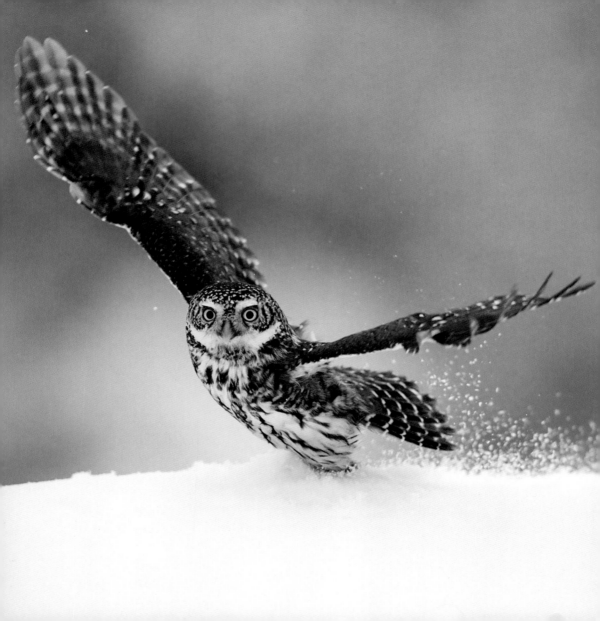

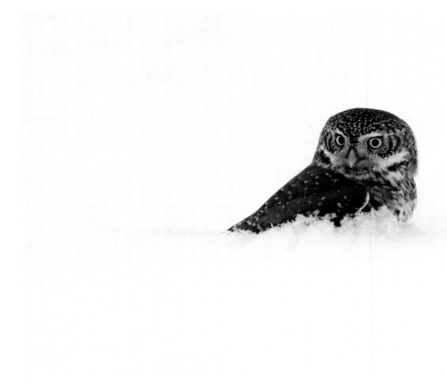

Eurasian Pygmy Owl

Glaucidium passerinum

The diminutive pygmy owl is only the size of a starling, but nonetheless is a fierce predator that can catch prey bigger than itself. Voles and mice are its main source of food but it will also take small birds.

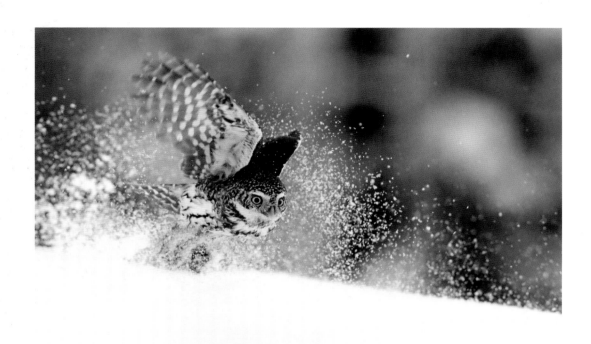

When the opportunity arises, a Eurasian Pygmy Owl will hunt more food than it can eat. This surplus is stored in a hollow in a tree or in a nest box, providing a source of food for days when hunting success is low.

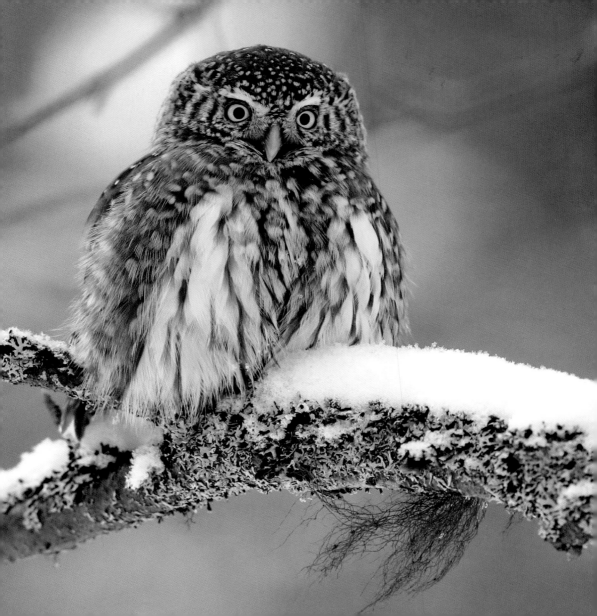

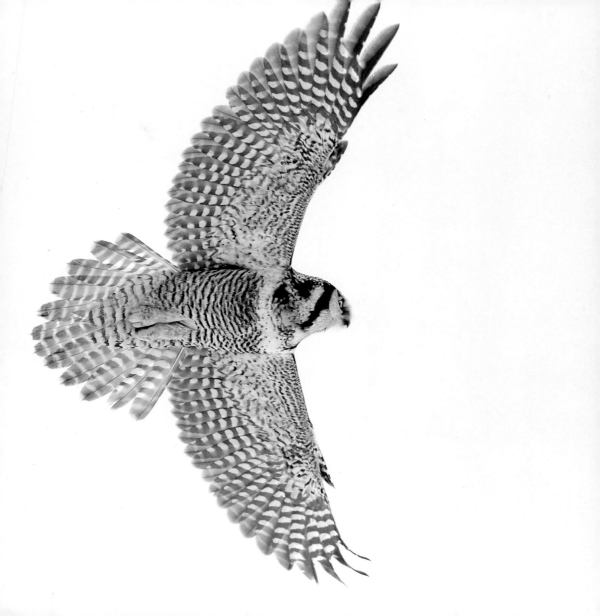

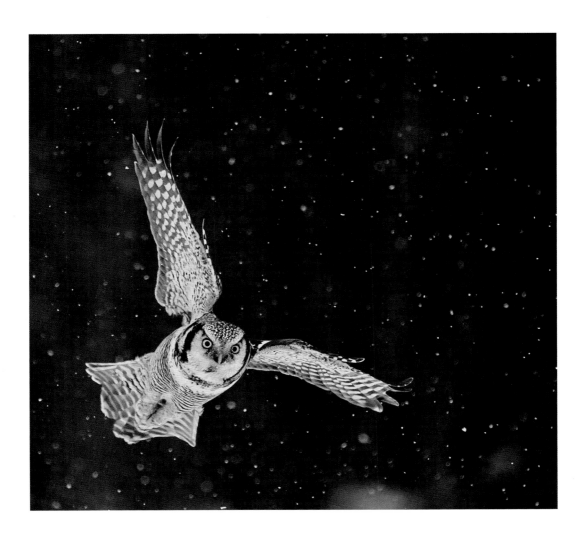

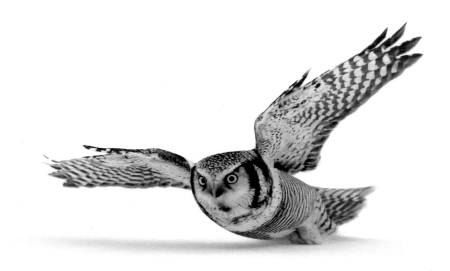

Northern Hawk Owl

Surnia ulula

Hawk owls rely on their super-sharp eyesight and incredible speed when hunting. Perching high in a treetop on the lookout for voles that emerge from the snow, they can spot one from as far away as one kilometre.

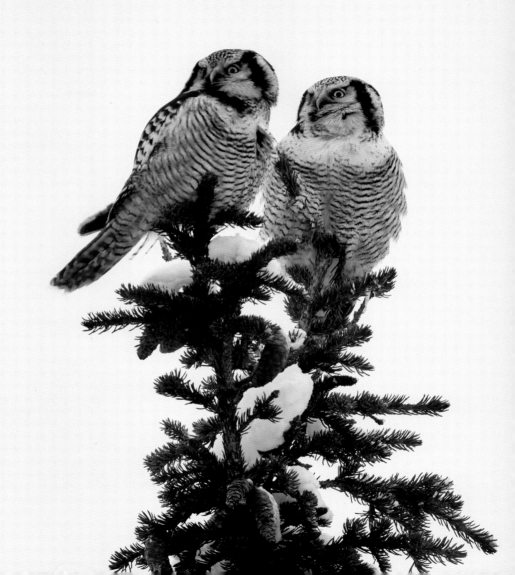

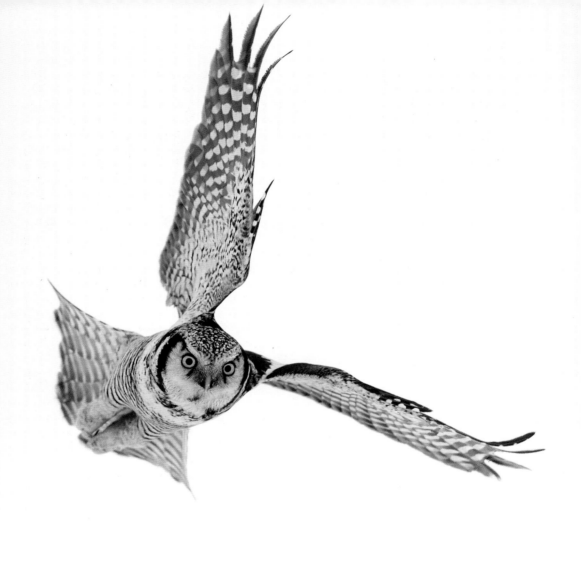

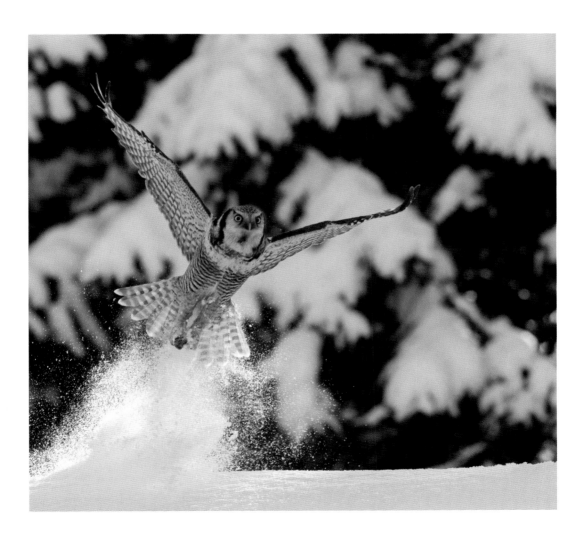

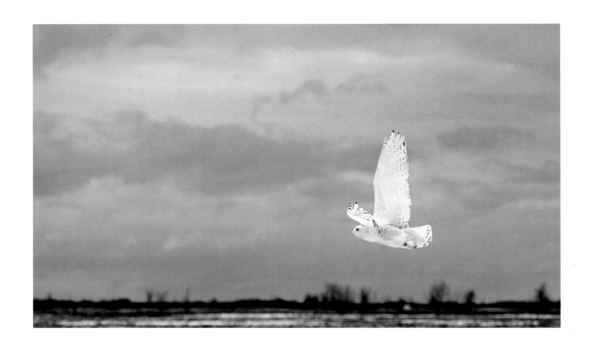

Snowy Owl

Bubo scandiaca

This ghostly white owl is a circumpolar breeder in the Northern Hemisphere's treeless tundra, settling wherever lemmings and voles are plentiful. Should populations of their prey species decline after the breeding season, they can travel long distances in search of food, and some end up wintering in wide open areas further south. If they find a location which is particularly bountiful in terms of prey, a Snowy Owl can spend the entire winter in a relatively small territory, and in such situations it is often possible to admire these fearless birds at close range.

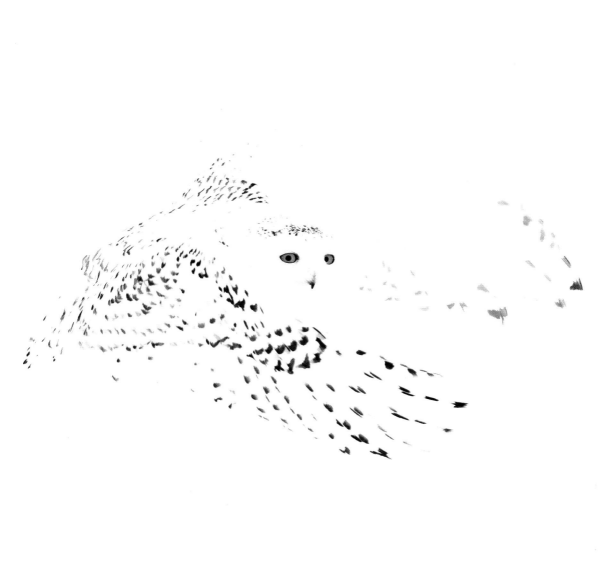

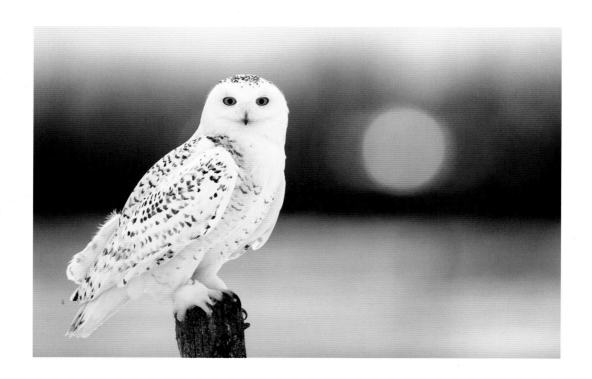

Snowy Owls tend to be most active around sunrise and sunset, but during the short days of midwinter they will sometimes hunt in the middle of the day. Using fence posts and barn roofs as vantage points, the owl uses its excellent vision to spot prey. Once it has a vole in its sights, it takes off and flies towards the prey, gliding the last stretch as silently as a ghost.

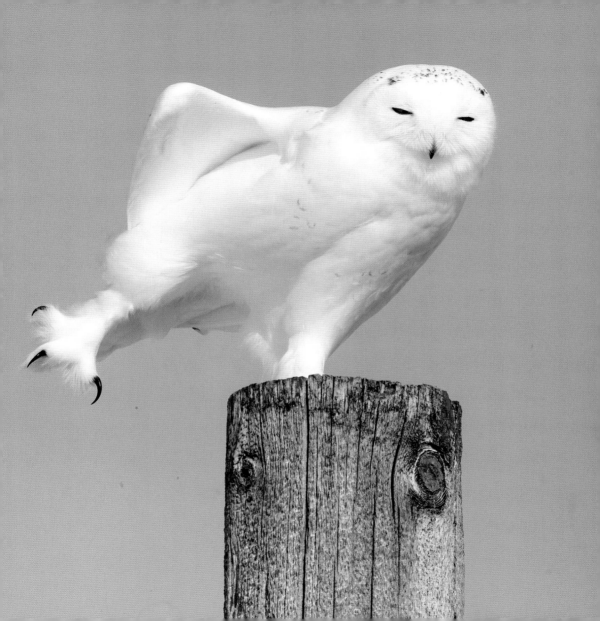

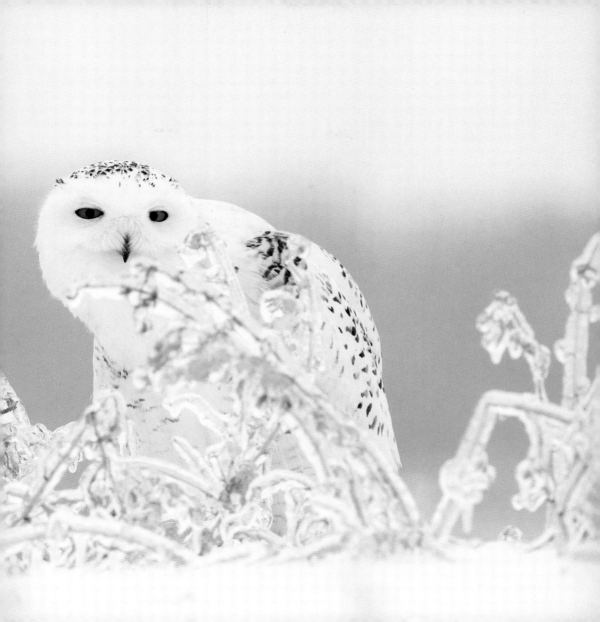

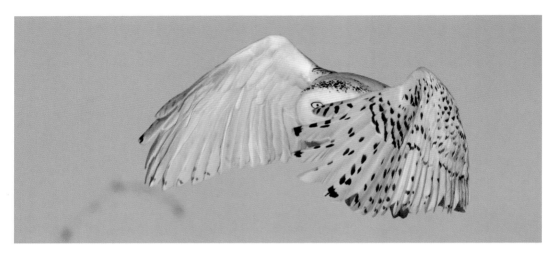

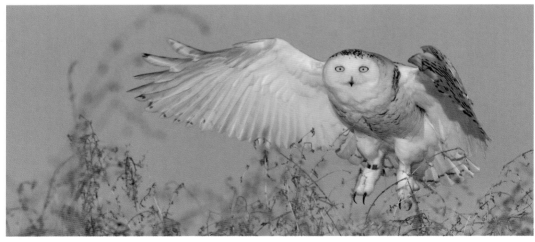

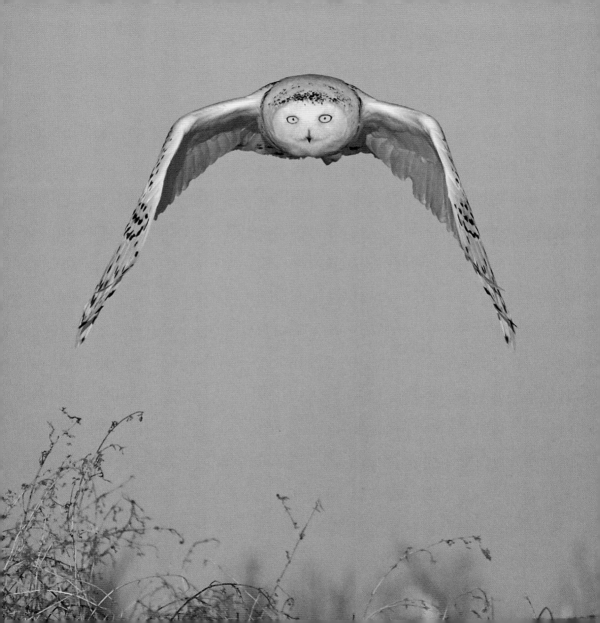

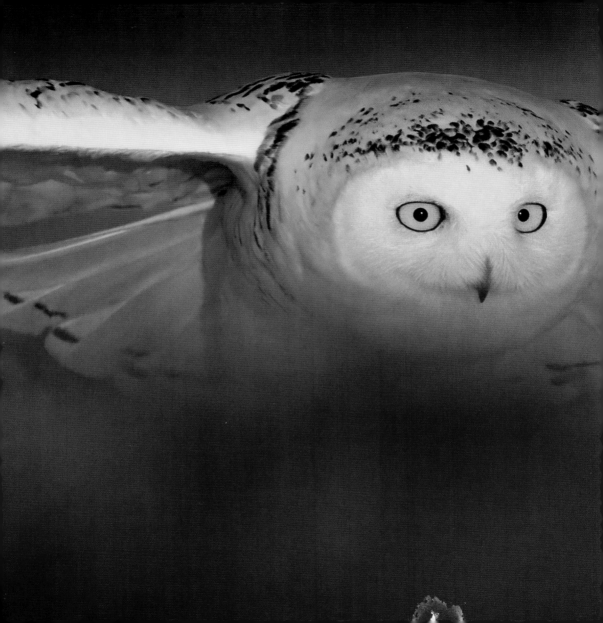

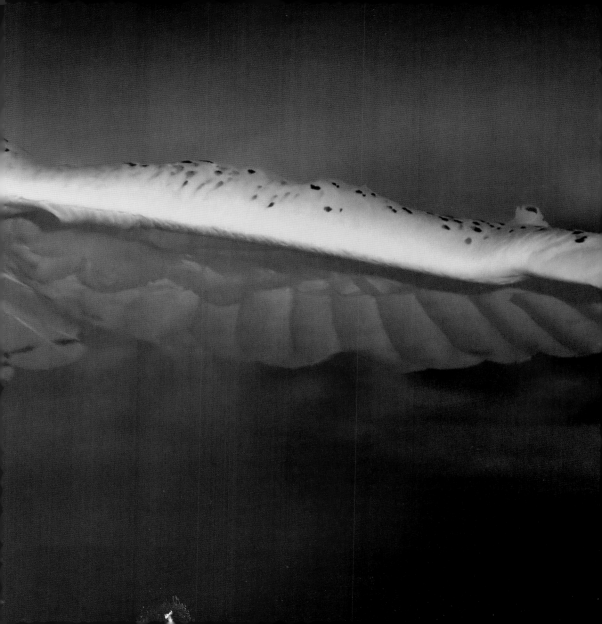

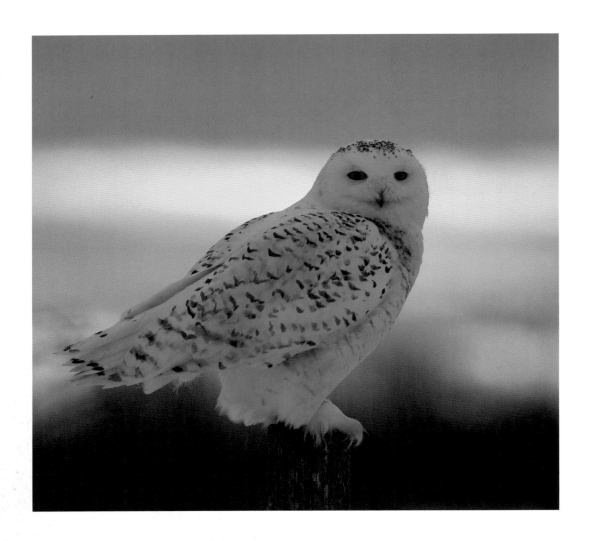

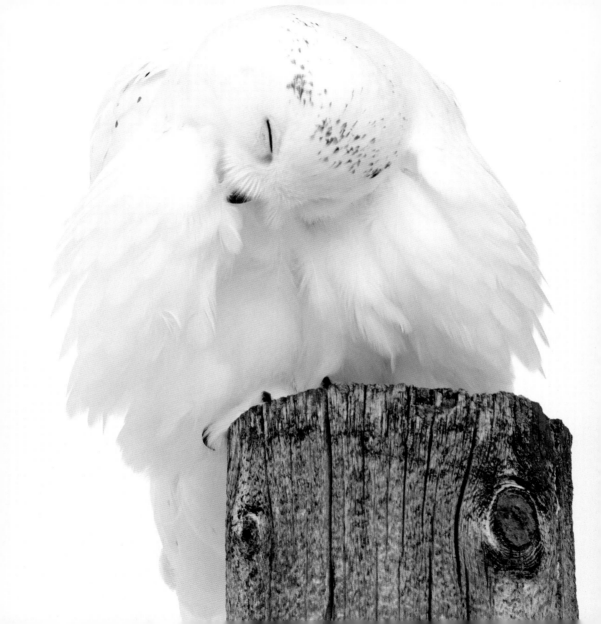

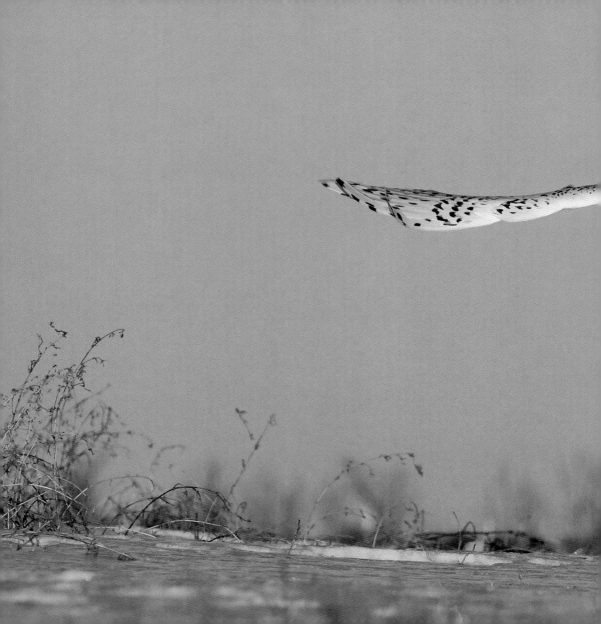

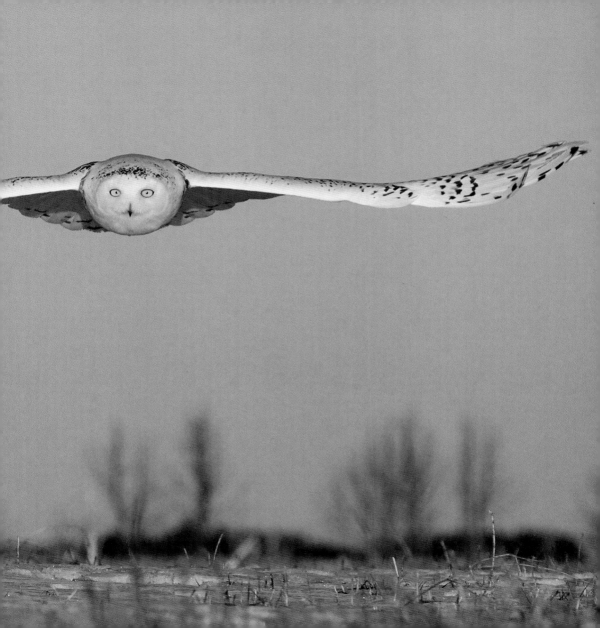

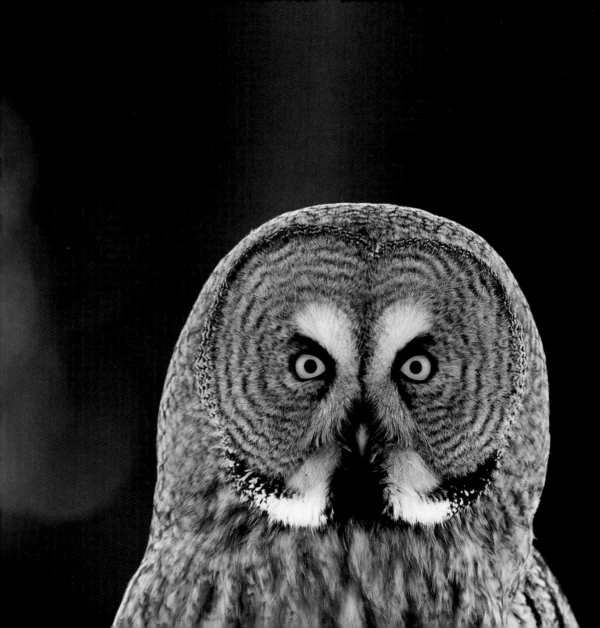

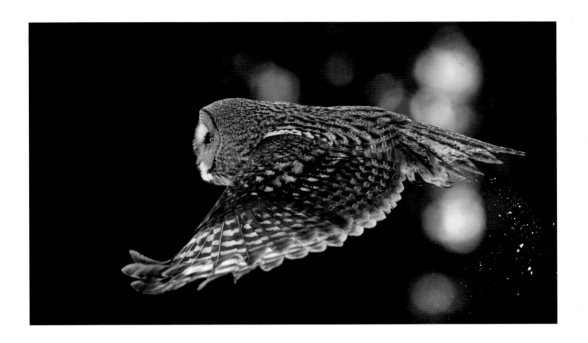

Great Grey Owl

Strix nebulosa

When the taiga forest is deep under winter's spell, and there are plenty of voles, the Great Grey Owl lives out of sight of the human eye. When the larder is depleted, the owls emerge from the woods, and often more than one can be seen keeping a lookout in the trees along the edges of a field.

The owl's hunting proficiency is built on an incredibly acute sense of hearing. It can pinpoint the exact location of a vole moving under snow from a couple of hundred metres away, and almost without fail it catches the rodent by grabbing it with its powerful talons from beneath snow up to half a metre deep.

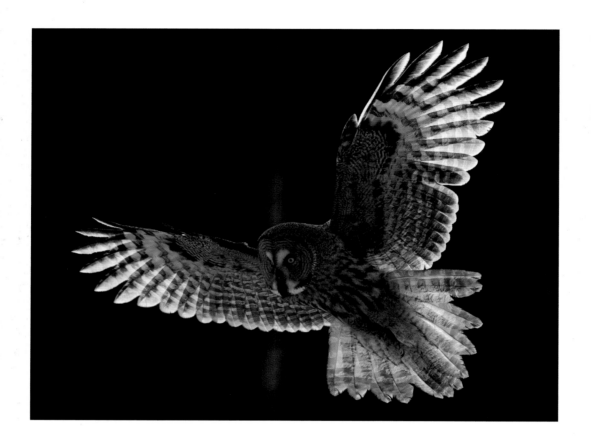

The Great Grey Owl's soft, rounded feathers make it completely silent when flying and gliding, which gives it the element of surprise when catching prey, but also enables it to focus on even the faintest sound coming from under the snow.

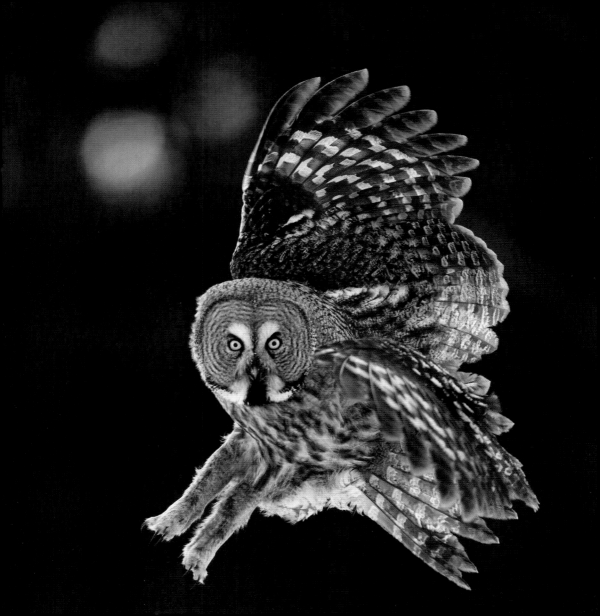

The rounded and slightly concave feathering on its facial disc helps to guide incoming sounds into its sensitive ears.

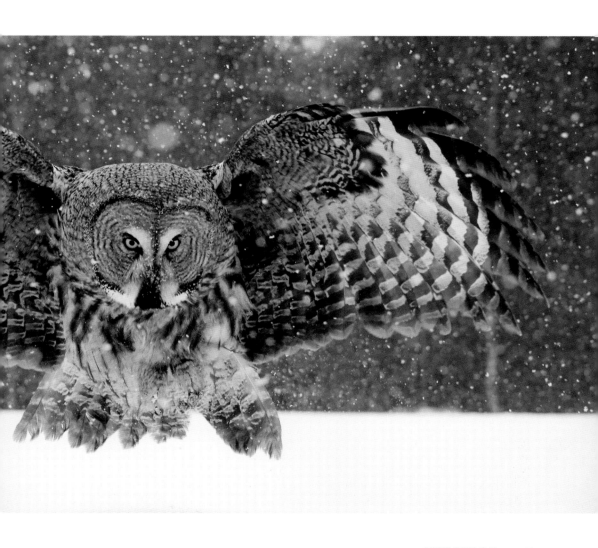

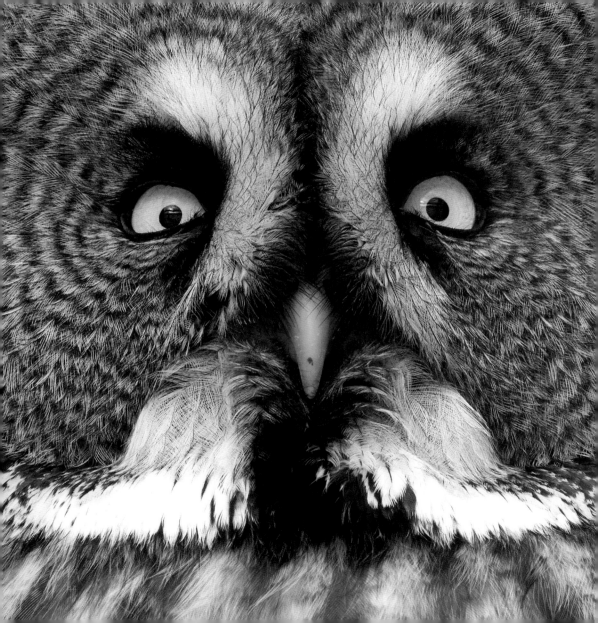

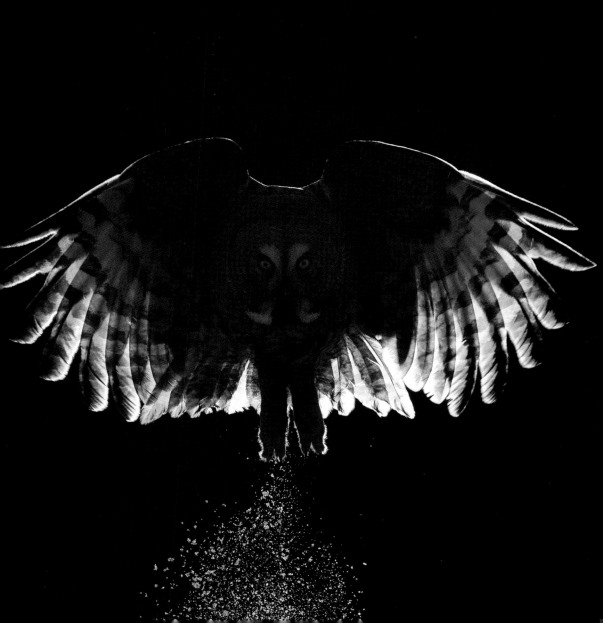

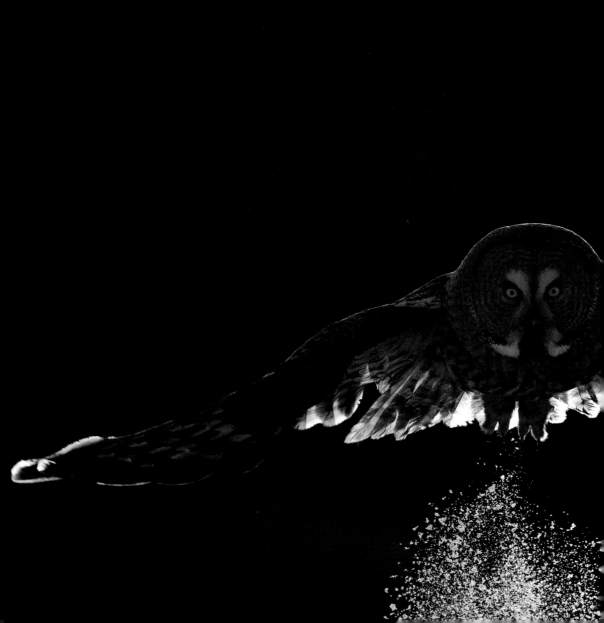

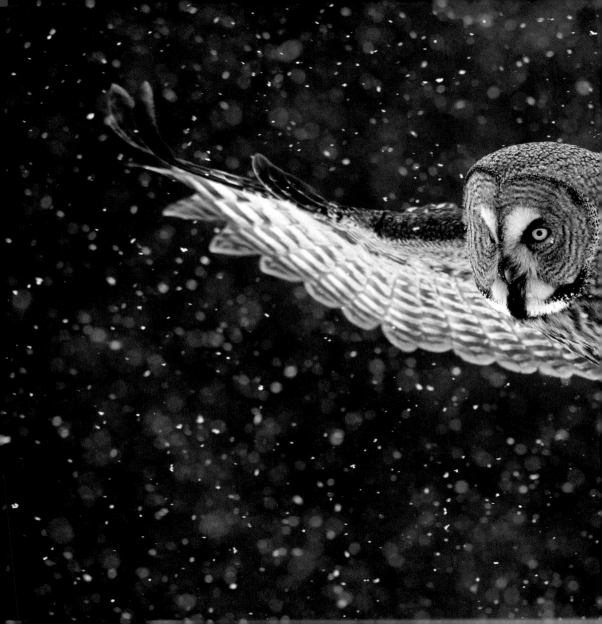

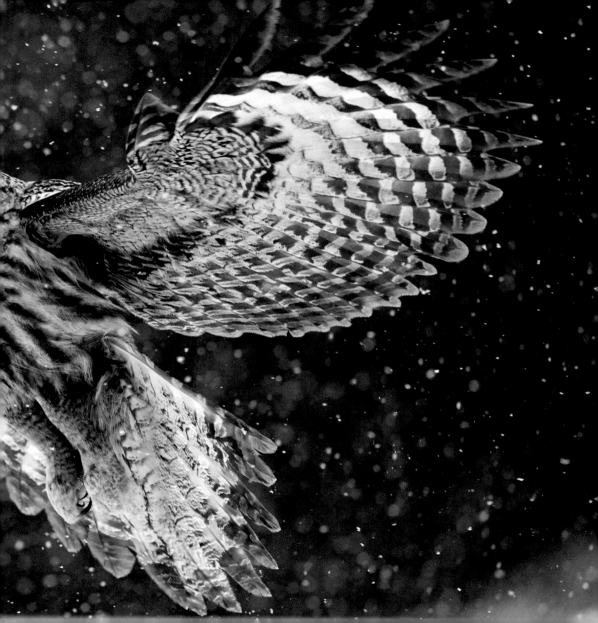

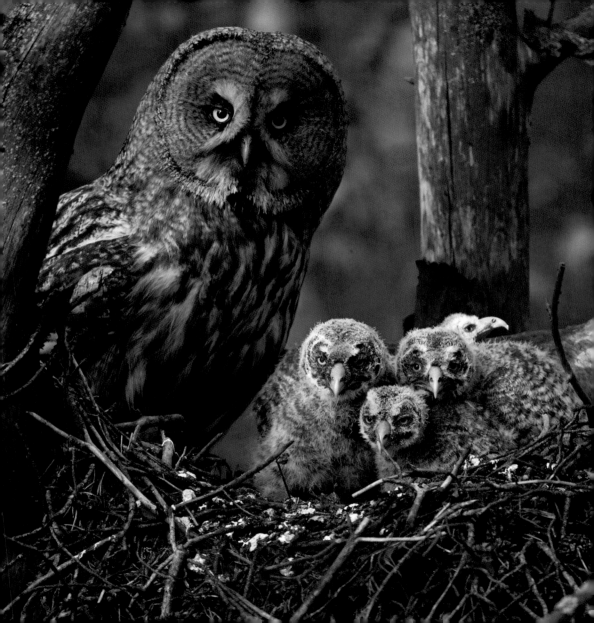

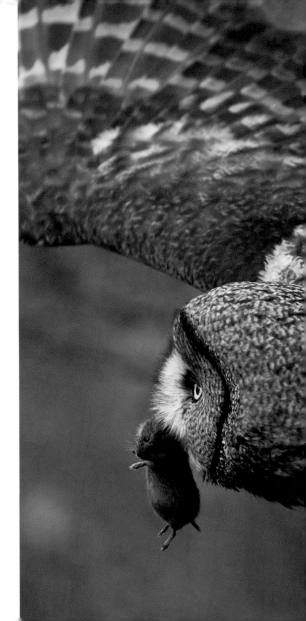

Great Grey Owls prefer to nest high up in a tree, preferably in an old raptor nest. But if none can be found, they can also settle in a standing stump of a tree or even on the forest floor on top of a big ant nest. When there is no shortage of food, there can be as many as eight owlets in the nest, but normally the brood has three to four chicks. On the right, a male brings a Wood Lemming *(Myopus schisticolor)* to the nest.

GREAT GREY OWL

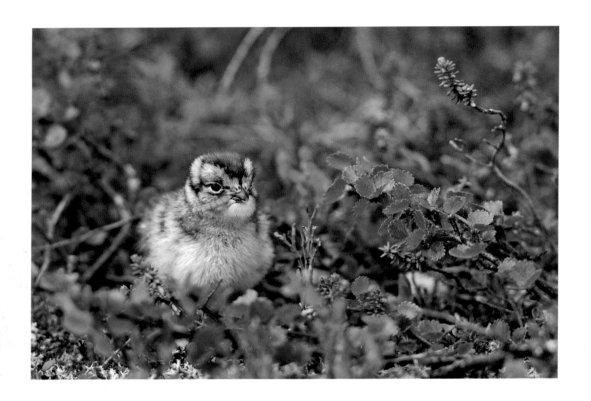

Rock Ptarmigan

Lagopus muta

The female leads her chicks away from the nest only a few hours after hatching, and the young birds start feeding themselves immediately. Unlike adults, the chicks also eat insects; the added protein is vital to their survival during the first few weeks of life, when rain and colder spells could prove fatal.

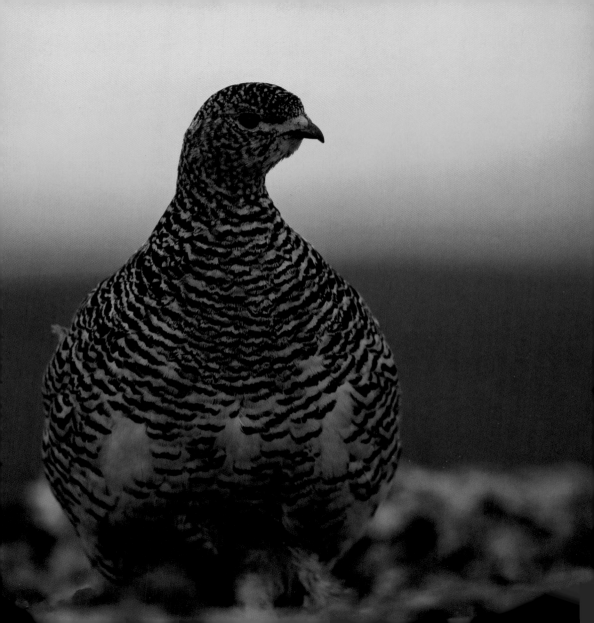

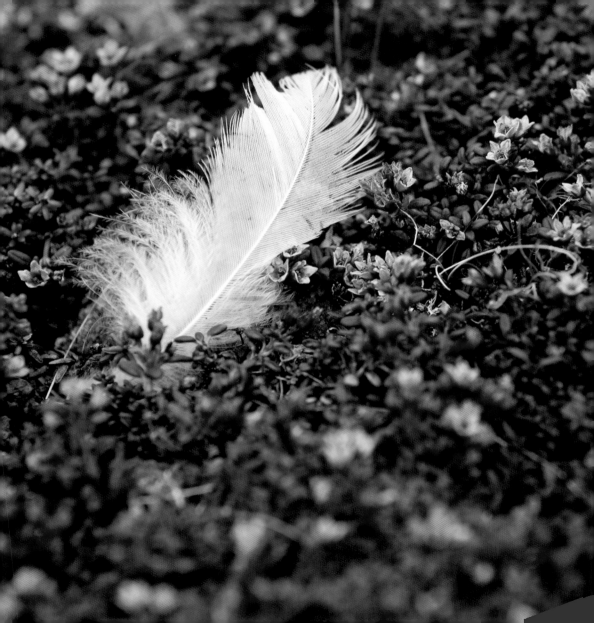

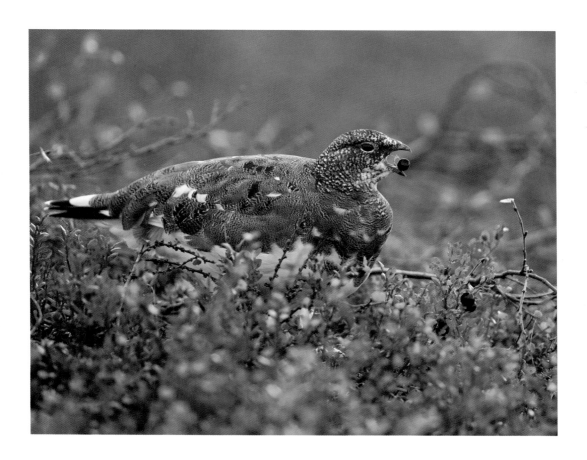

Rock Ptarmigan moult into a dappled brown-and-grey plumage for summer and autumn, blending almost seamlessly into their rocky environment in the upland areas of the Arctic. Berries form an important part of their diet in the autumn, giving much-needed sustenance for the winter hardships ahead.

After the first snow, Rock Ptarmigan slowly begin to moult into their all-white winter plumage. As the snow melts in spring, the white feathers are once again replaced by darker ones, and it is relatively easy to find white ptarmigan feathers on the hillsides in early summer.

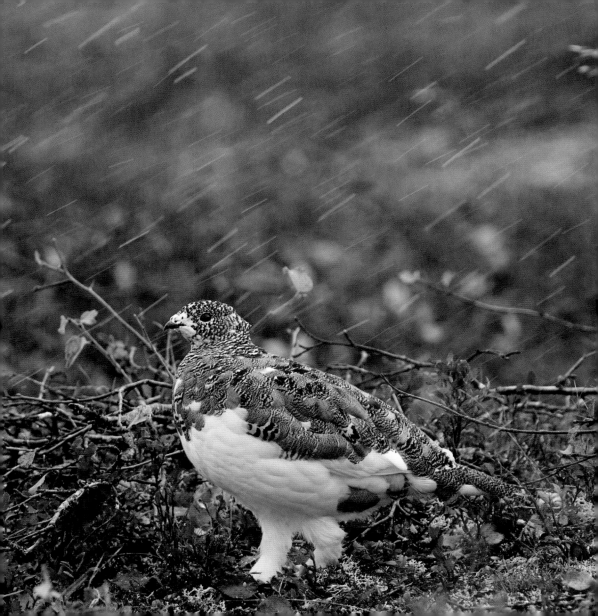

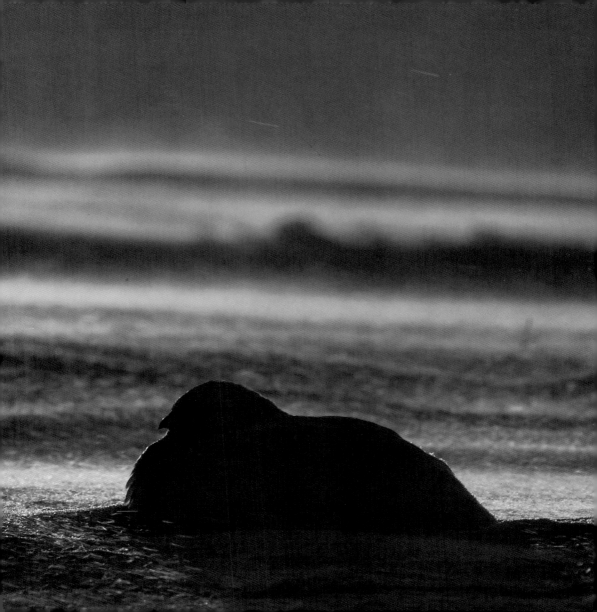

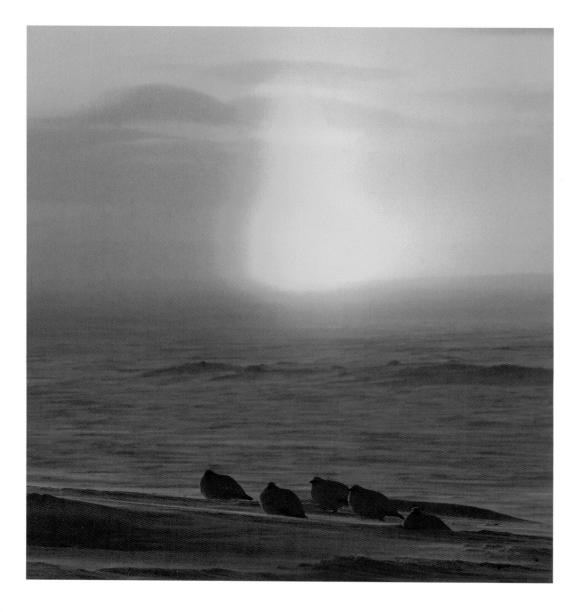

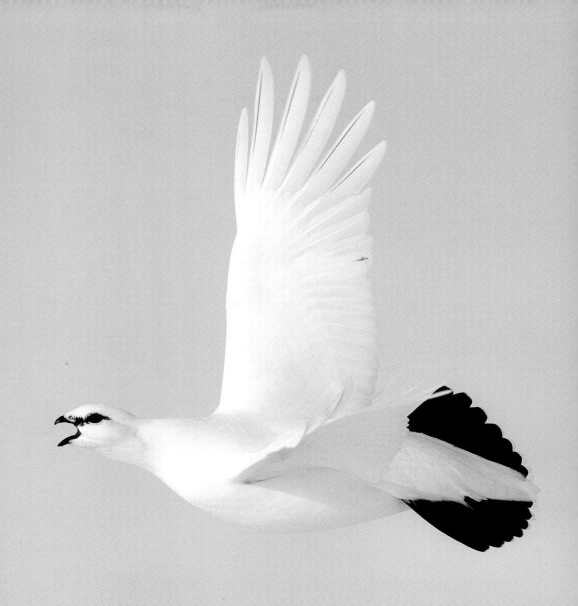

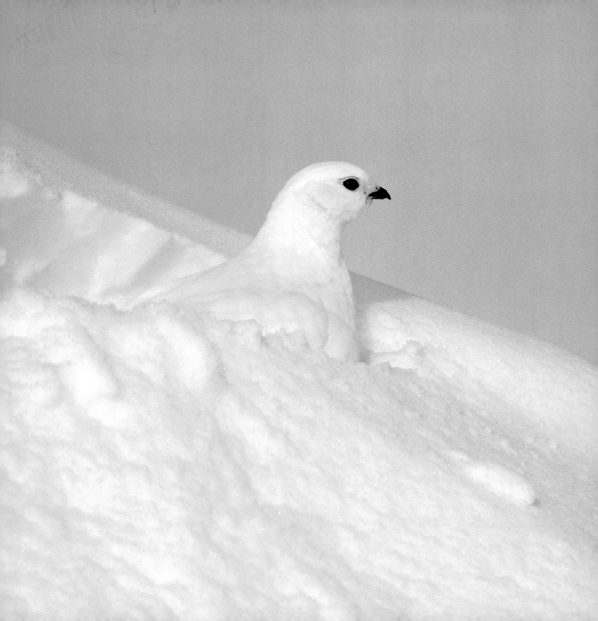

Rock Ptarmigan are well adapted to life in the Arctic winter. By burrowing, they use the snow as cover against the fierce winds and as insulation against the biting cold. Some winters have extremely hard snow conditions but ptarmigan have learned to follow in the reindeers' footsteps, literally: as the deer dig through the snow searching for food, they leave the way open for the birds to find a meal.

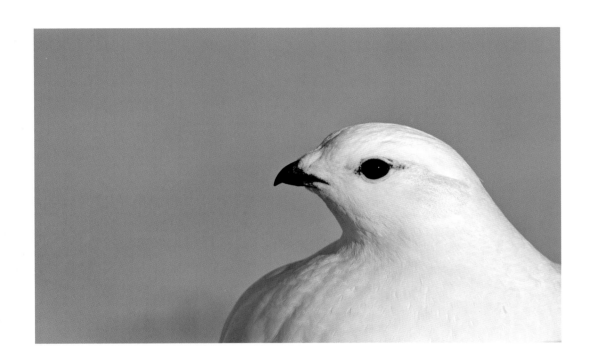

As the days grow longer and the snow glitters in the spring sunshine, Rock Ptarmigan males proclaim their territories by letting out their unique display calls, perching on top of their display boulders and launching into beautiful courtship flights.

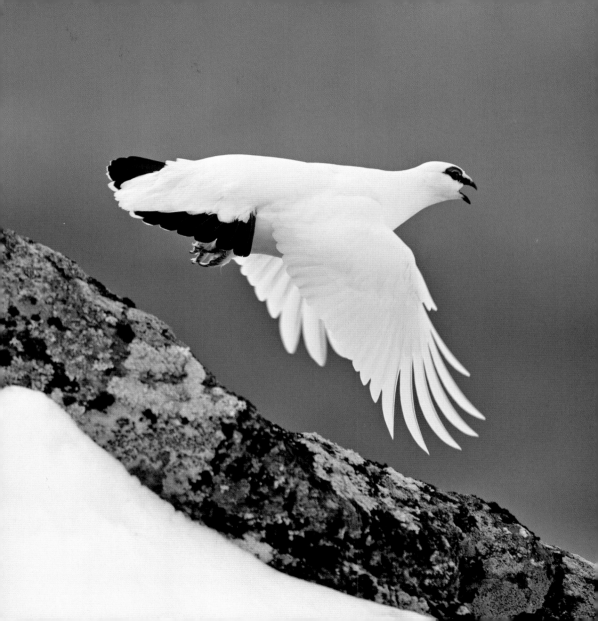

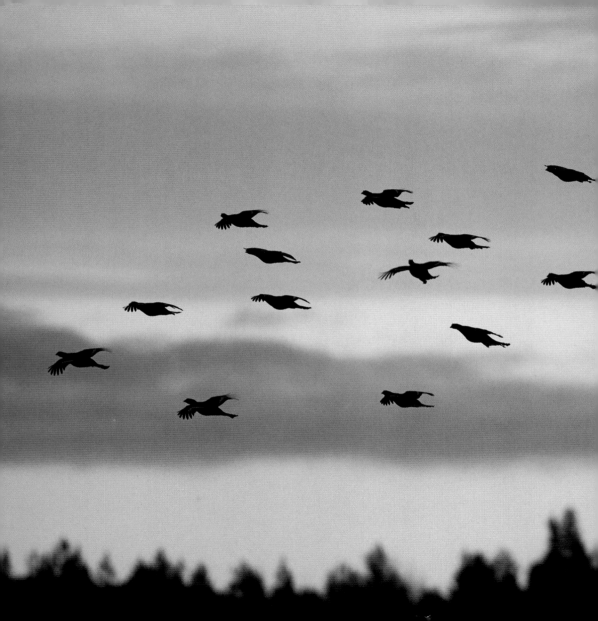

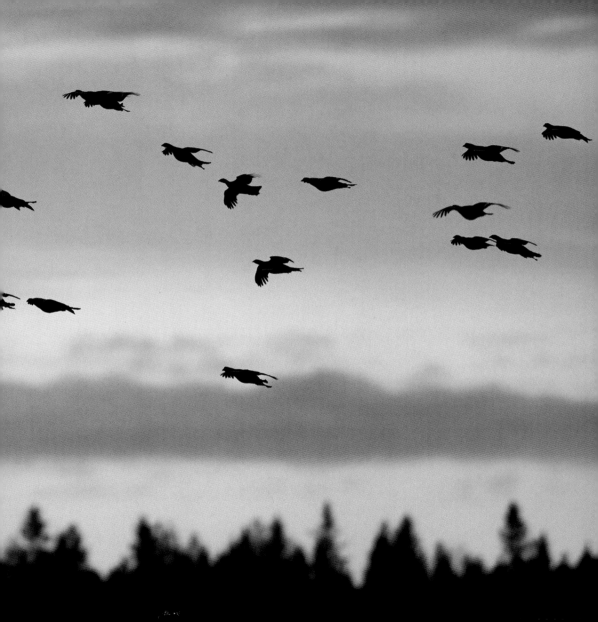

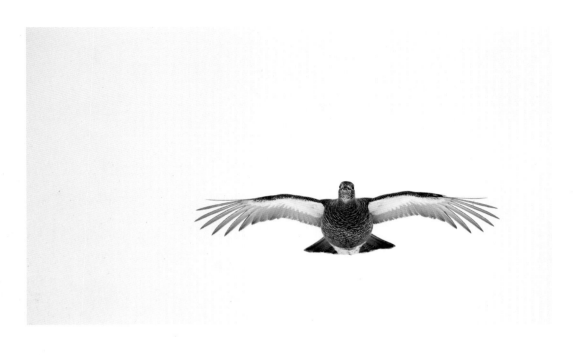

Black Grouse

Lyrurus tetrix

From late winter until the end of spring males gather diligently, every morning, at their traditional display sites known as leks, which are often on treeless bogs. In the beginning the females join them only for short visits, as if to check the situation, before going back to feed, which is their main concern as they prepare for the arduous phase of incubating the eggs.

On mornings when the air temperature is sub-zero, exhaled breaths are clearly visible as the excited males let out their display calls.

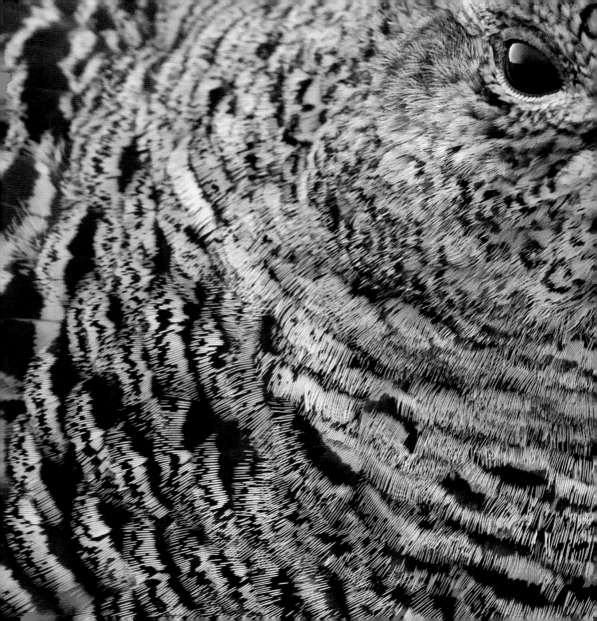

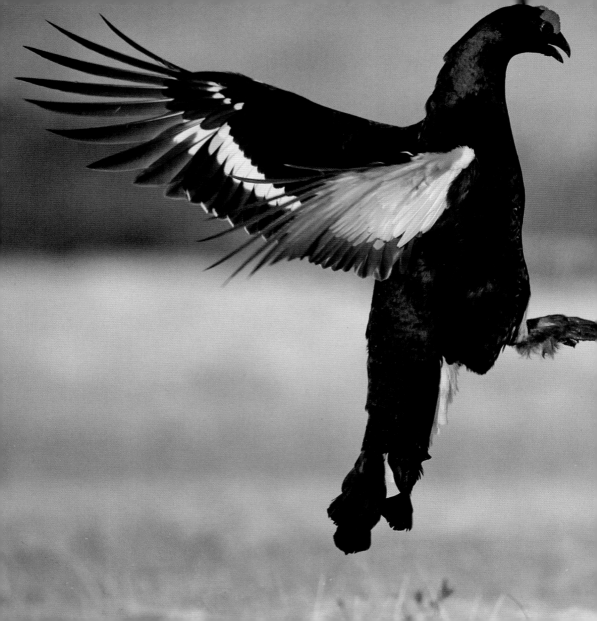

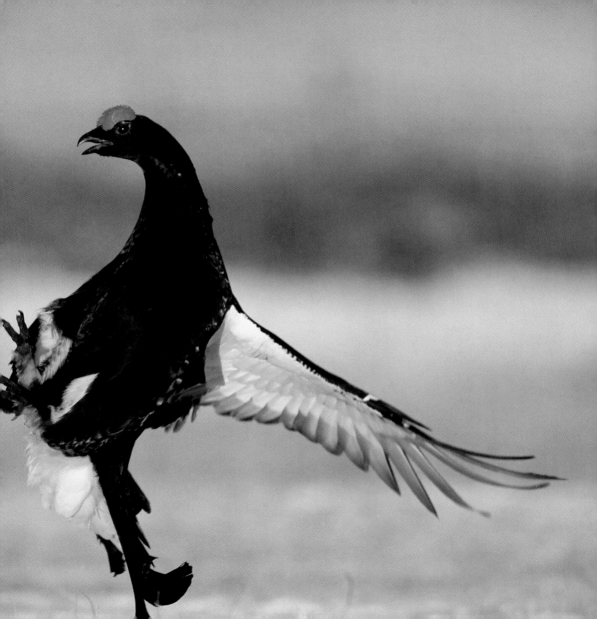

Early in the displaying season, the males spend only a couple of hours at the lek each day, but come late spring, as mating time approches, they can stay for between four and six hours. A passing Northern Goshawk (*Accipiter gentilis*) may frighten the flock away, but only for a short while; they usually return within a quarter of an hour.

With the day's lekking over, the male grouse depart in order to attend to their other activities, and they all leave more or less at the same moment. Usually this moment of departure is difficult to predict, which makes flight photography somewhat challenging!

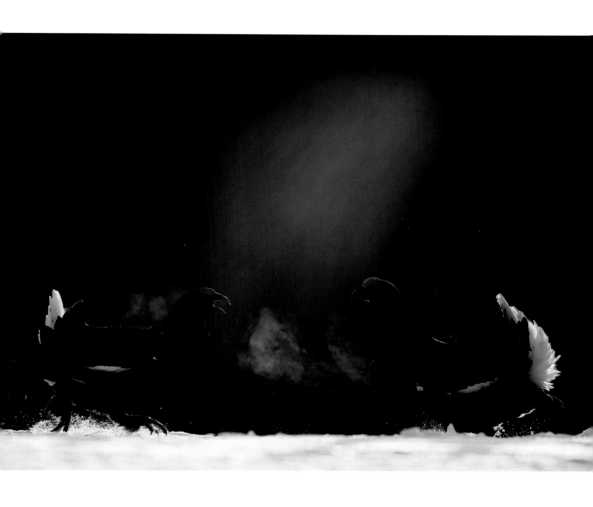

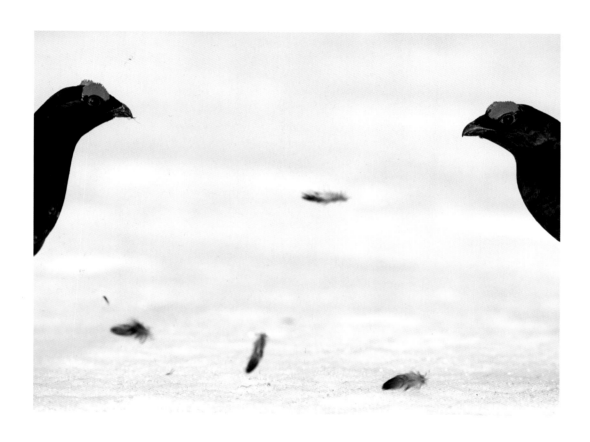

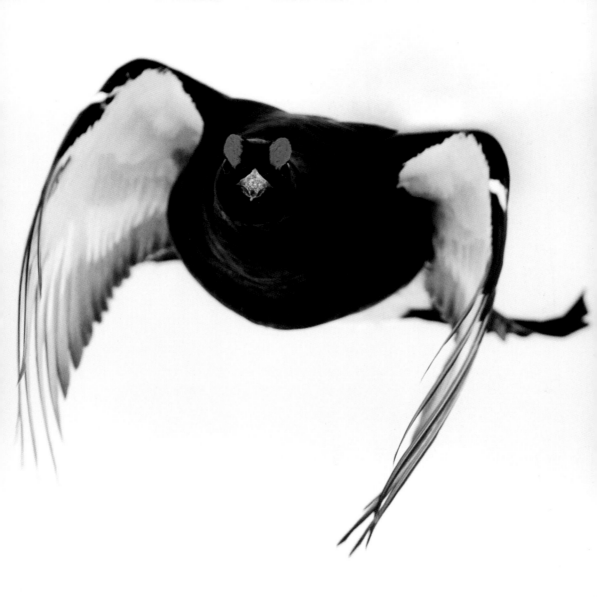

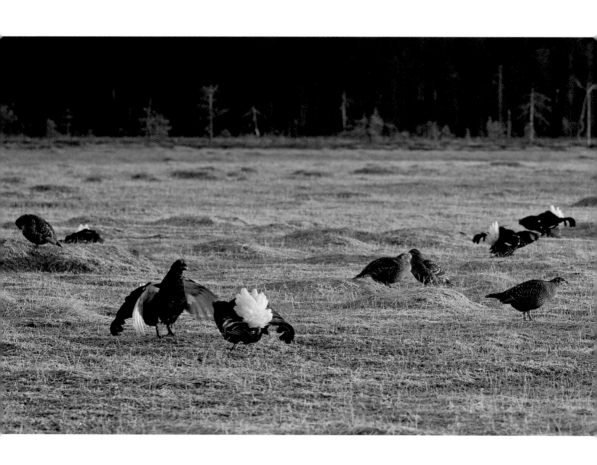

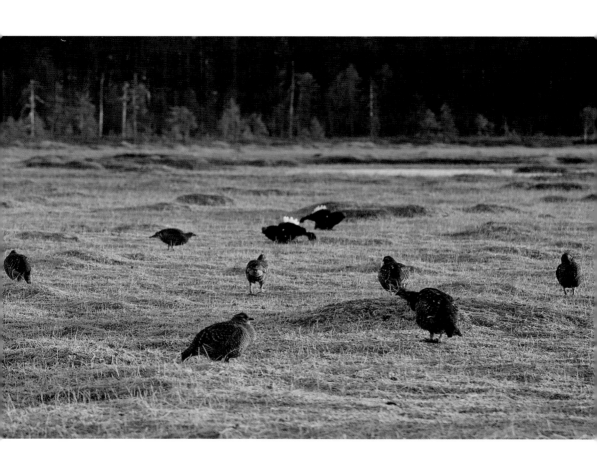

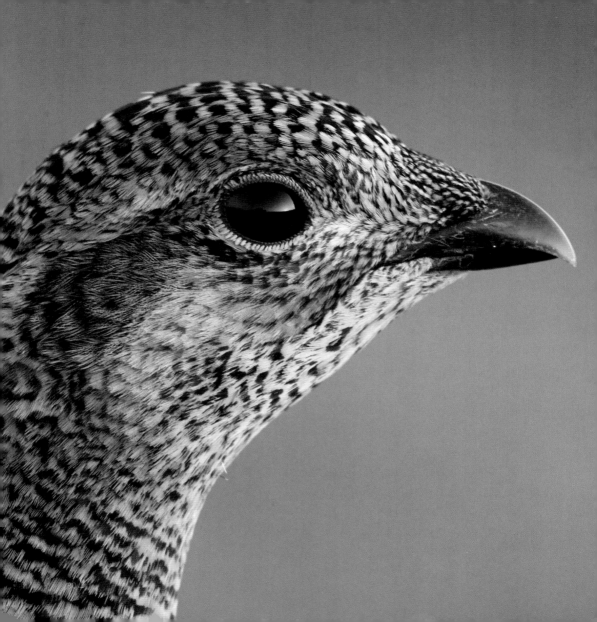

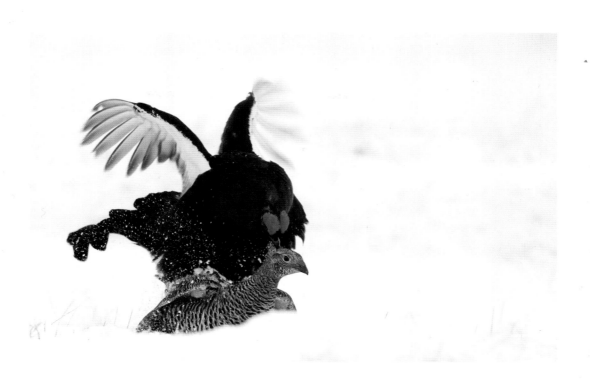

As spring progresses, the female Black Grouse start spending more time at the lek, taking stock of the potential mating partners on offer. Most females copulate with the male dominating the centre of the lek. With the females' arrival, the males are energized into showy display fights.

An incubating female blends seamlessly into the surroundings. The nest is impossible to find other than by accident, when a startled bird takes off explosively from the ground.

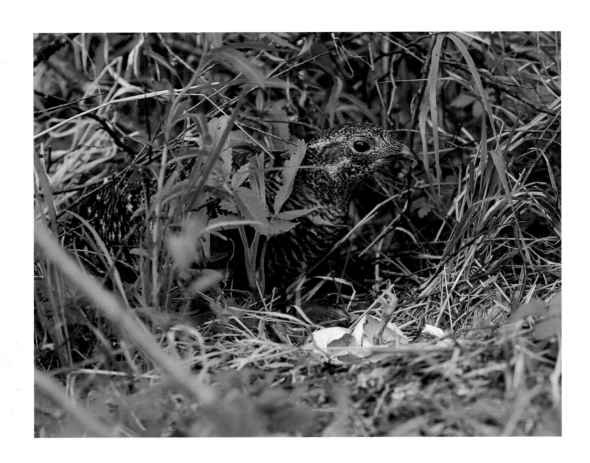

Newly-hatched Black Grouse chicks are wet and appear to be helpless. They spend a couple of hours buried in the warmth of the female's plumage and emerge all dry and fluffy. Young grouse are precocial, meaning that they are ready to leave the nest soon after hatching and feed themselves independently, led and guided by their parent.

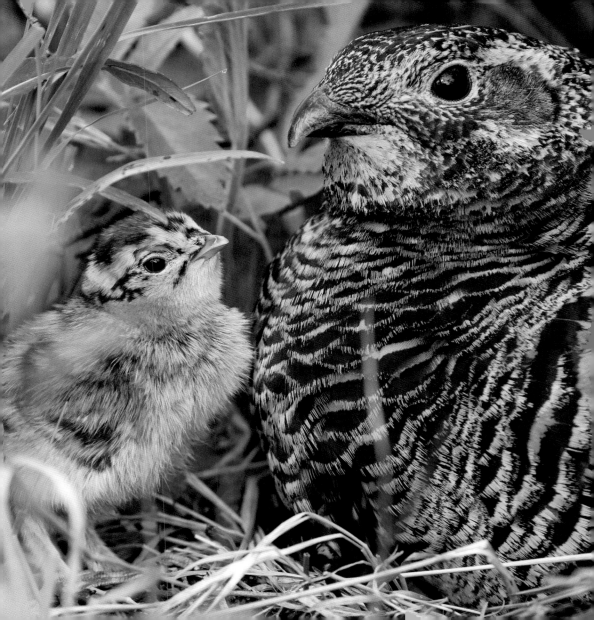

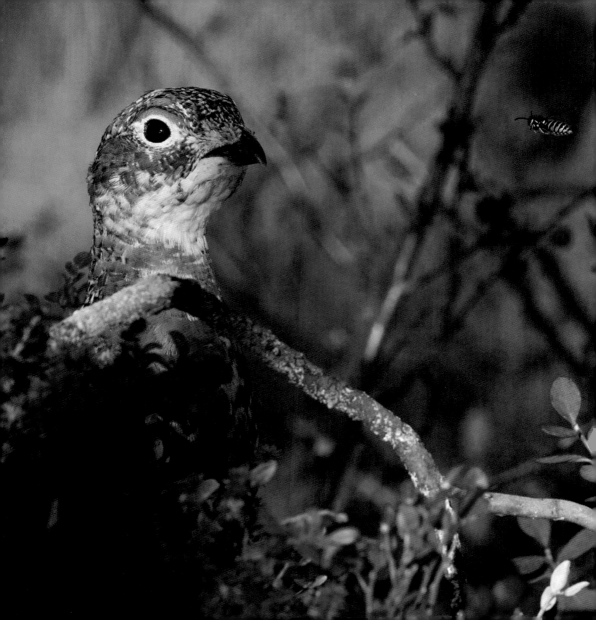

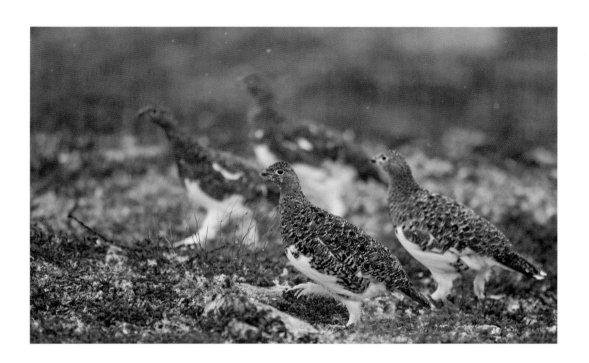

Willow Grouse

Lagopus lagopus

Willow Grouse have a beautiful red-brown plumage in the autumn, making it hard to spot them against the foliage as it turns to shades of orange and brown. Feeding on vegetation and berries, the broods stick together in family groups well into late autumn.

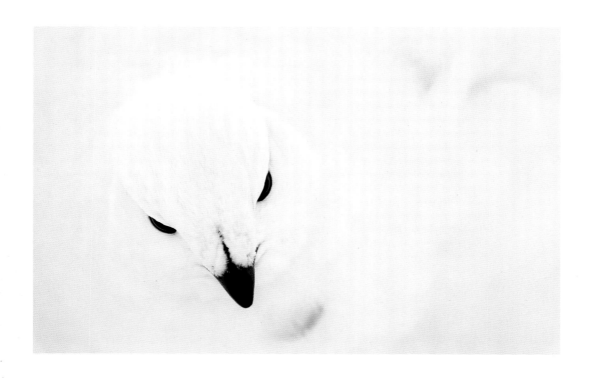

Like the closely-related Rock Ptarmigan, Willow Grouse moult into an all-white plumage for winter. Especially on cloudy days, this helps them to blend completely into their snow-covered environment.

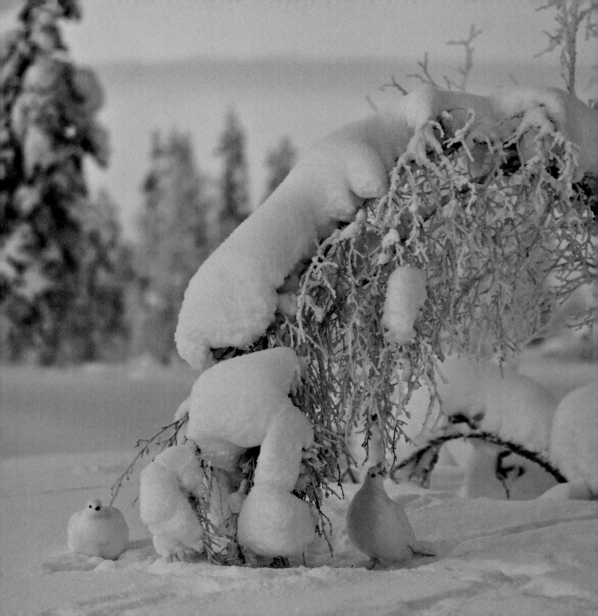

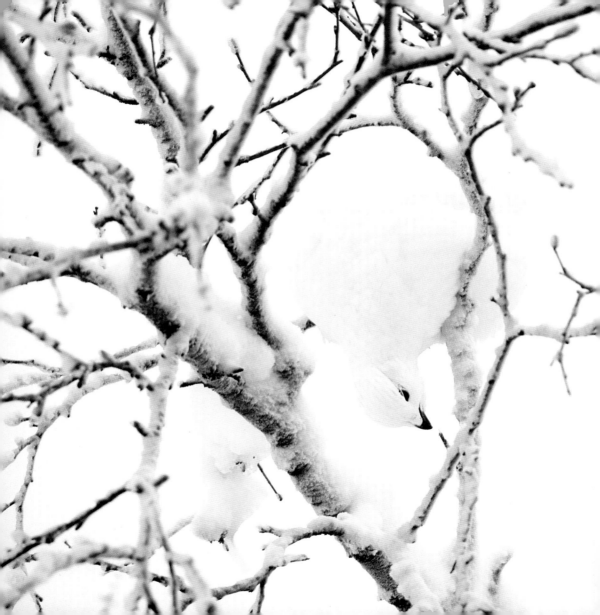

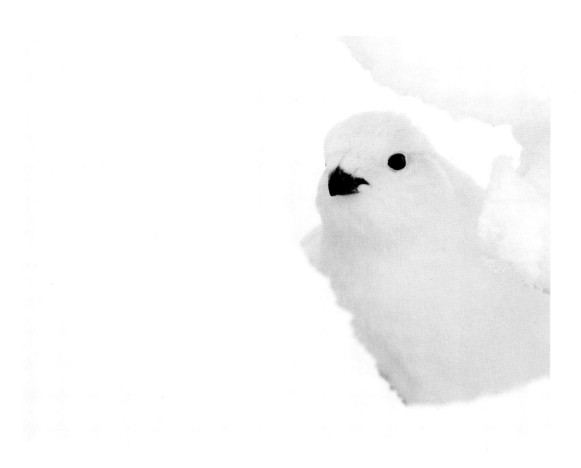

Lapland winter nights are long. Willow Grouse use the short periods of precious daylight to feed on buds and twigs. The rest of the day is spent digesting the hard food in snow-burrows. The dusky winter daylight causes colours to fade and makes the natural environment appear black and white.

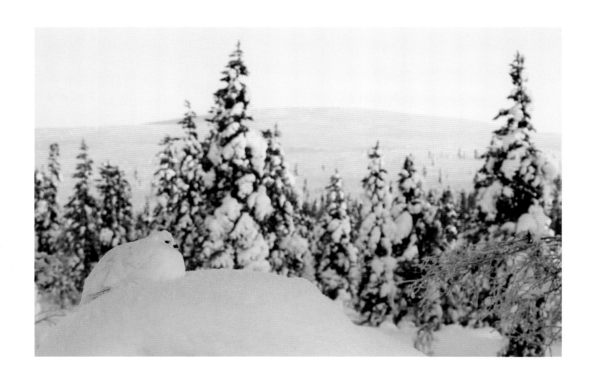

Willow Grouse prefer to move in flocks during the winter. In mid-January the polar night ends and come February the Arctic regions are bathing in beautiful, low-angle sunlight. More sets of eyes mean a better chance of spotting a predator!

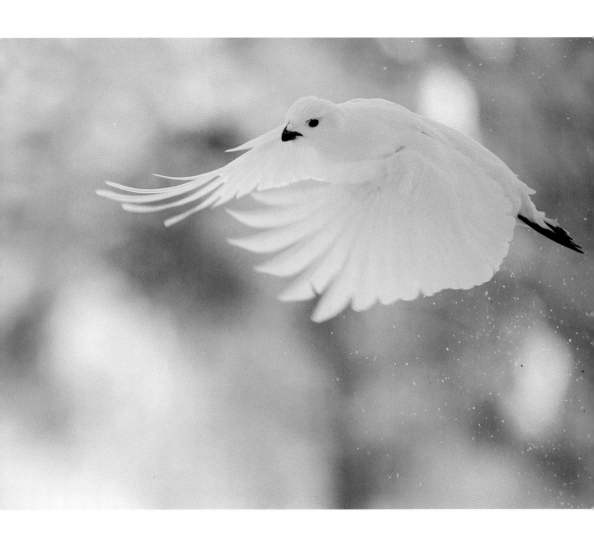

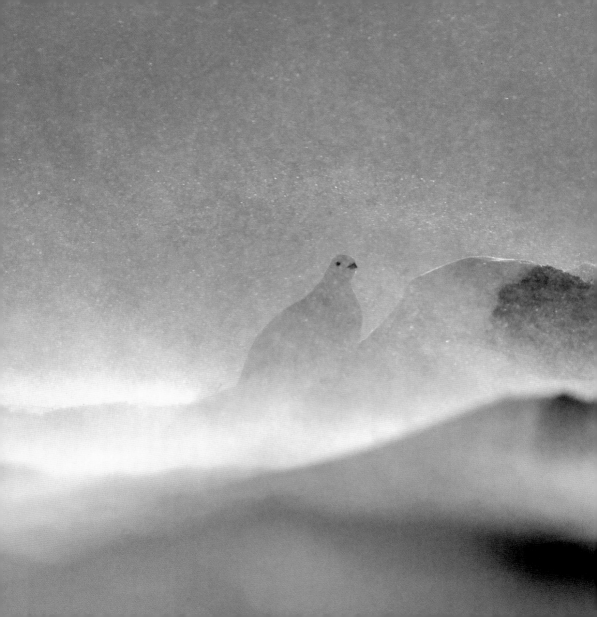

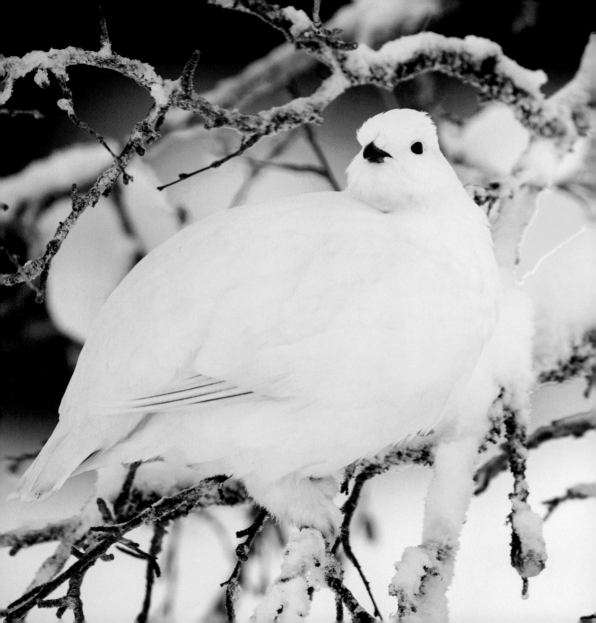

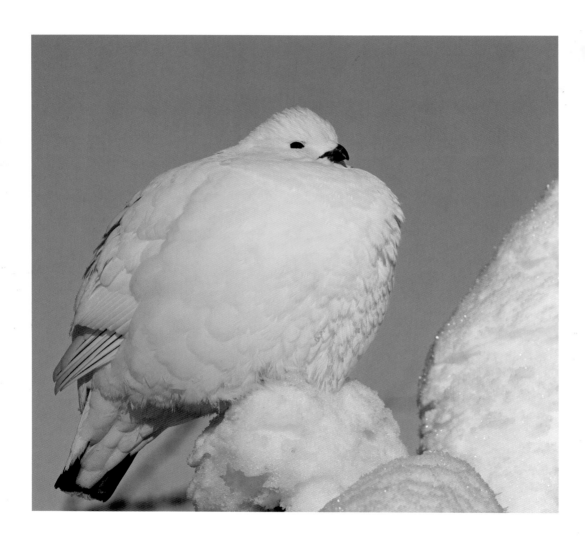

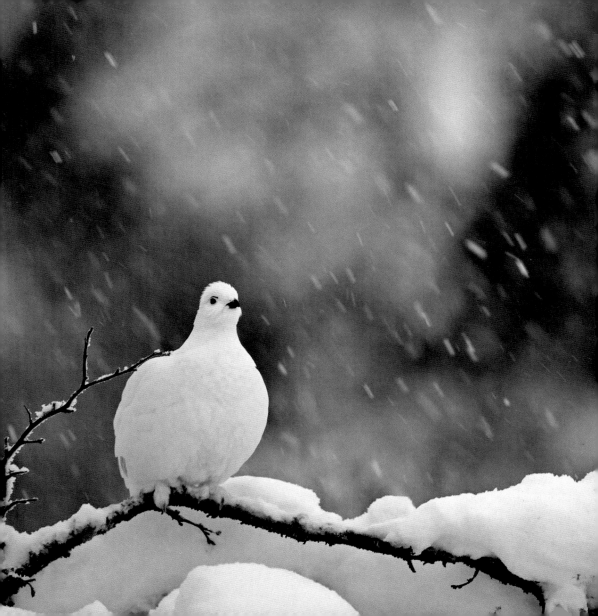

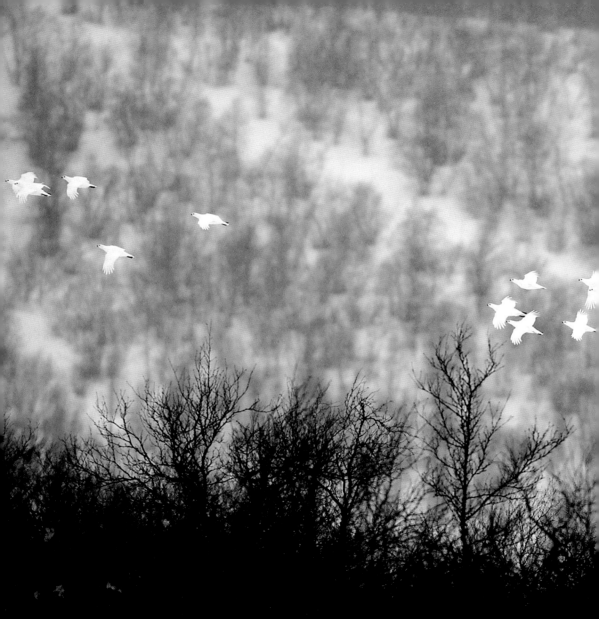

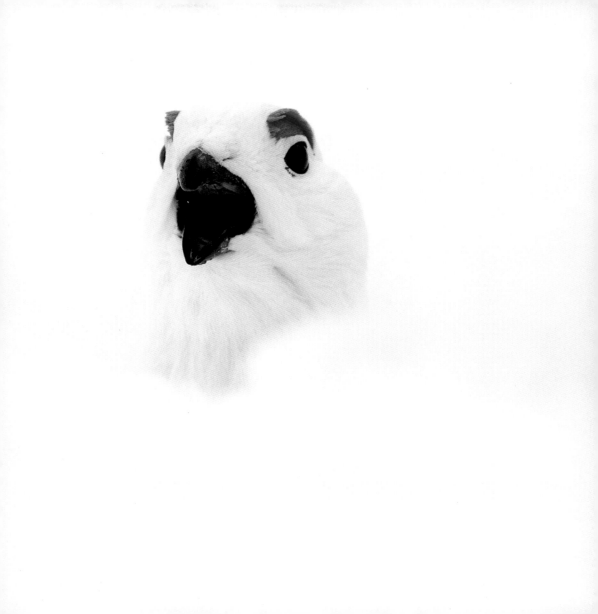

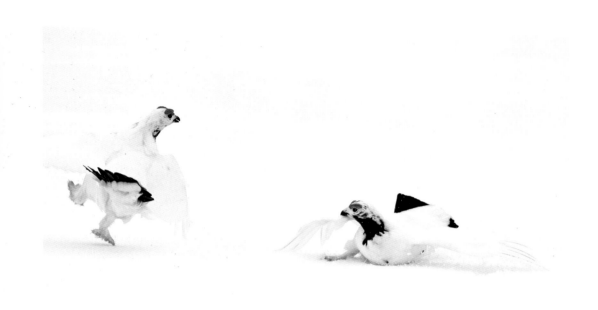

When winter is turning into spring, Willow Grouse males fight over territories and stake their claim with a set of harsh display calls, which sound much like cackling nasal barks. Any intruding males are chased away without hesitation, sometimes after a fight.

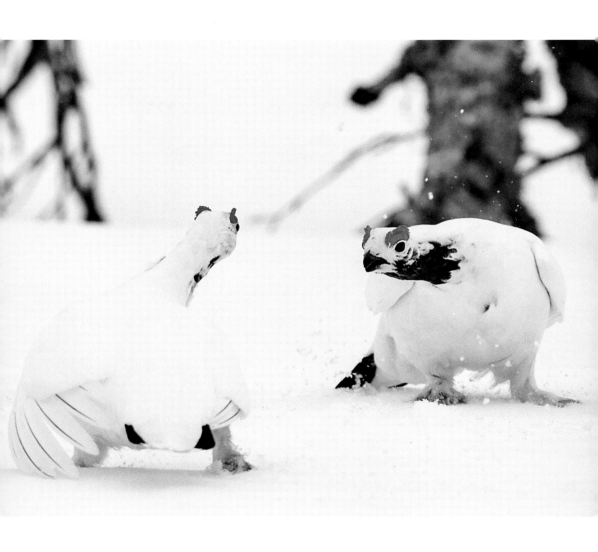

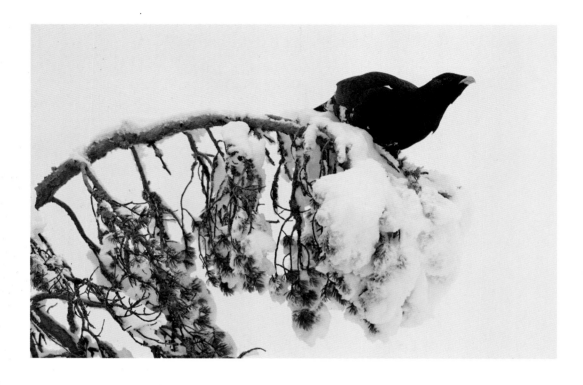

Western Capercaillie

Tetrao urogallus

In winter these huge grouse feed almost exclusively on pine needles. They prefer damaged trees whose needles are easier to digest due to their lower resin content.

At the end of March conditions can still be very wintery, but the approaching display season starts to stir the capercaillies' senses.

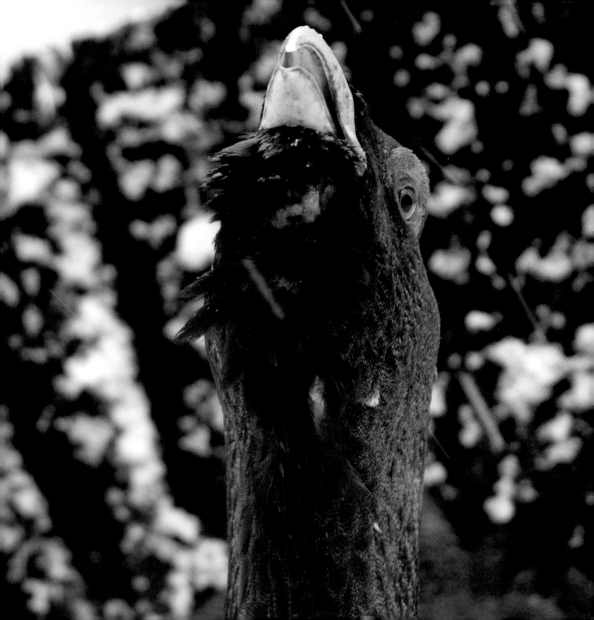

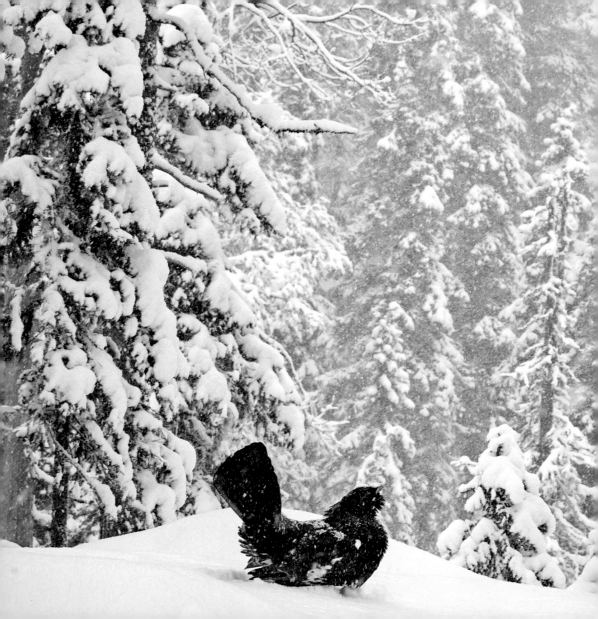

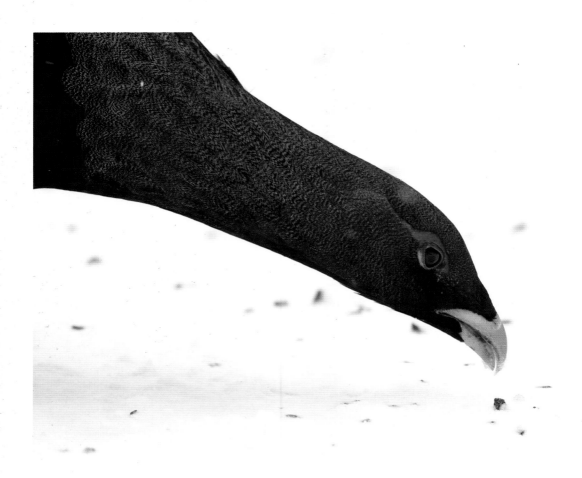

Like other members of the grouse family, the Western Capercaillie swallows small pebbles to act as grinding stones in the bird's muscular stomach, the gizzard. Here they help to digest the nearly indigestible food.

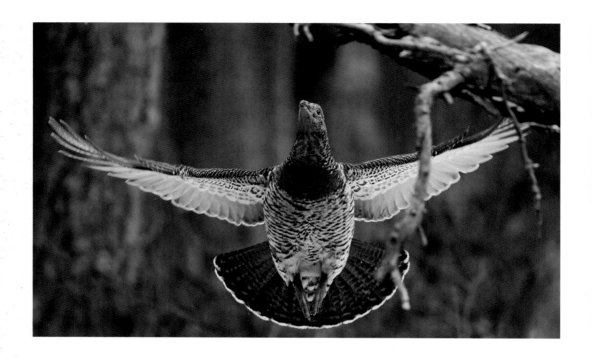

Decade after decade, Western Capercaillies return to their traditional leks, where the males claim small display territories and engage in sometimes fierce fights amongst themselves. Later in the spring, females begin to attend the lek daily in order to gauge the skills of their potential suitors.

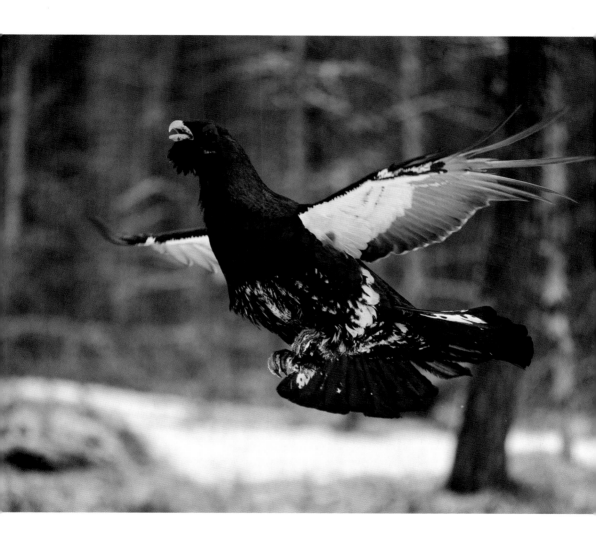

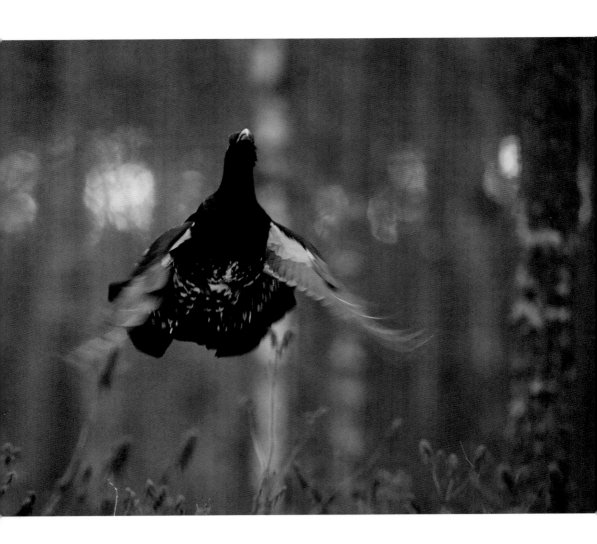

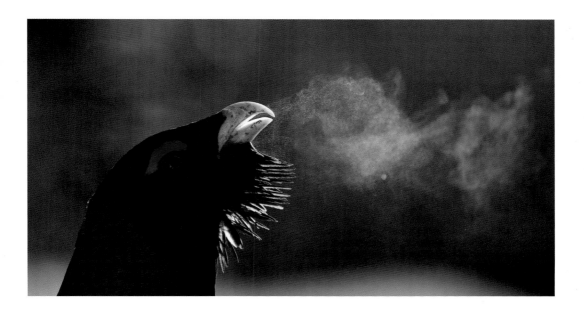

With the appearance of the females, male Western Capercaillies launch into flamboyant display jumps, short flights, and energetic chases. No cold frosty morning or heavy snowfall dampens their fervour. Lekking takes place every morning, whatever the weather.

The individual that wins and defends the centre of the lek is the reigning male, who gets to mate with almost all the females in the flock. A female indicates her readiness to mate by crouching and spreading her wings.

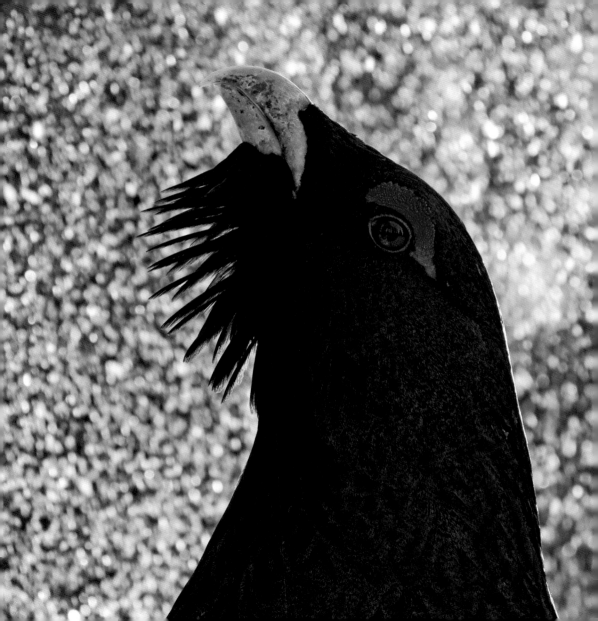

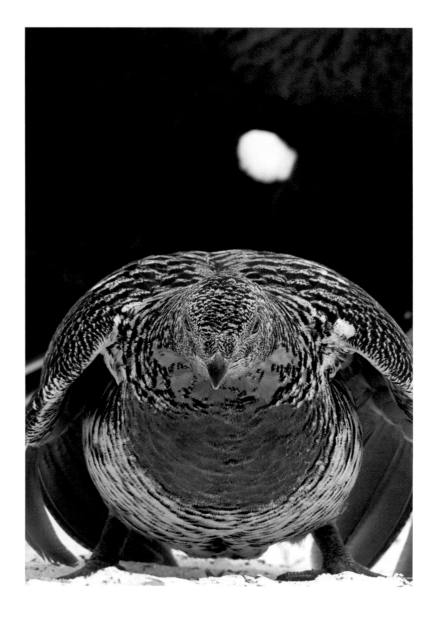

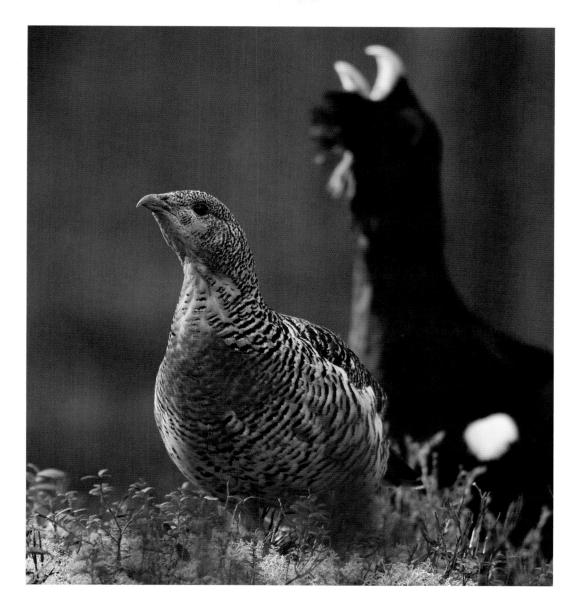

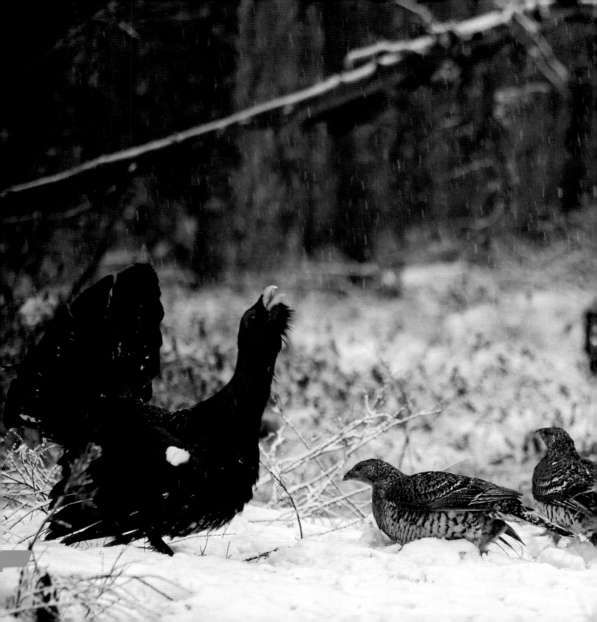

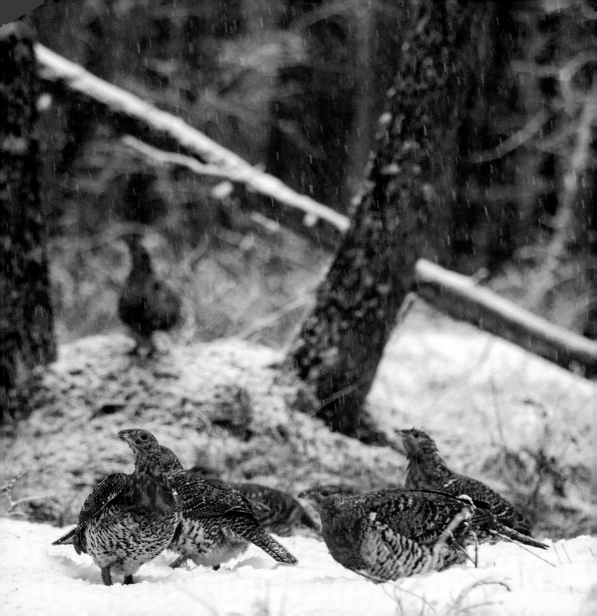

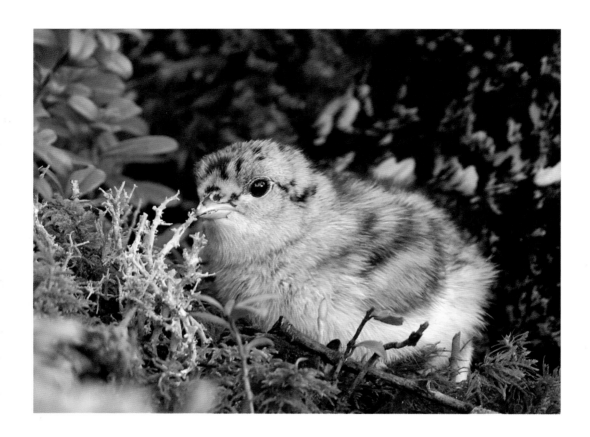

Usually, Western Capercaillie females lay between six and nine eggs, and they start to incubate only when the clutch is full in order to get the eggs to hatch in close proximity. In only a few hours after hatching, the chicks are dry and ready to leave the nest, led by their mother into the woods to feed independently.

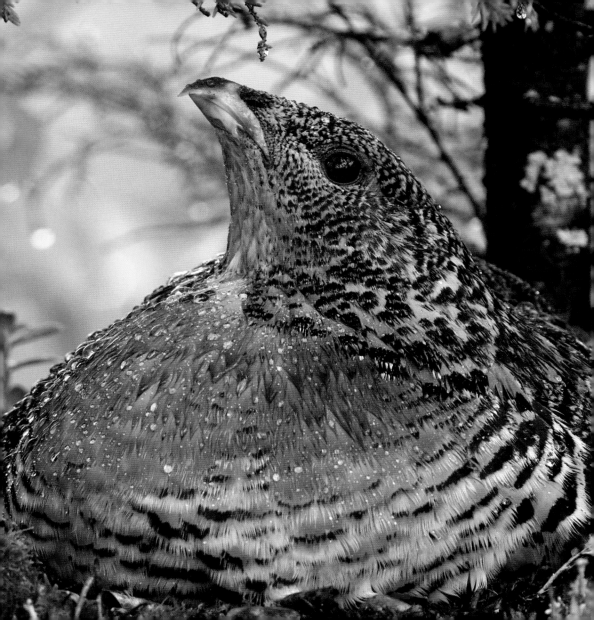

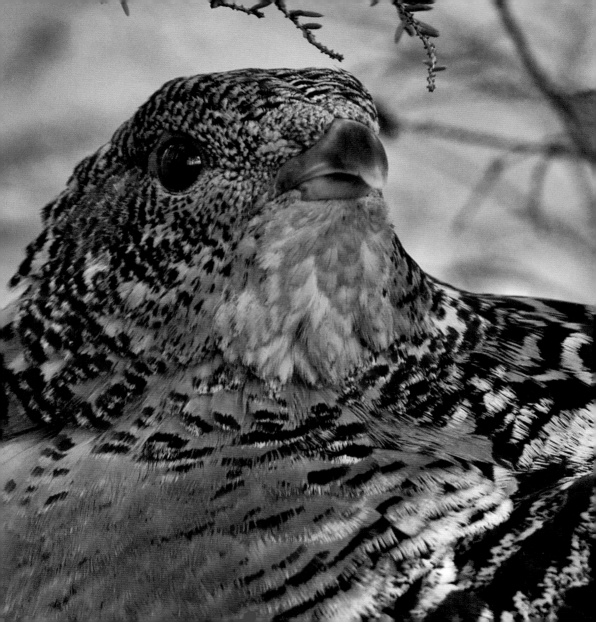

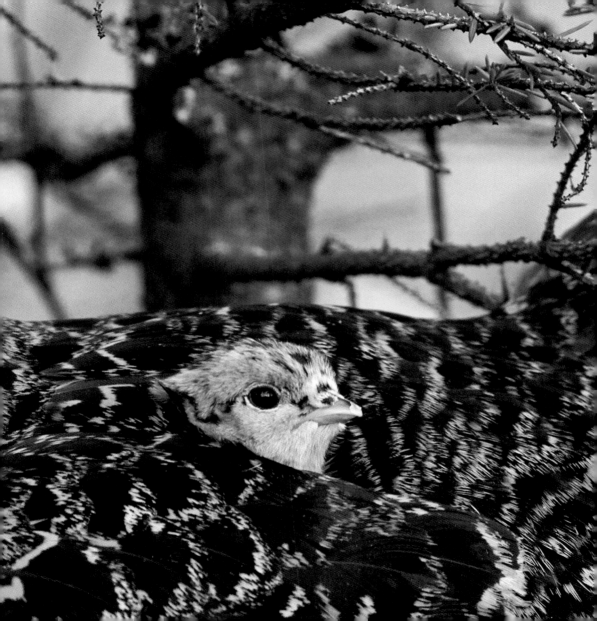

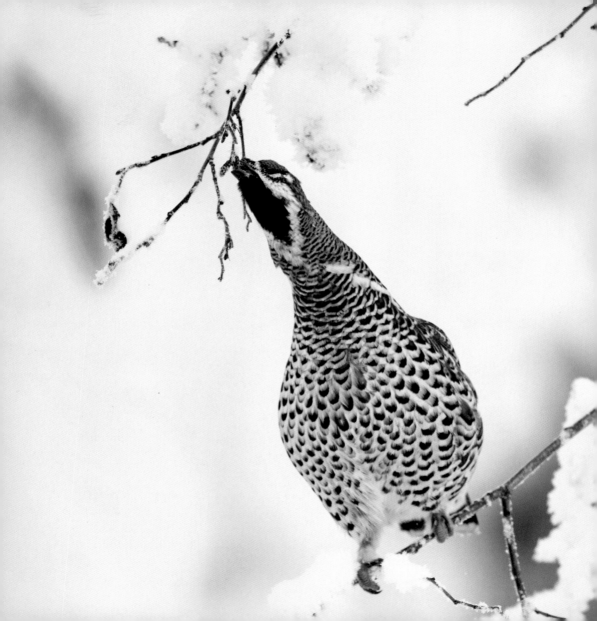

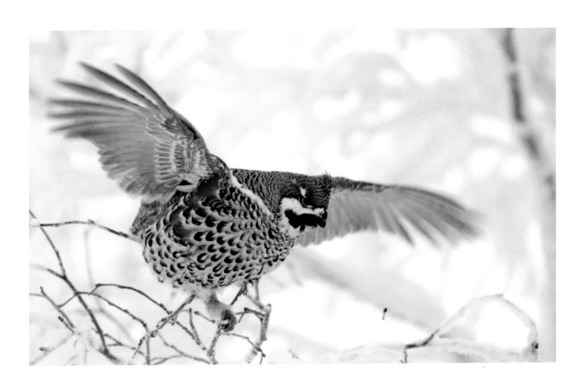

Hazel Grouse

Tetrastes bonasia

The winter diet of this small grouse consists of the buds, catkins and twigs of broadleaf trees. They seem to prefer the trees lining the edges of an opening, a road or some other sunlit spot, where the buds are bigger and more nutritious than those growing in the darker conditions inside a forest. The birds are masters at balancing on even the thinnest of branches when foraging for the juiciest items to eat.

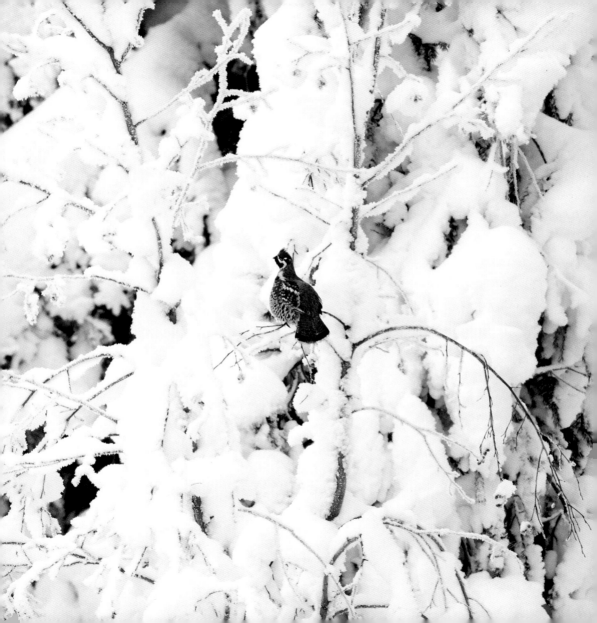

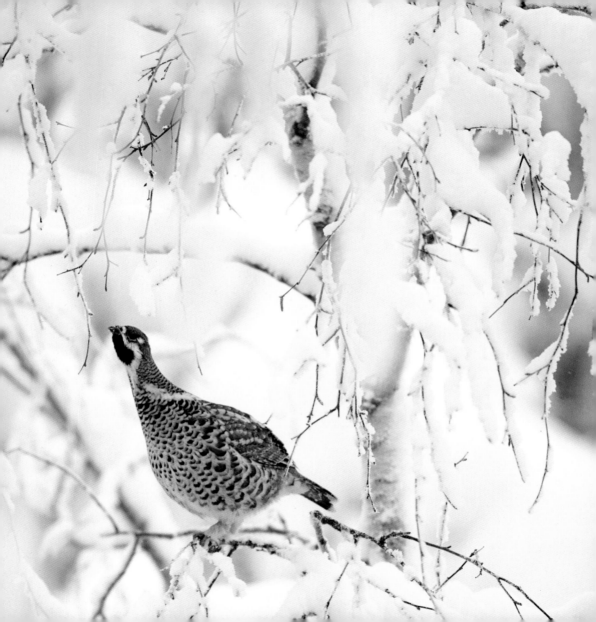

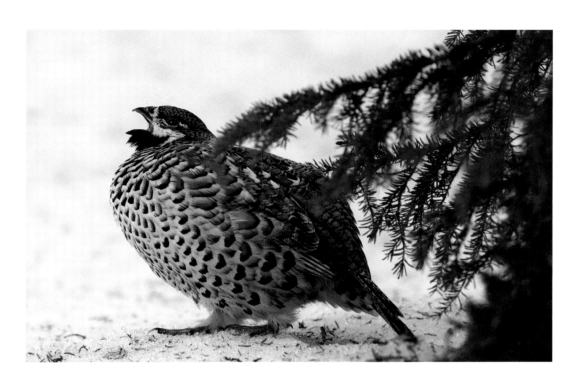

Hazel Grouse are already paired up by autumn. Come spring the males define the borders of their territories with faint but energetic whistling, and this activity continues until the chicks have hatched.

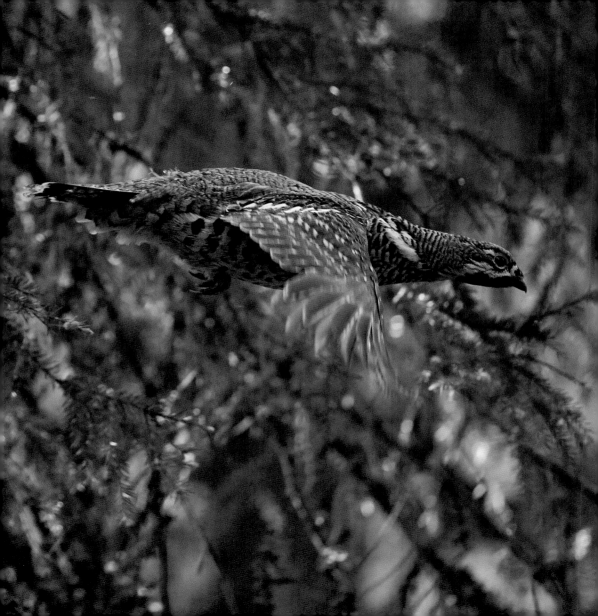

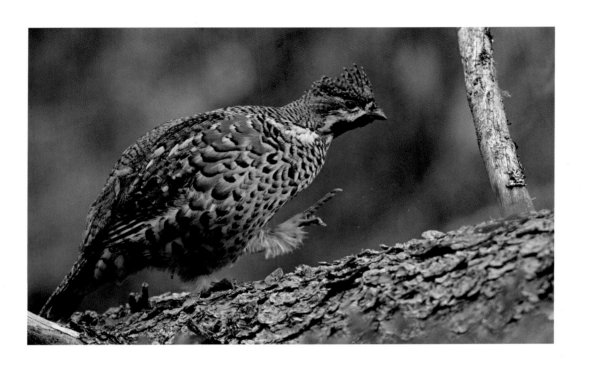

While the female Hazel Grouse incubates the eggs, the male keeps guard over the nest. Potential rivals are discouraged with territorial whistles or, if this is not enough, chased away with the defending male in hot pursuit. The male does not take part in incubation – this is entirely down to the female.

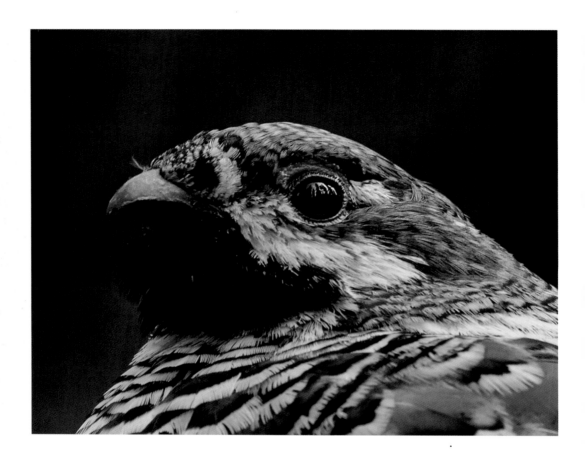

Some Hazel Grouse are quite confiding and may quickly learn to accept a human presence. I followed this male in its daily activities for quite a few days, and got to photograph it at close range as it bathed in sand – behaviour which is rarely seen or photographed.

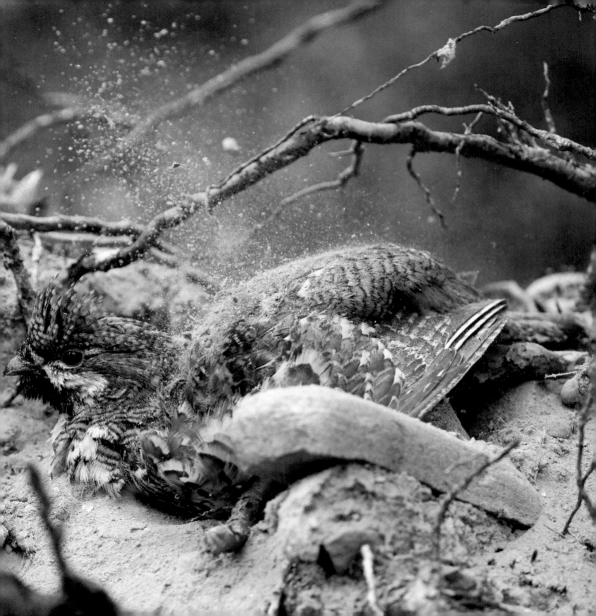

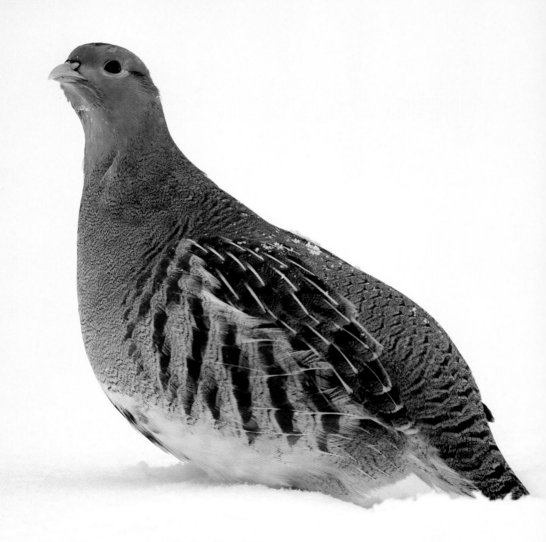

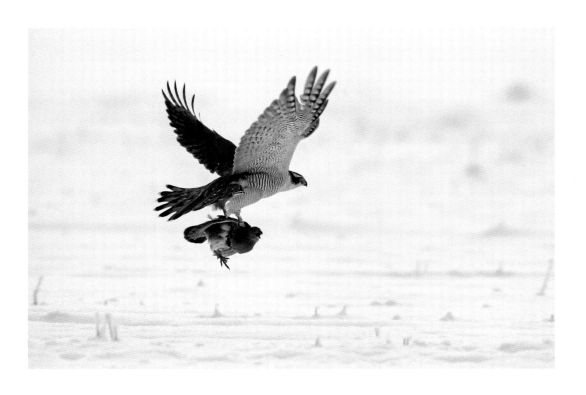

Predators, especially Northern Goshawks (*Accipiter gentilis*), harvest Grey Partridge flocks so efficiently that come spring many groups have been reduced in number by up to 50 per cent since the autumn. In spring the remaining flocks break up as the birds pair off for the breeding season.

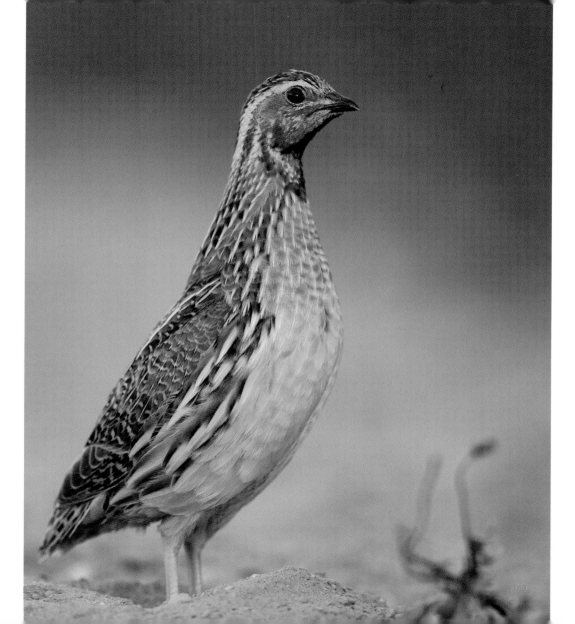

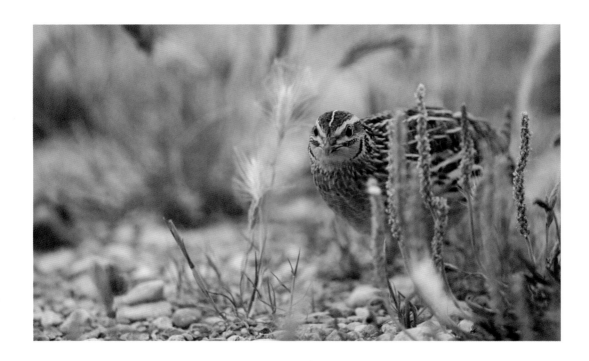

Common Quail

Coturnix coturnix

Starling-sized quail are very cunning, hiding efficiently even in sparse vegetation. Often the only hint of their presence is the trisyllabic 'wet-my-lips' whistle, delivered from the depths of a field or a meadow. Sometimes a quail is startled into flight by a passer-by, almost from under a person's feet, and the bird flies a hundred metres or so with rapid wingbeats before dropping down to hide again in the dense vegetation. The quail is the only north European gamebird that migrates long distances.

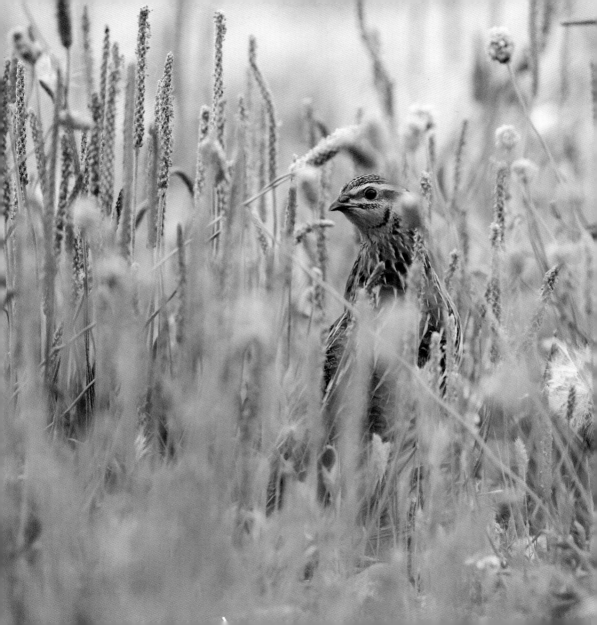

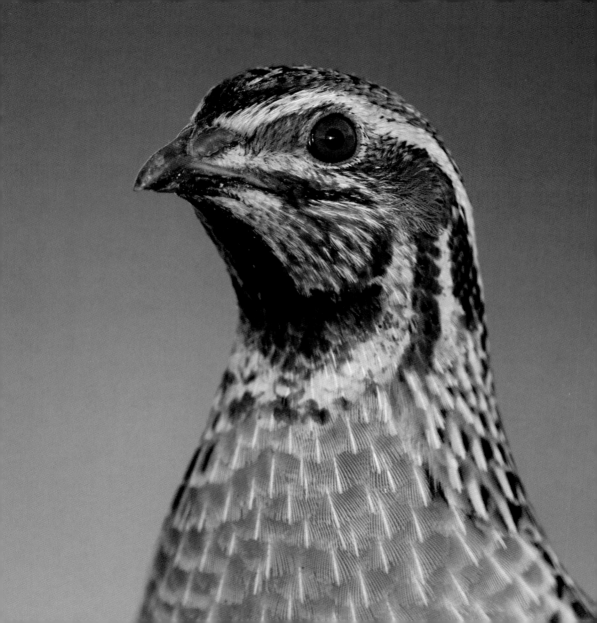

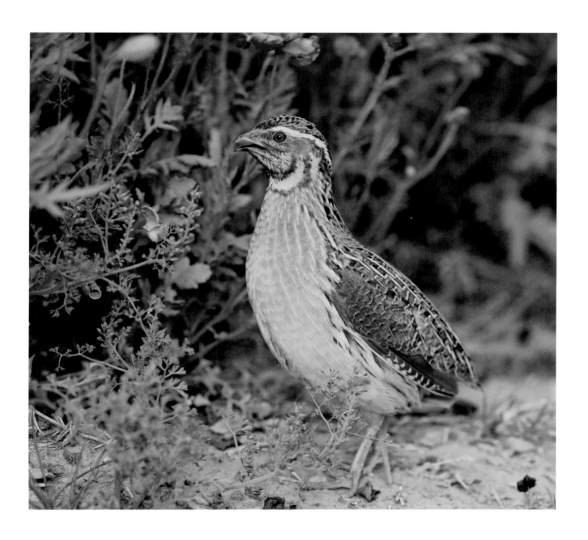

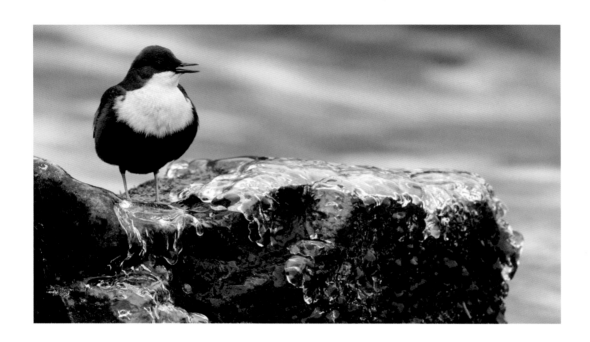

White-throated Dipper

Cinclus cinclus

The dipper is a dapper little bird which can survive in the far north even in the depths of winter, as long as its lifeline, a flowing river or stream, stays open. It is constantly bobbing as it moves along the shore. To feed it dives under the surface of the water to find aquatic invertebrates and their larvae and pupae.

Dippers pair off and claim a territory in the spring, sometimes while conditions are still very wintery. Its song carries surprisingly far across the noise of the surging rapids. In the final stages of nest-building, the nest is lined with colourful leaves.

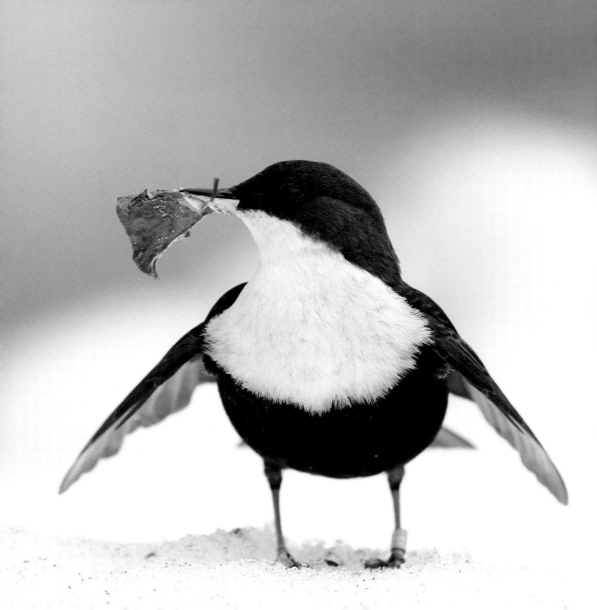

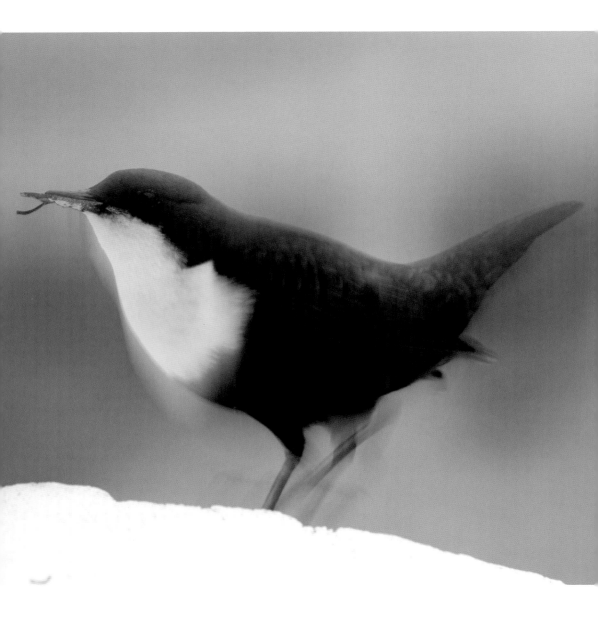

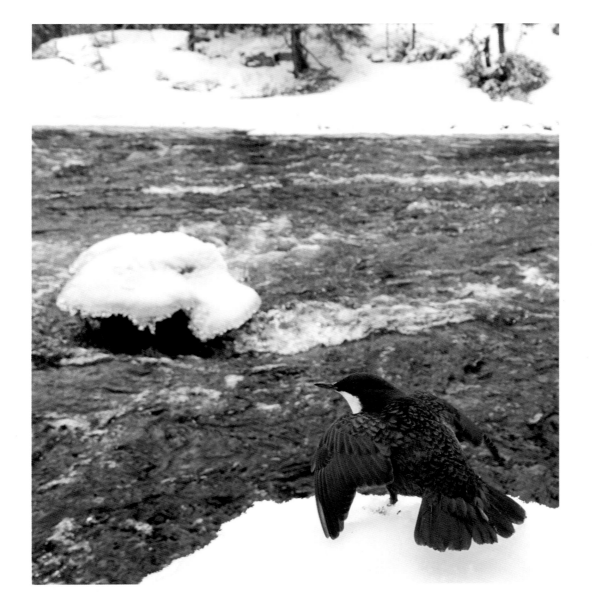

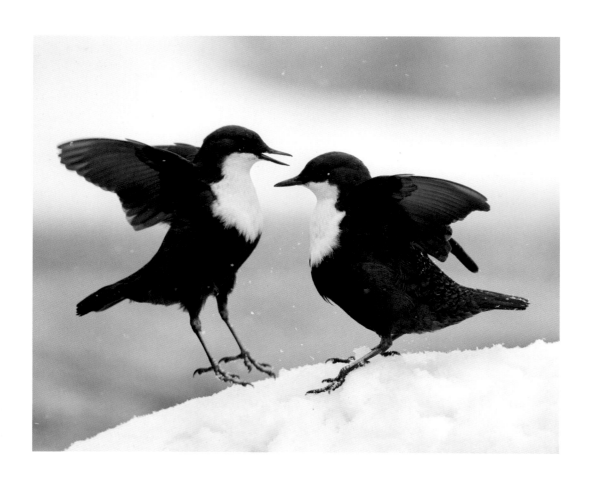

A displaying White-throated Dipper will sing, flutter its wings and sometimes eagerly jump up against its potential mate.

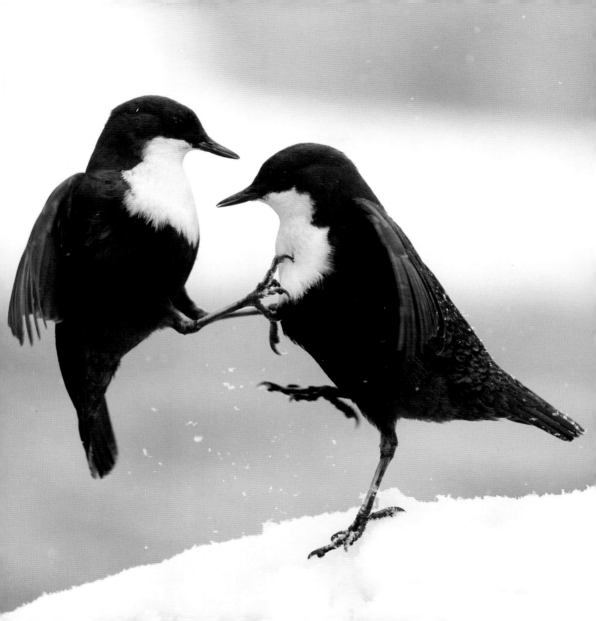

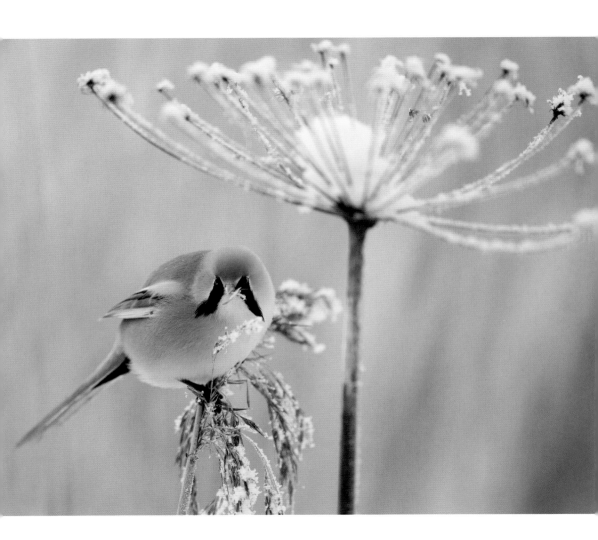

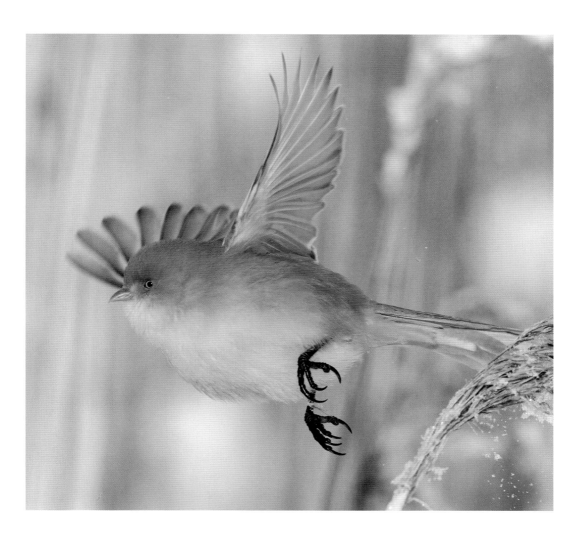

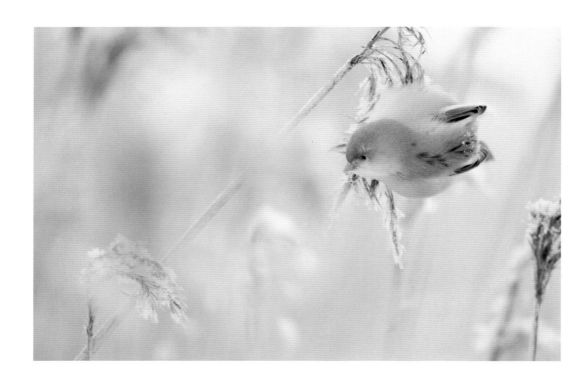

Bearded Tit

Panurus biarmicus

The beautiful, exotic-looking Bearded Tit spends its life inside dense reedbeds. During a run of mild winters populations can gradually spread north. An especially hard winter can decimate entire northern populations, but Bearded Tits produce three broods of young each year and can reclaim lost ground relatively quickly. As the climate warms, it is becoming more firmly establishing in the northerly reaches of its range.

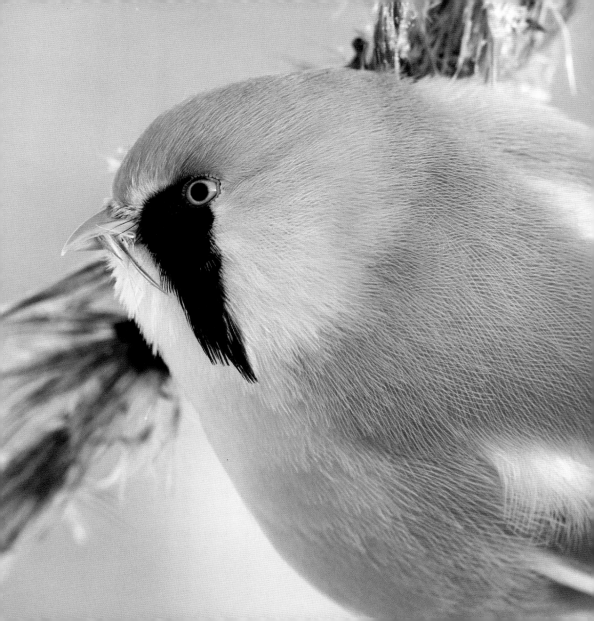

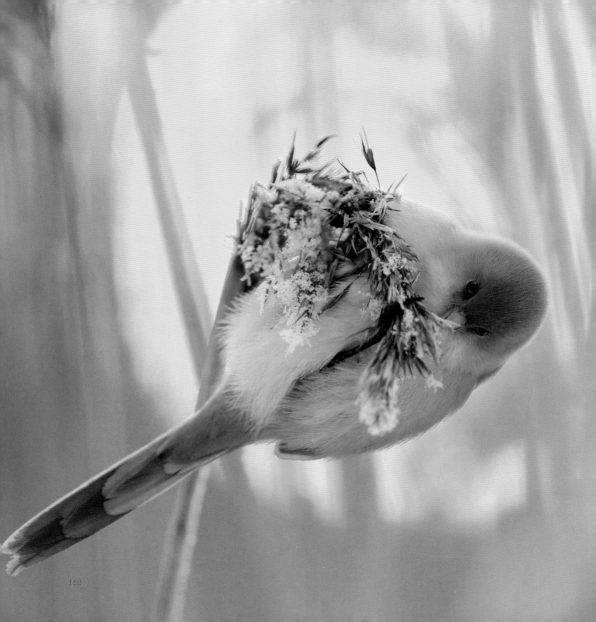

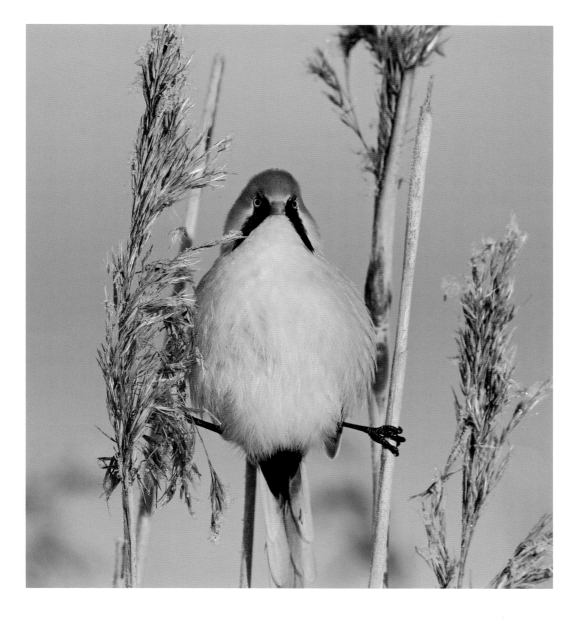

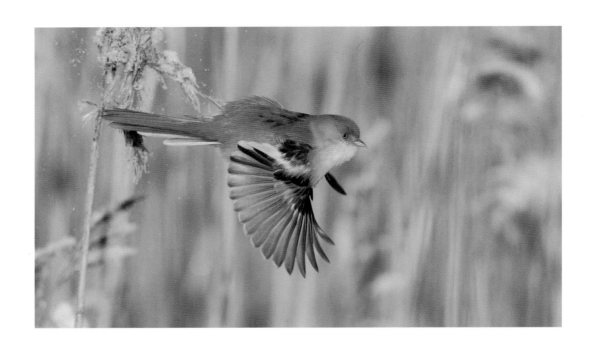

The short and rounded wings of Bearded Tits are an adaptation to life inside a dense reedbed. The birds can easily balance on the flimsiest of reed plumes, picking out the seeds.

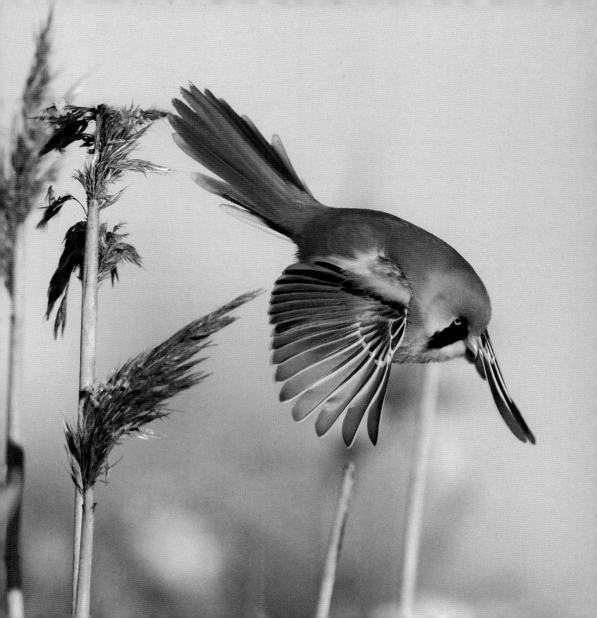

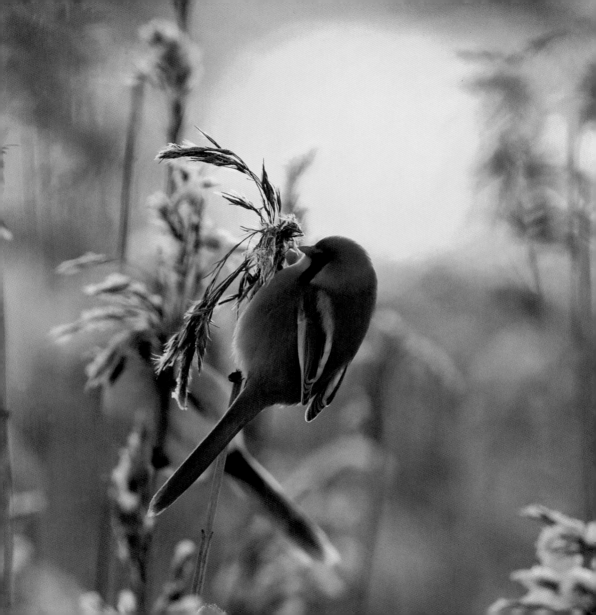

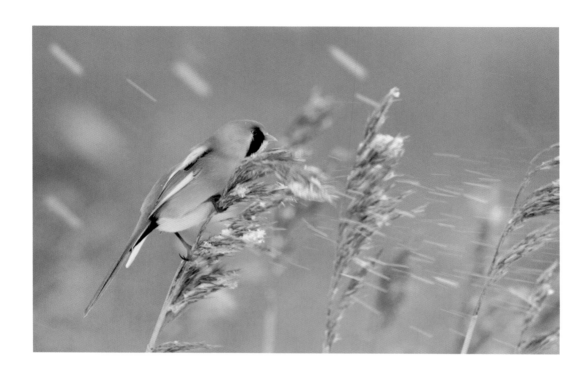

A long cold spell freezes the shallow water and enables a photographer to walk on the ice and reach the Bearded Tits inside a reedbed, to closely follow these fearless birds as they feed. A midwinter, low-angle sun and the reflection of light off the snow and ice create fabulous conditions for photography.

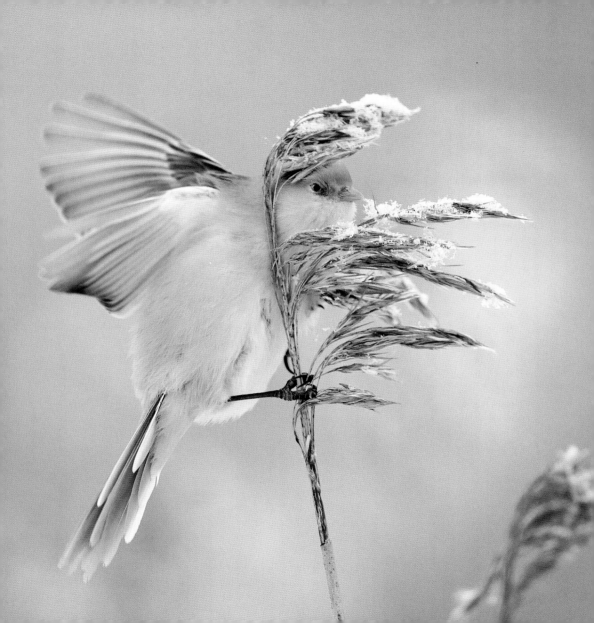

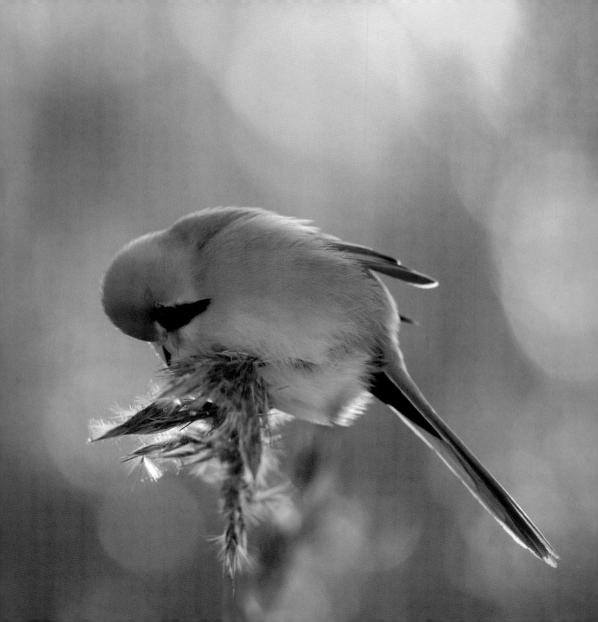

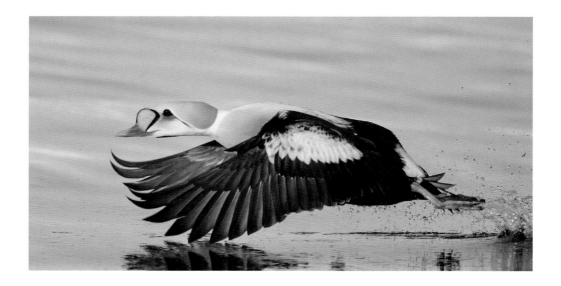

King Eider

Somateria spectabilis

The breeding grounds of this spectacular duck are on shores and islands in the Arctic Ocean. For the most part, the Russian population migrates to northern Norway in early winter as the ocean starts to freeze. Conditions along the shores of the Varanger Peninsula are extreme in winter, but the Gulf Stream keeps the ocean free of ice. As long as there is enough food, the birds are not bothered by the cold.

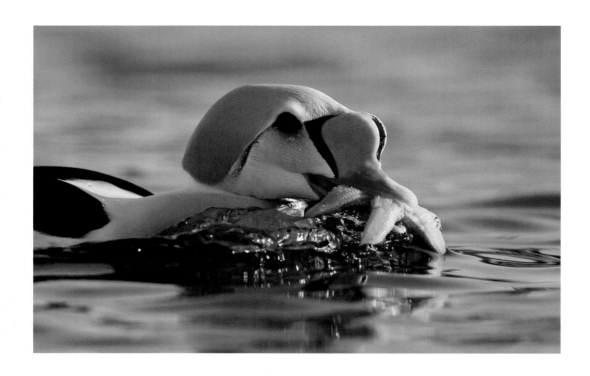

King Eiders dive deep, even deeper than 25 metres, to forage on the sea bed for the likes of bivalves and starfish, often consuming their food before resurfacing.

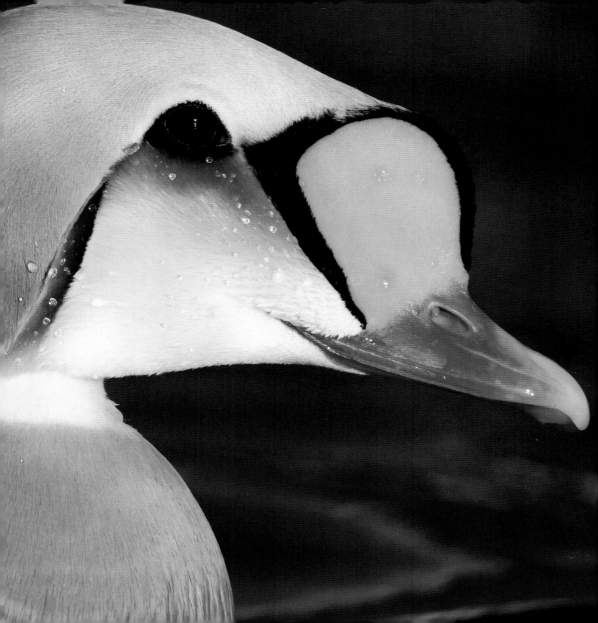

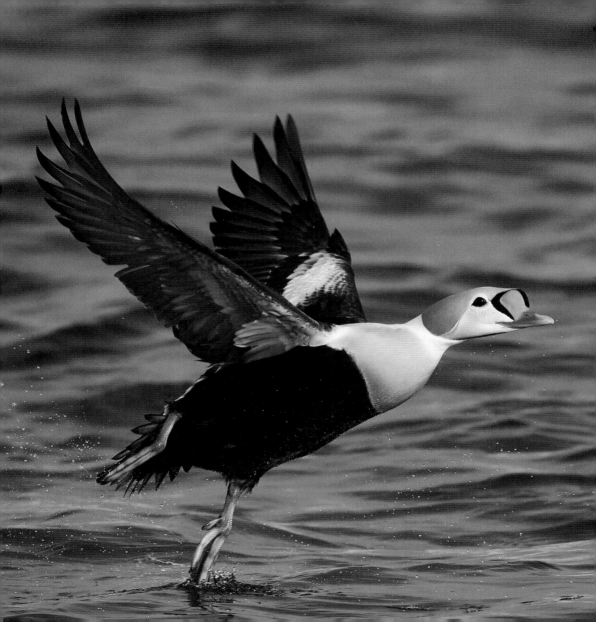

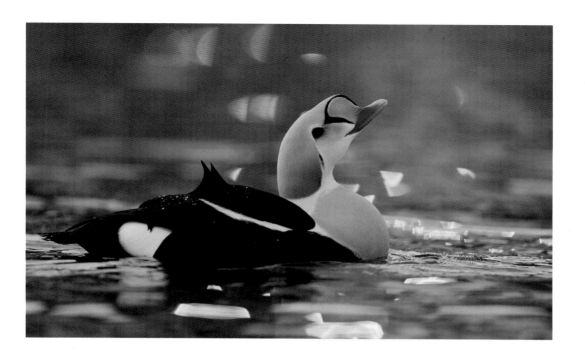

In terms of looks, a drake King Eider cannot be described as modest. On its head it has the most fantastic feather pattern with incredibly fine details and a rich palette of colours. The female is the polar opposite, and in fact benefits from an inconspicuous plumage that helps her to blend in with her surroundings while incubating.

King Eiders winter in flocks, where their instinct to display starts to stir in tune with the advancing spring and increasing hours of sunlight in early March.

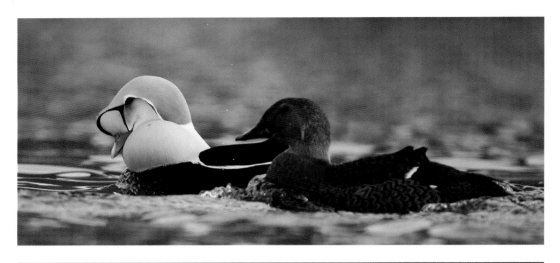

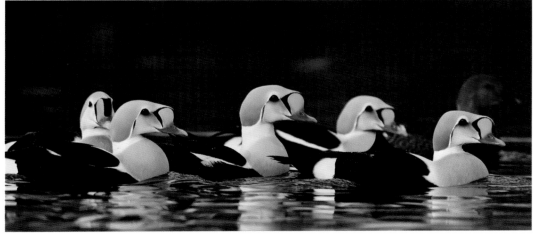

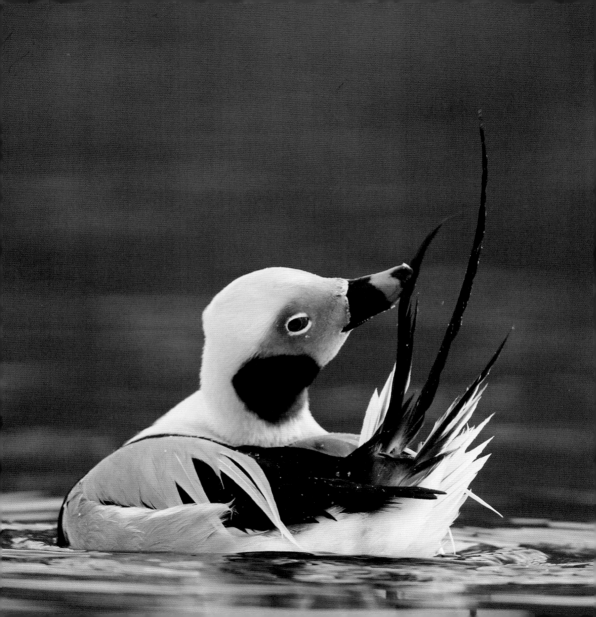

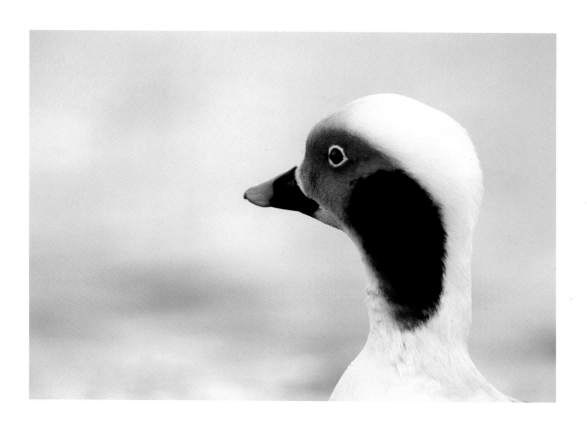

Long-tailed Duck

Clangula hyemalis

Unlike the extravagant King Eider, the Long-tailed Duck sports a refined and elegant plumage. Despite its delicate looks, it is a resilient and hardy bird that is able to winter along the Arctic coasts in northern Norway.

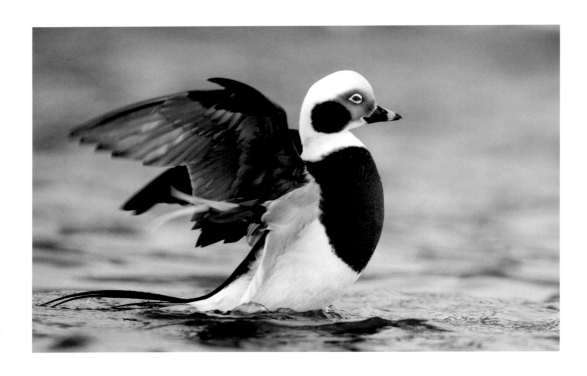

Long-tailed Ducks winter in small flocks. The females are easy to distinguish from the males, thanks to their short tails and more subdued plumage.

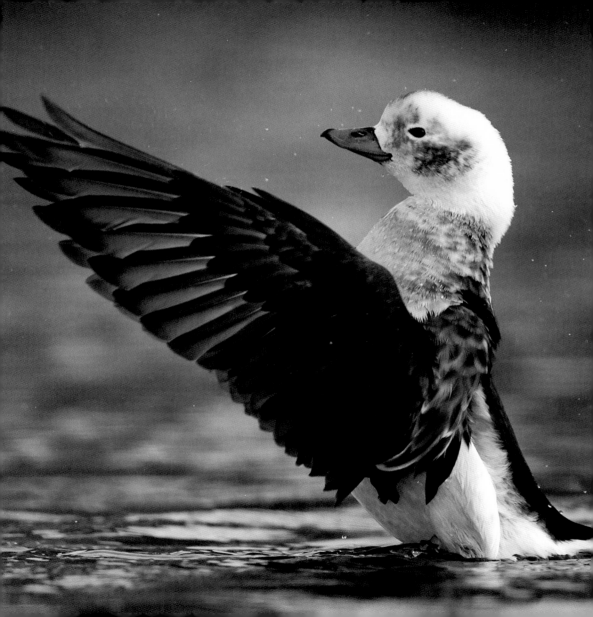

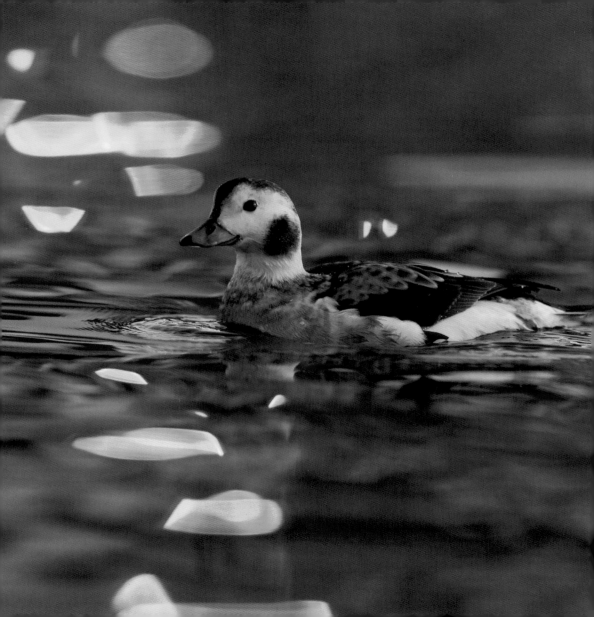

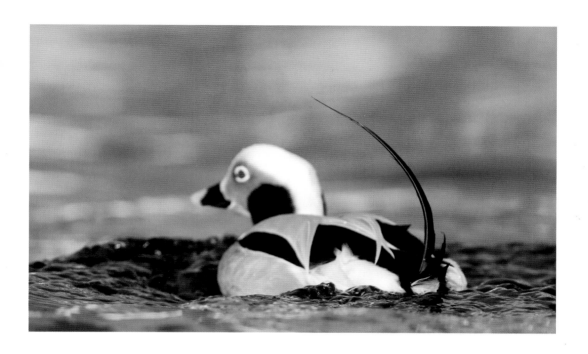

Drake Long-tailed Ducks can make a lot of noise while measuring their strength against each other, as they compete for female attention.

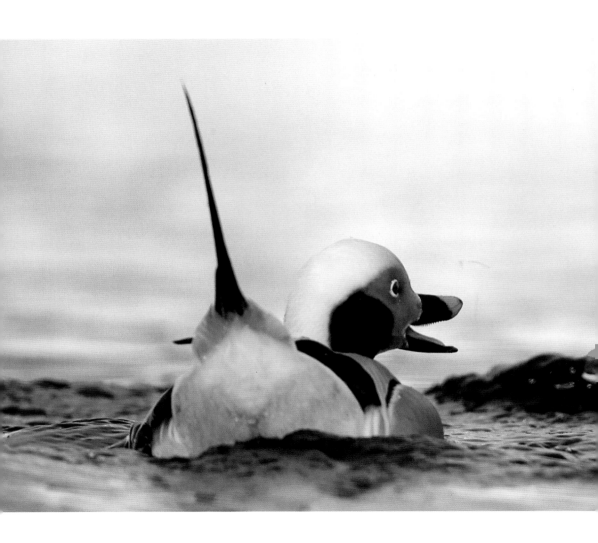

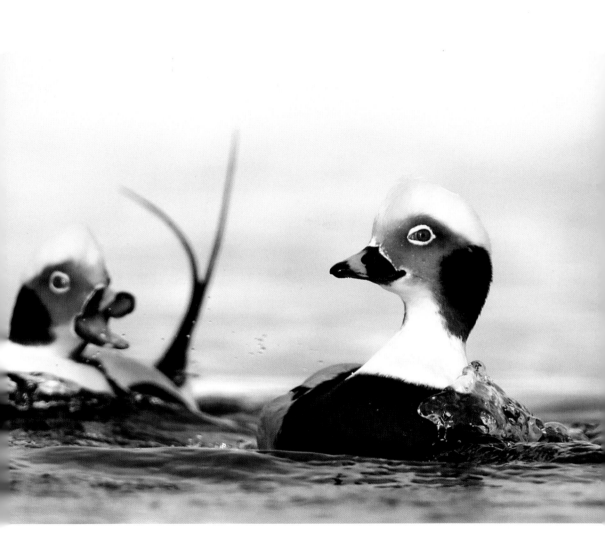

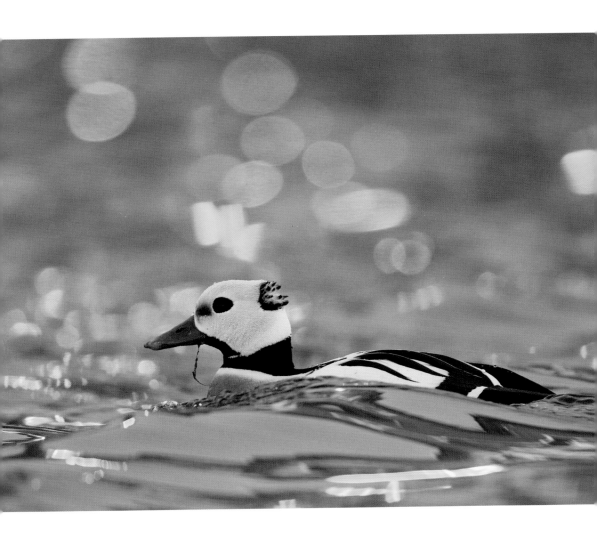

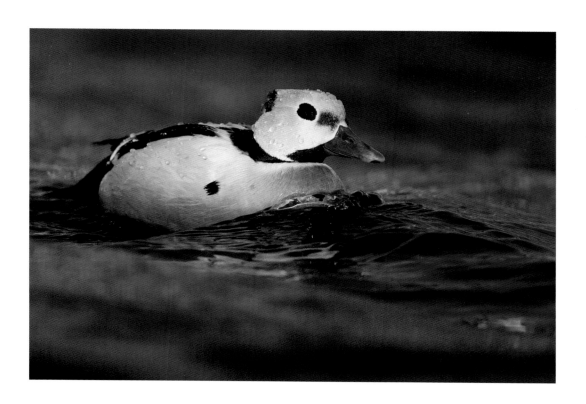

Steller's Eider

Polysticta stelleri

The Steller's Eider is the third species in the group of so-called 'Arctic ducks' that winters on the shores of the Varanger Peninsula. As with the King Eider, the Steller's Eider male is a colourful and handsome bird, whereas the female has a sober mottled brown plumage which is typical for all eider species.

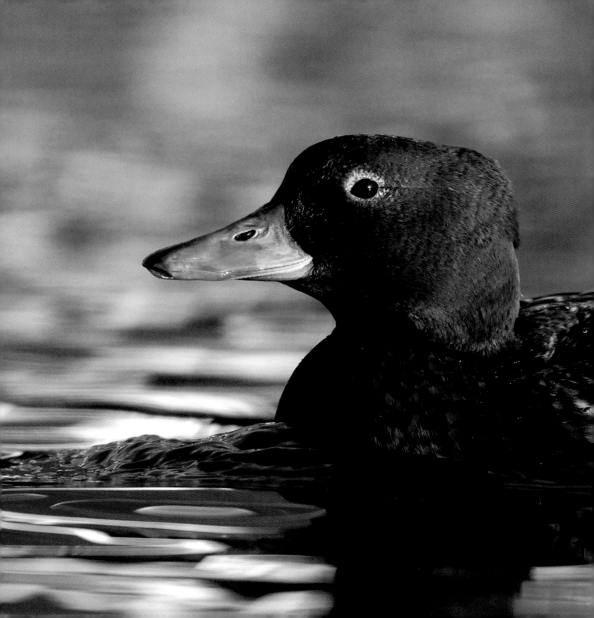

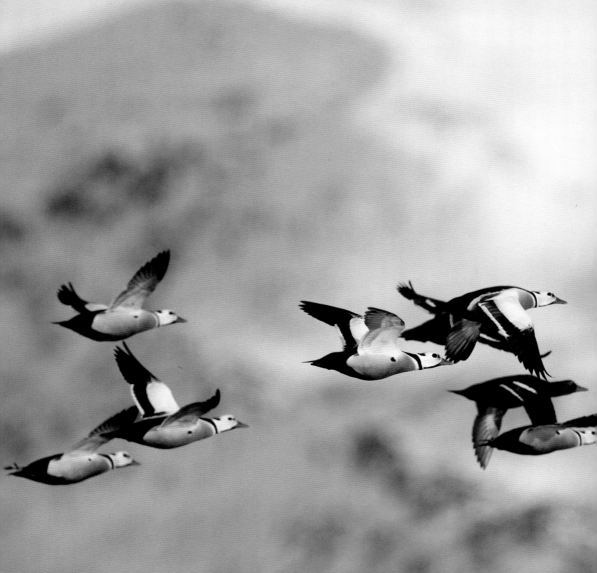

Steller's Eiders winter in mixed flocks containing both females and males. For an experienced observer, the way the birds keenly scan their surroundings with an extended neck is a telltale sign of their intention to take off soon. When a White-tailed Eagle (*Haliaeetus albicilla*) approaches, a seal emerges or a boat gets closer, the birds take flight with swishing wings, heading off to a safe distance.

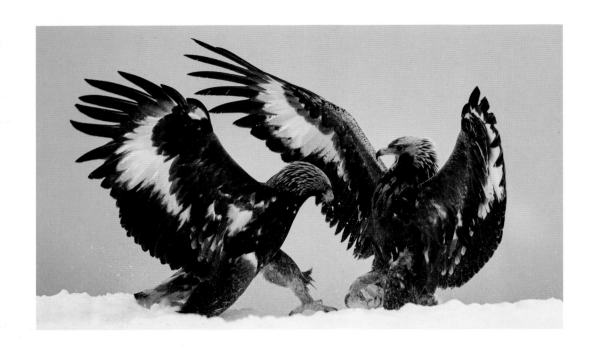

Golden Eagle

Aquila chrysaetos

The best opportunities for photographing Golden Eagles arise during the short midwinter days when the little light available is often of a very high quality. The lack of daylight hours means that the eagles will visit feeding stations quite regularly. And when several eagles come to the same carcass, scuffles help to determine the pecking order, with the result being that the strongest is able to feed first. Survival of the fittest is the ruling law.

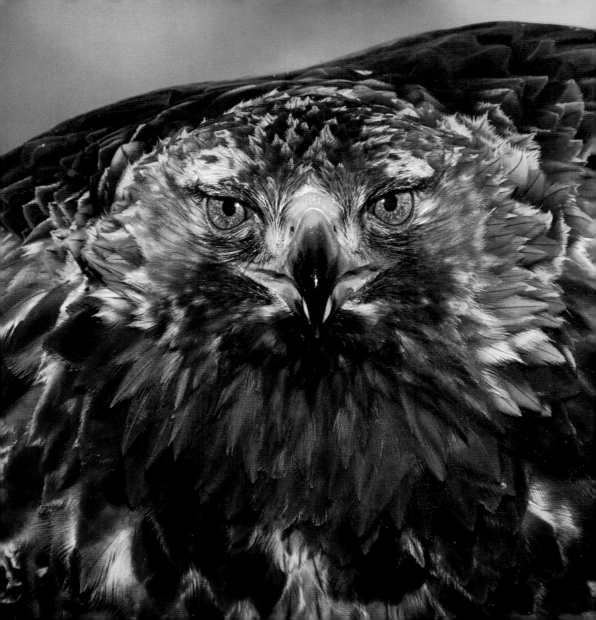

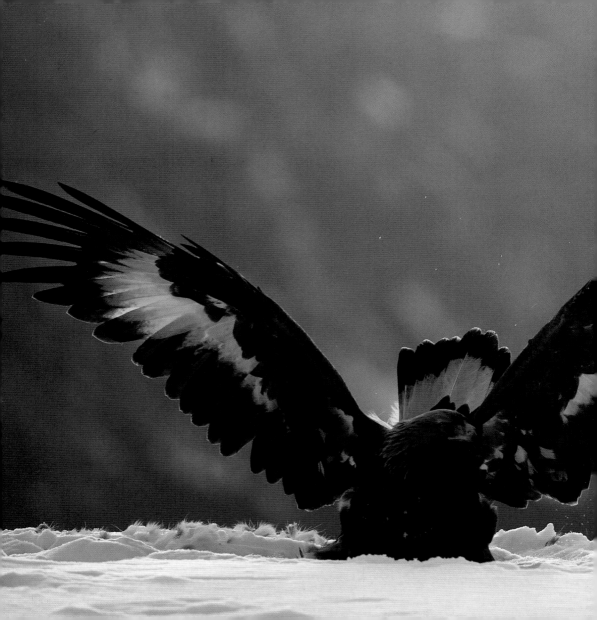

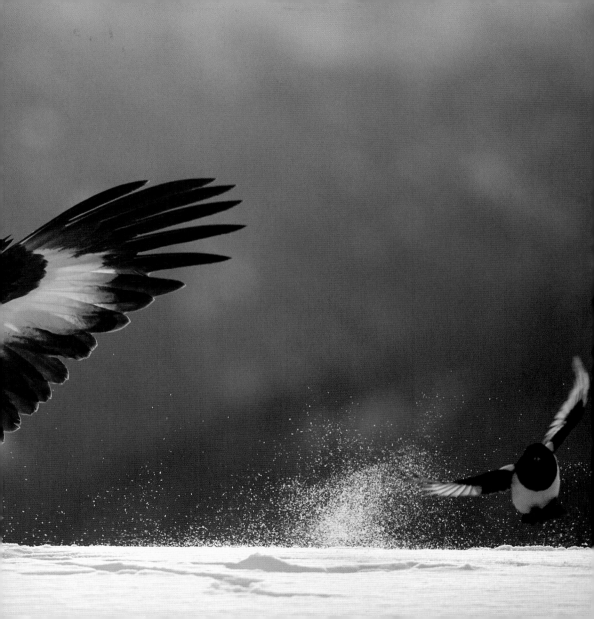

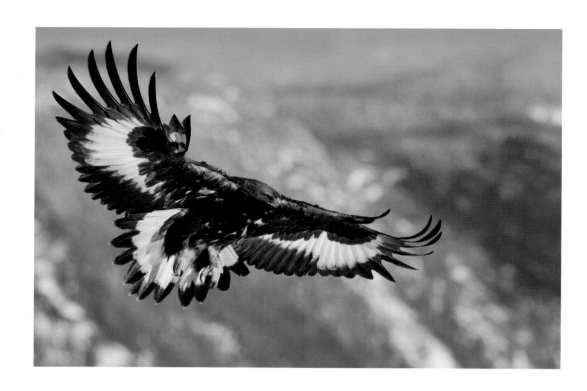

Golden Eagles are extremely cautious birds, and when a new food source becomes available they can spend hours in nearby trees, waiting and gauging the safety of the situation before descending to feast on the carcass. More often than not, the eagle waits for the ravens, crows and magpies to arrive before deciding that it's safe enough.

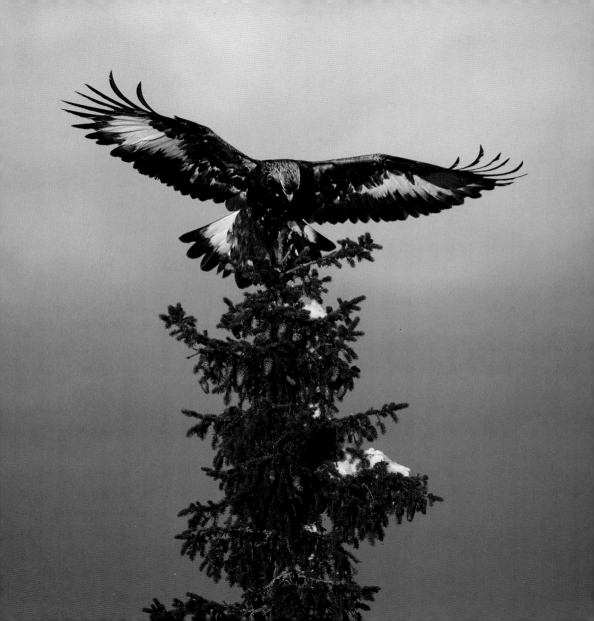

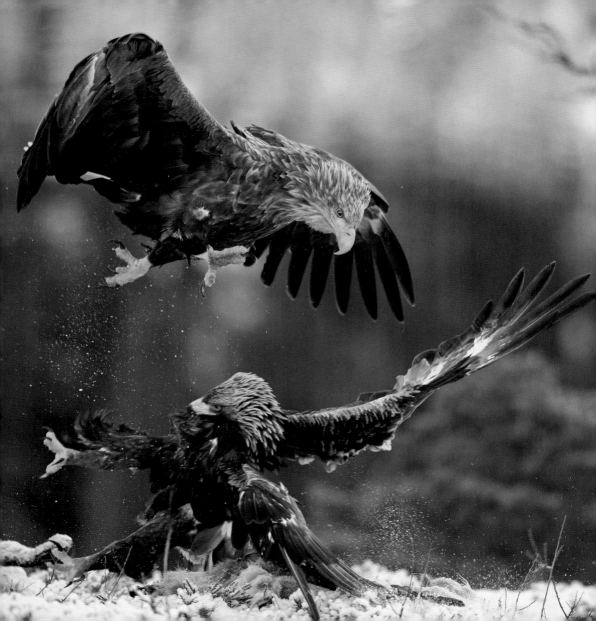

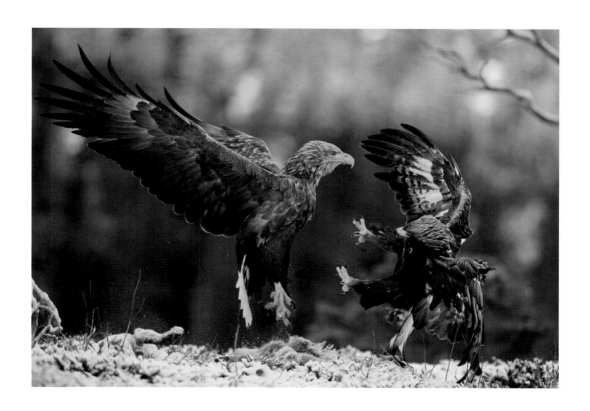

Although bigger in size, the White-tailed Eagle tends to be the one to give way when the opponent at a feeder is the more aggressive Golden Eagle. However, sometimes the roles are reversed, and in this case the large and experienced female White-tailed Eagle skilfully evaded the Golden Eagle attack and then chased it off, landing back on the carcass to continue feeding.

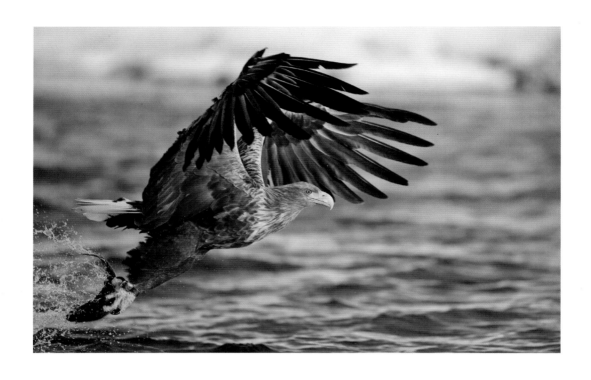

White-tailed Eagle

Haliaeetus albicilla

From the tip of its yellow bill to the end of its white tail, an adult White-tailed Eagle is an impressive sight both in flight and in close-up portraits. In regular flight it can look a little heavy and clumsy, but when hunting it is agile and fast, effortlessly entering into a steep dive and, in a split-second, grabbing its prey from the water.

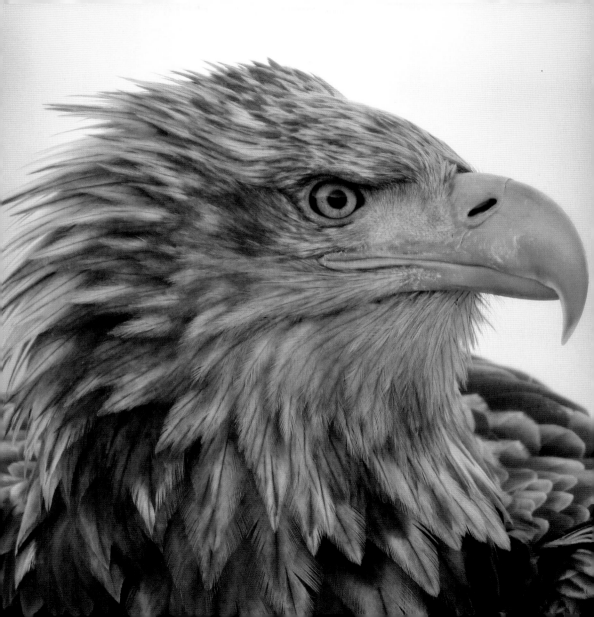

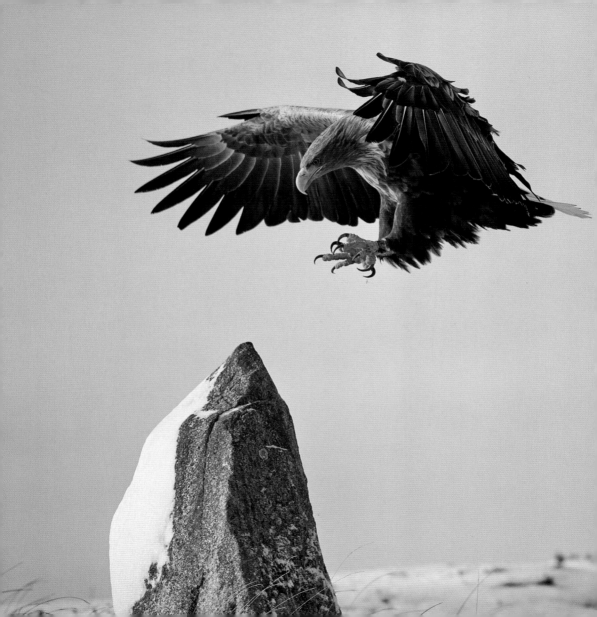

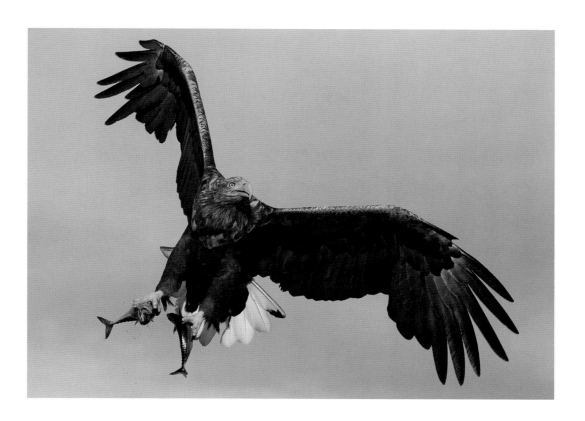

At some point in our joint history, White-tailed Eagles have learned to exploit a food source in the fish discarded by humans. Where people fish on ice, eagles come to clean up their leftovers; others grab fish that are thrown overboard from fishing boats. Even so, it is not common to see a White-tailed Eagle with a double catch. This eagle took a fish that was tossed into the sea for it and started to fly off to eat it, but then turned and came back to take a second fish. A bold move!

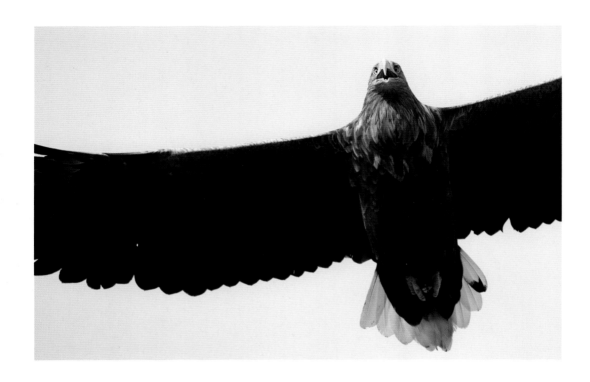

In the 1960s, people in Finland and Sweden realised that the White-tailed Eagle population was close to zero thanks to the decades-long use of environmental toxins and persecution by humans spanning well over a century. The beginning of WWF Finland and the conservation efforts to revive White-tailed Eagle populations go hand in hand, starting officially in 1972. In 1975, there were only four White-tailed Eagle chicks in Finland. An ambitious programme, spanning 40 years, of winter feeding and educating people has helped the White-tailed Eagle population to recover. In 2014 White-tailed Eagles in Finland raised 450 chicks – a fine example of conservation success.

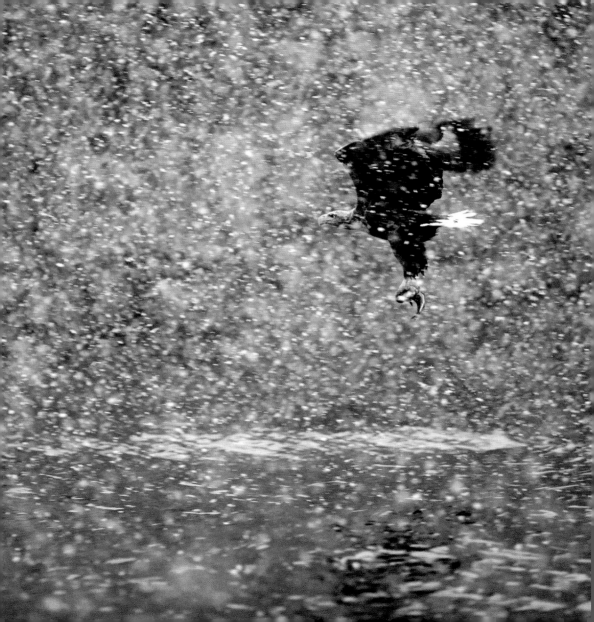

One of the main goals of a photo trip to Norway one October was to capture a White-tailed Eagle and the moon in the same image. First we spent the afternoon and early evening photographing the eagles as they caught fish. Then, as moonrise approached, we positioned the boat at a spot facing a cliff where an eagle was standing guard. After a while the moon climbed above the cliff, and when it was at optimal height the eagle took off and headed just where we wanted it to go. Sometimes the pieces fall perfectly into place but mostly, even with the most meticulous preparations, not quite so perfectly as here; this is the beauty of wildlife photography!

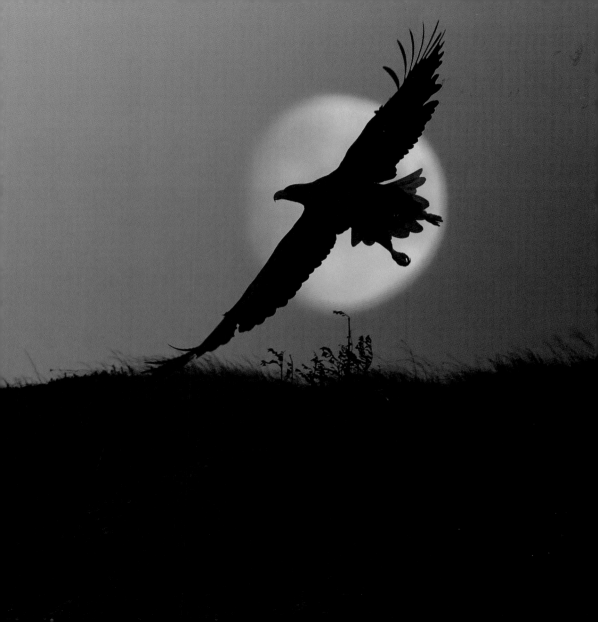

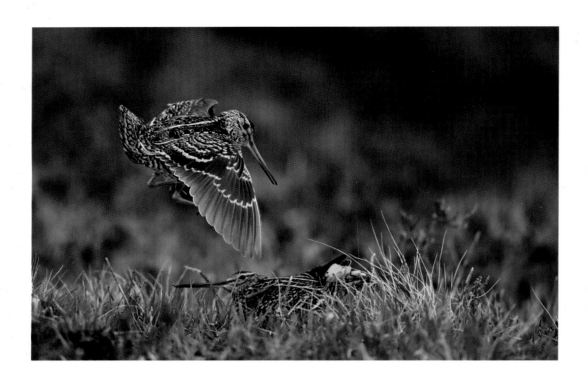

Great Snipe

Gallinago media

In the evenings from mid-May to mid-June, Great Snipe males gather at their traditional lek sites and perform a peculiar group display, where the action lasts through the night. Each male claims a small piece of land, which they defend, and every so often they get up on top of a tussock to sing their heart out, in a perfect 'chin up, chest out, shoulders back, stomach in' pose, and flapping their wings to show off. The females are the quiet audience.

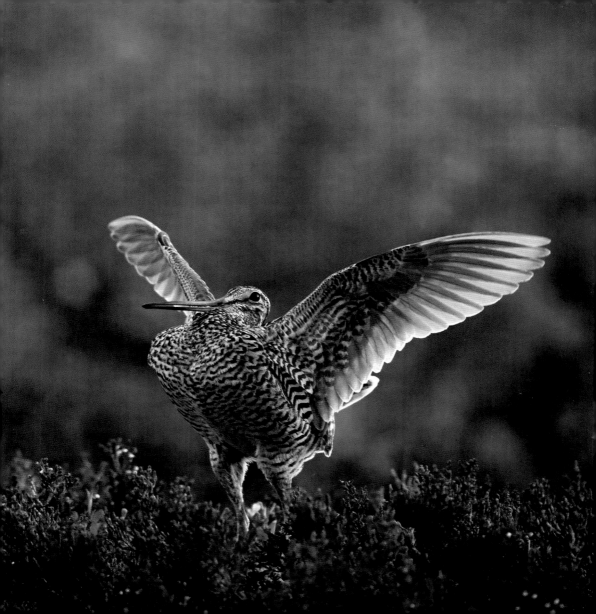

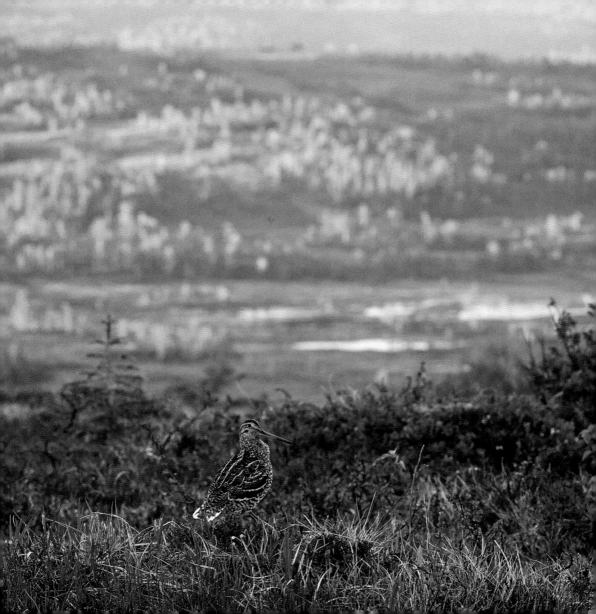

A high plateau in the Scandinavian Mountains in Norway is ideal for photographing displaying Great Snipe. The relatively small birds are visible in the low vegetation, and in June conditions remain so light all through the night that even action photography is possible.

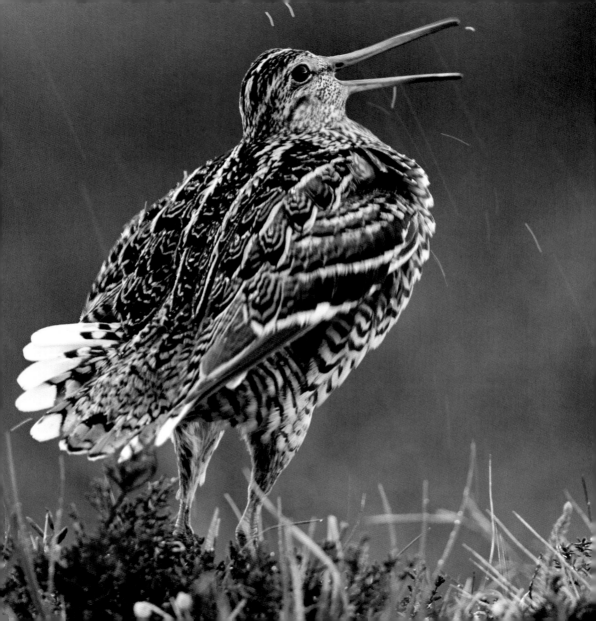

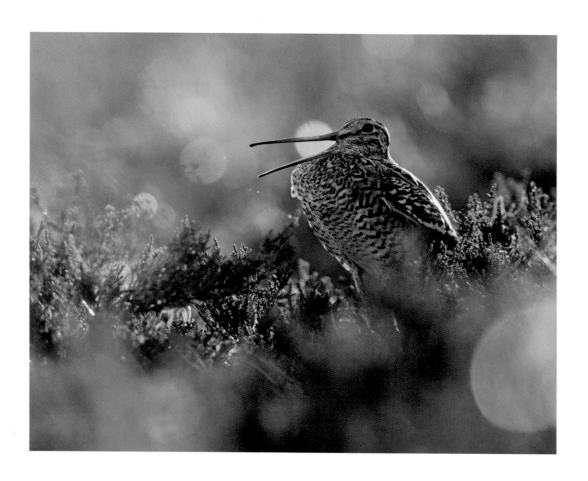

Imagine the sound created by a table tennis ball being bounced on a hard surface, in a crescendo, and you have the display call of a Great Snipe.

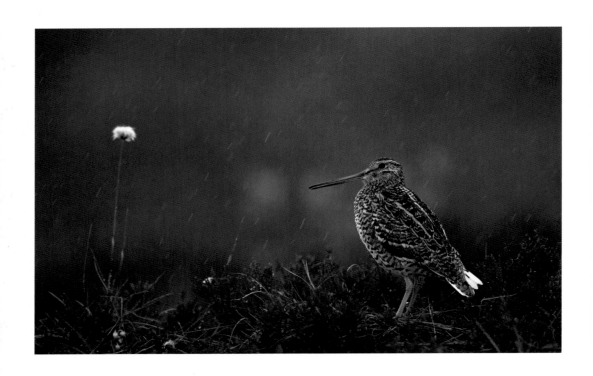

Sometimes rivals encroach on territories and try to fend each other off by what can only be described as singing competitions or by strutting around and showing off. If this does not produce the desired outcome, a short but fierce skirmish is inevitable.

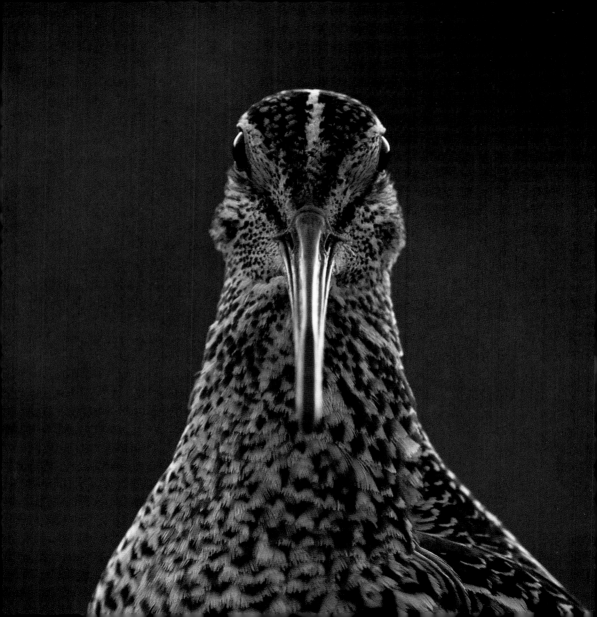

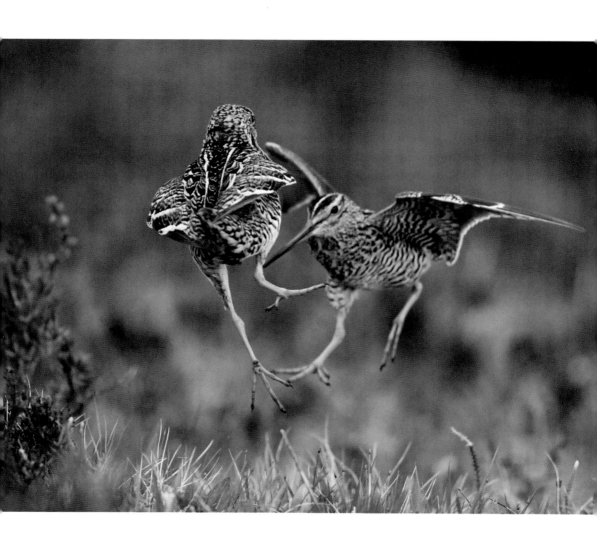

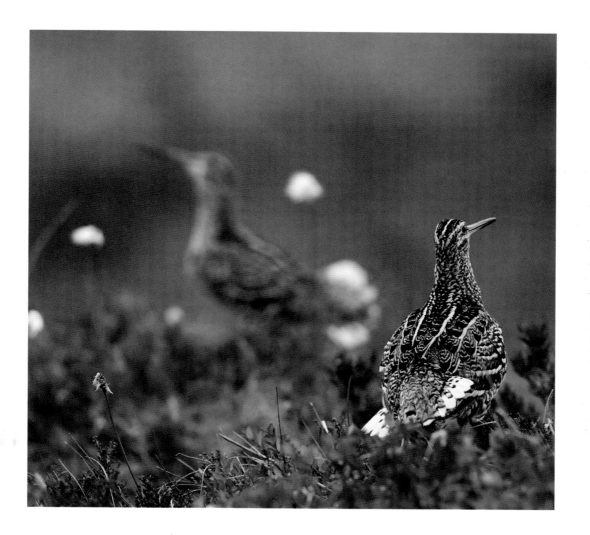

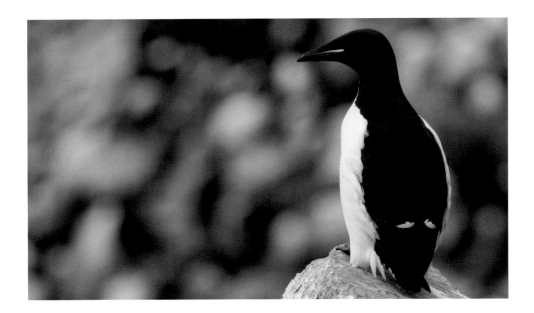

Brünnich's Guillemot

Uria lomvia

Just outside the town of Vardø, on the Varanger Peninsula in northern Norway, is the famous lighthouse and bird island Hornøya. Known for its huge seabird colonies it is a truly lovely experience both during the summer breeding season, when it is easy to visit, and in spring as the birds return from wintering out on the open sea, when it is less so.

One of the island's rarer specialties is the Brünnich's Guillemot, which can be distinguished from the Common Guillemot by the white stripe along the gape of the bill. Approximately 500 pairs of Brünnich's breed on the island, making it one of the southernmost outposts for this species.

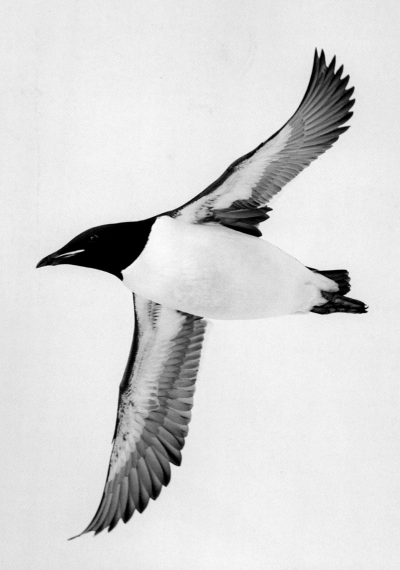

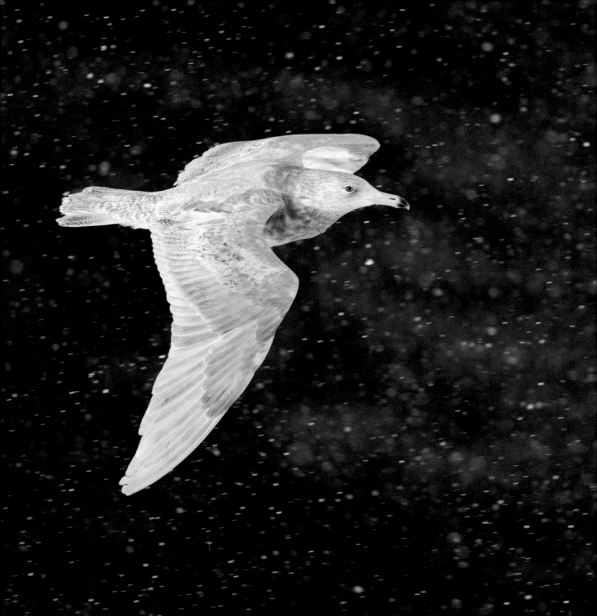

Glaucous Gull

Larus hyperboreus

In March and April Glaucous Gulls patrol the sea and shore in search of food, but they don't breed on the island, instead continuing north to breed on the Russian tundra and on islands in the Arctic Ocean.

Great Black-backed Gull

Larus marinus

The world's largest species of gull. Hundreds of pairs breed on Hornøya and its neighbouring islands. They are big and strong and feed other seabirds' eggs and young, and even adult birds.

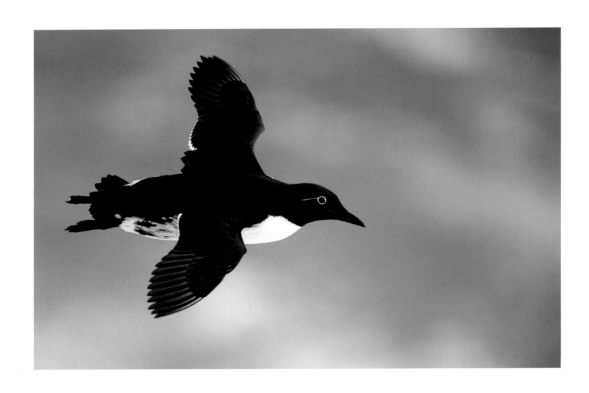

Common Guillemot

Uria aalge

With around 15,000 pairs, the Common Guillemot is by far the most numerous breeding bird on Hornøya.
They return from the open sea in early March, when the island can still be covered in snow.

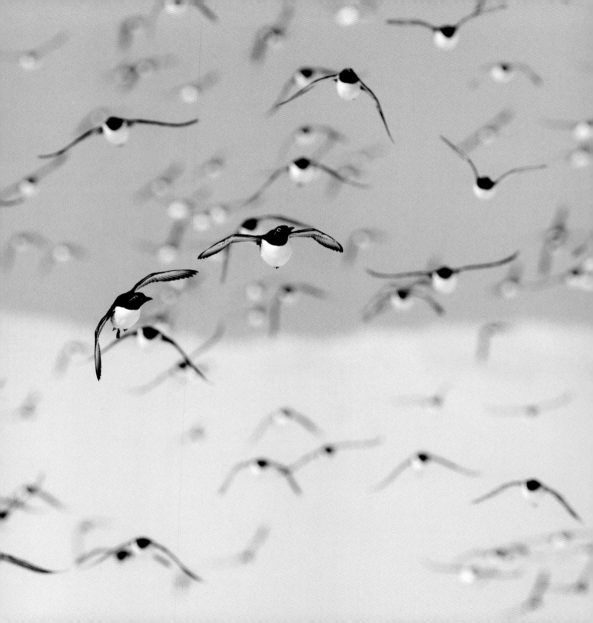

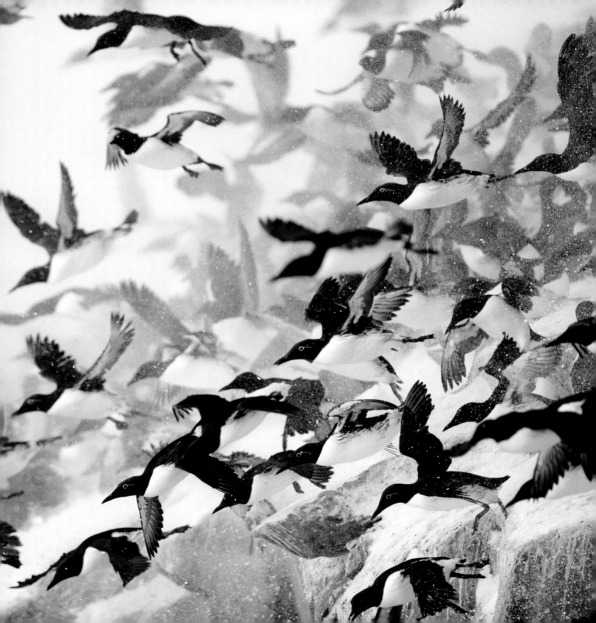

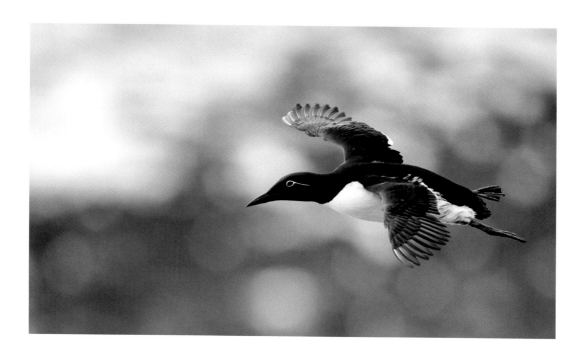

Common Guillemots spend the winter out at sea. Upon returning to their breeding island they rest on the water in big rafts just offshore, and every once in a while huge flocks – sometimes all of the birds – get up and circle around the island as if to muster the courage to set webbed foot on solid ground again after months at sea. To stand on the cliff and hear and see the thousands of birds whizz past at extremely close range is an incredible experience.

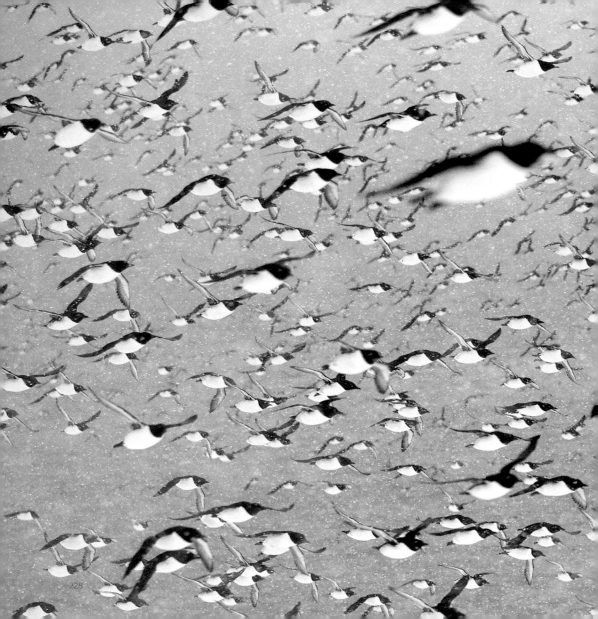

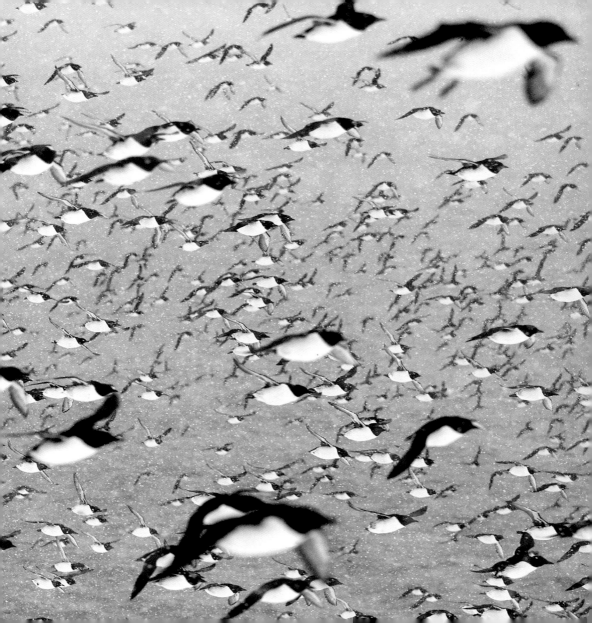

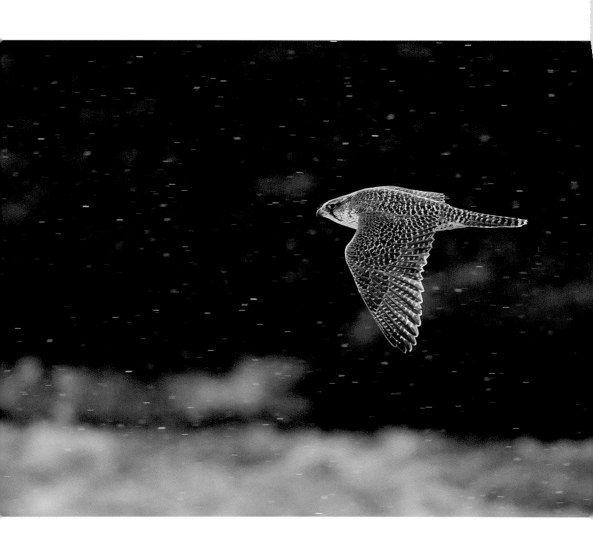

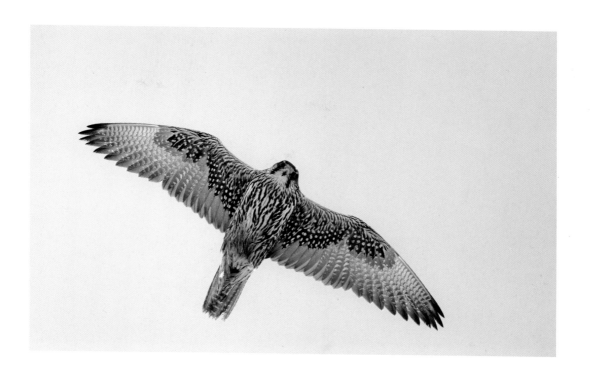

Gyr Falcon

Falco rusticolus

Gyr Falcons don't breed on Hornøya, but the island must be like a smorgasbord to them as there is certainly no shortage of food! It's easy to be alerted to the possibility that a Gyr could be close by and hunting as the kittiwakes and auks all hurl themselves off the cliffs in an attempt to escape the hunter, while the ravens and large gulls are calling out in warning and trying to chase off the predator.

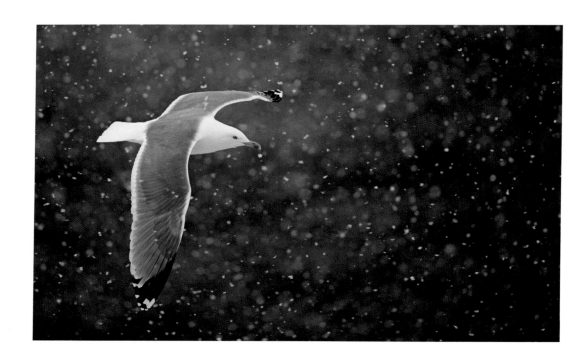

Herring Gull

Larus argentatus

Spring on Hornøya can offer the most delightful opportunities for photography. The weather can turn in an instant, sometimes dramatically, changing from heavy snowfall into a glorious sunset. In addition, when covered in snow, there is an abundance of light, with much of it being reflected off the snow and back up into the air, hitting the flying birds. The island is rich in high vantage-points which offer a good downward angle for photographing single birds and big flocks with the sea in the background.

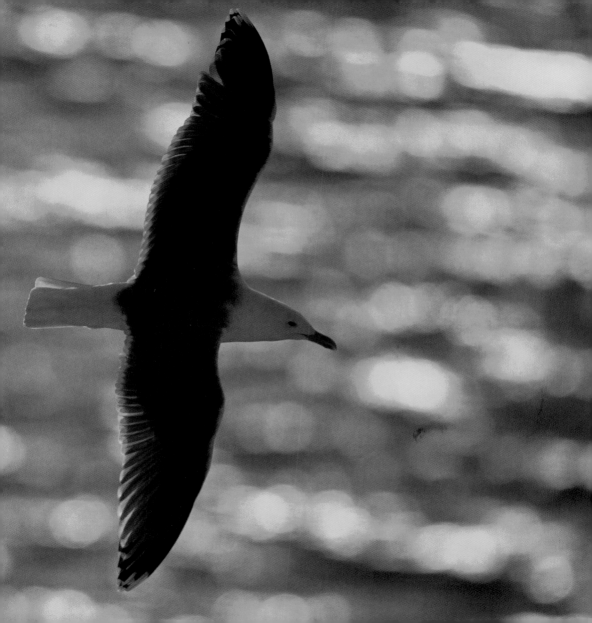

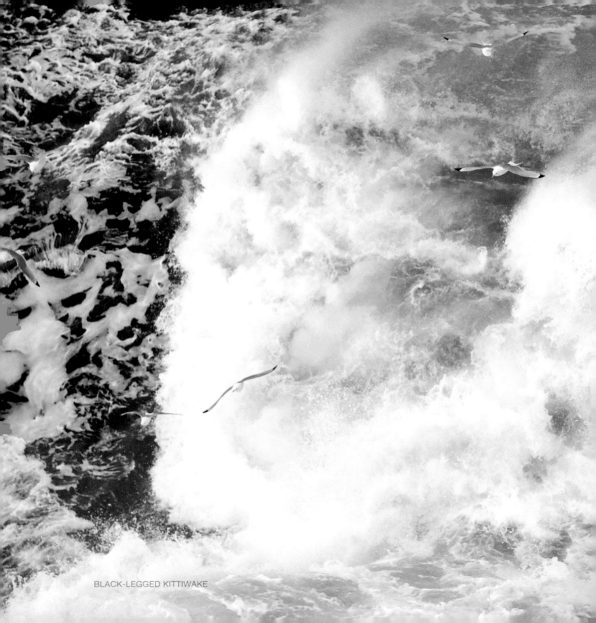

BLACK-LEGGED KITTIWAKE

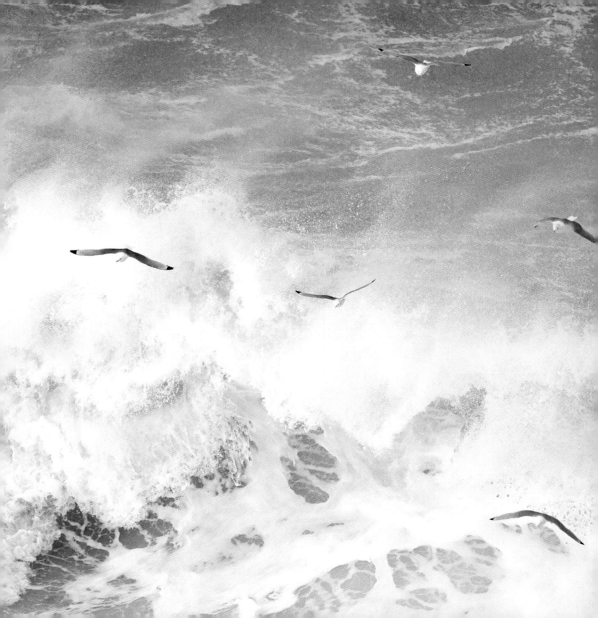

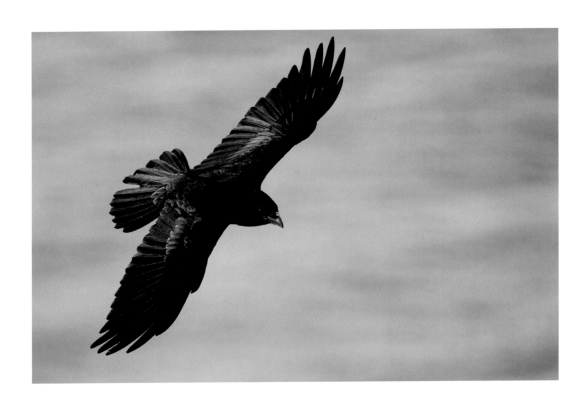

Common Raven

Corvus corax

Hornøya has 10–20 breeding pairs of ravens, and these birds are a common sight as they patrol the island's steep cliffs. They feed on carrion and the eggs and young of other birds. Part of their display behaviour in spring is acrobatic flight manoeuvres, complete with head-spinning dives and even flying upside-down.

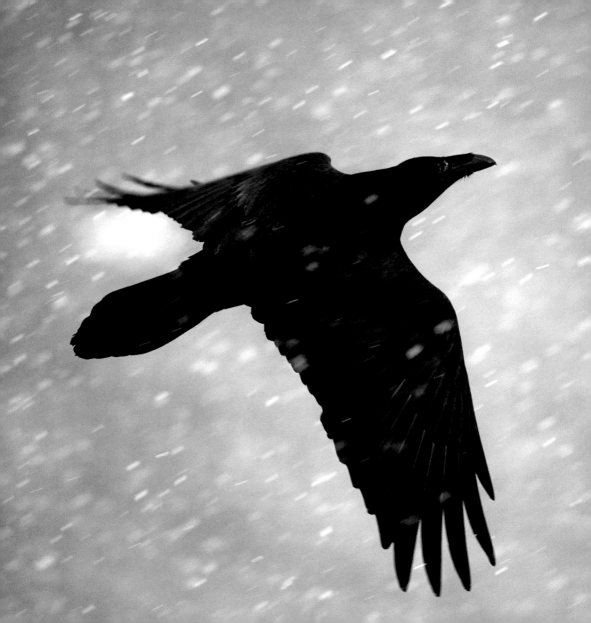

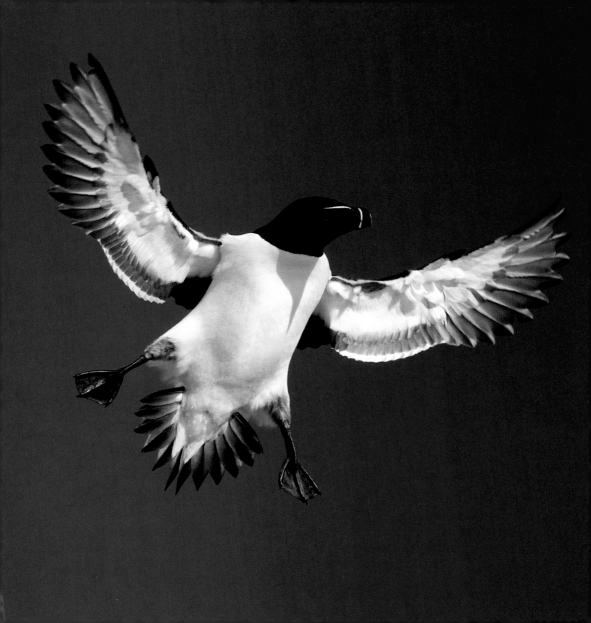

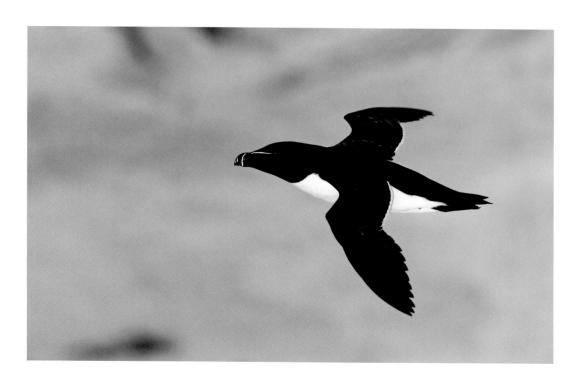

Razorbill

Alca torda

With its long, narrow wings and a thick-set body, the Razorbill has earned a fitting nickname, the flying cigar.

Its flight speed is very fast and it has to brake aggressively before landing in order to avoid any damage. It spreads itself as wide as possible to slow down, from the webbed feet to the wing-tips.

European Shag

Phalacrocorax aristotelis

There has been a sharp rise in the shag populations on Hornøya in the past couple of decades, with up to 1,300 breeding pairs in recent years.

Shag nests are modest affairs, set up in March in crevices on the cliffs, and built using seaweed and branches. The island is frequently hit by sudden snowstorms in spring as the icy conditions of the Arctic winter cling on, and when this happens the shags gather on the shores to ride the storm, returning to sea to fish once the fickle weather turns good again. Upon return, the pair shares a fleeting embrace.

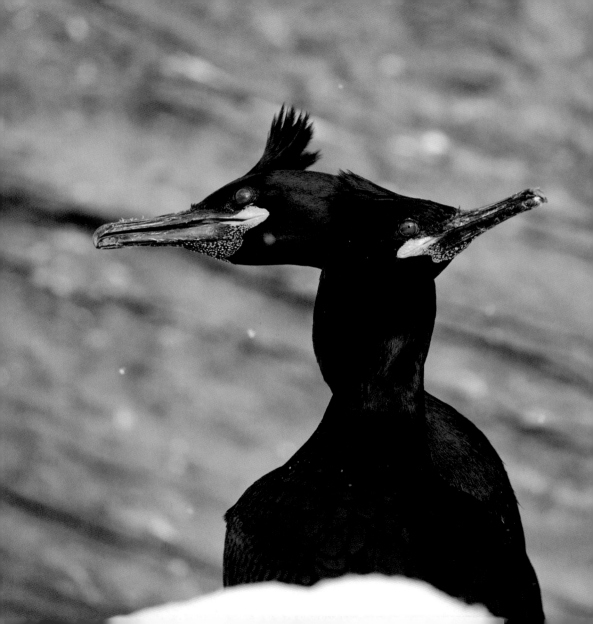

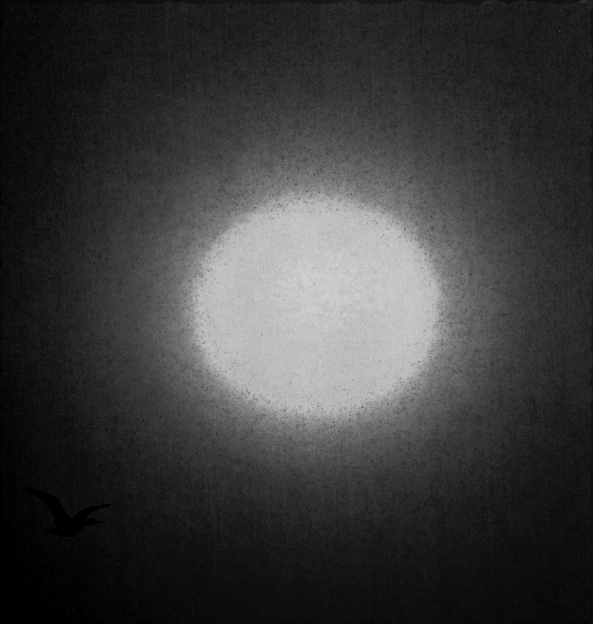

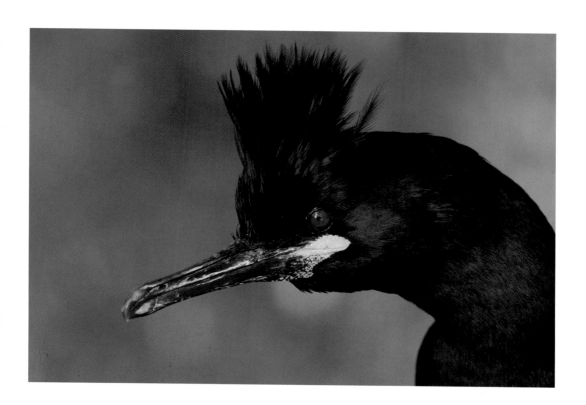

The region offers extraordinary light and weather conditions that a photographer can draw upon for inspiration. Heavy snowfall was coming in off the sea, aligned towards the setting sun. Before it blocked the sun, for a moment it was possible to shoot against a background where the thick snowfall softened the glare from the sun and dotted the sky with the snowflakes.

Black Guillemot

Cepphus grylle

On the otherwise black-brown Black Guillemot,
the webbed feet and the inside of the mouth
are as red as a fire engine. The mouth is
generally only visible when the bird is making
its high-pitched whistling calls. Flying fast
and close to the water's surface with rapid
wing-beats, its white wing-patches and white
underwings are clear identification features.

BLACK GUILLEMOT

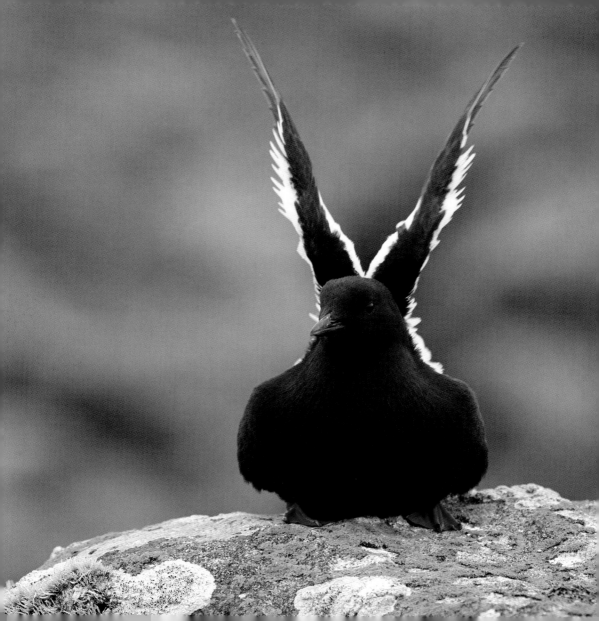

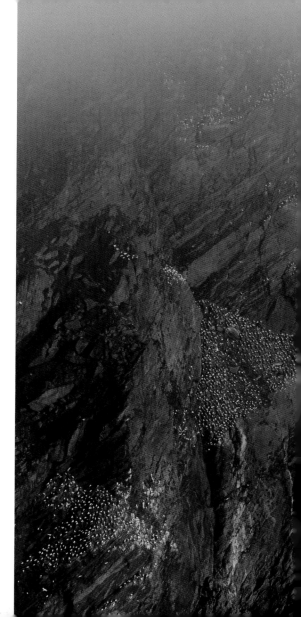

Northern Gannet

Morus bassanus

Shetland is a renowned birding spot, and one of the reasons why is its magnificent seabird colonies. Hermaness, a national nature reserve in the most northerly part of the northernmost island, Unst, is home to as many as 100,000 pairs of seabirds, including a gannetry of about 12,000 pairs.

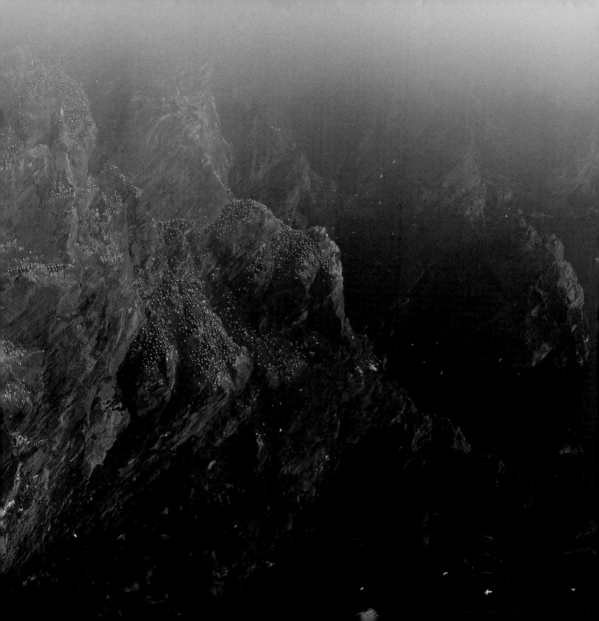

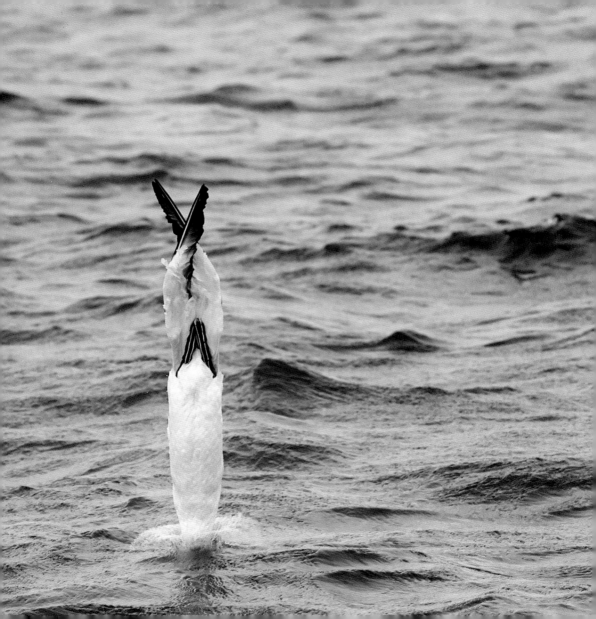

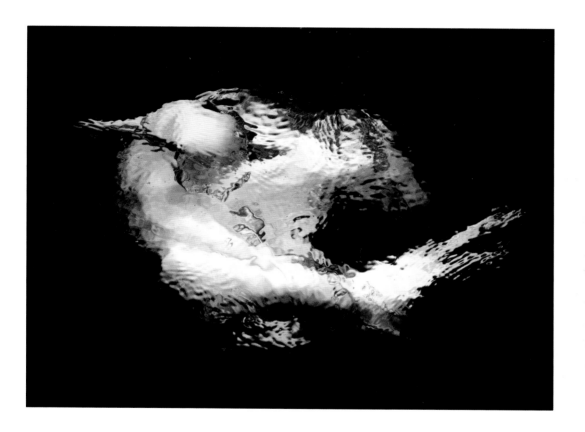

Gannets have a wingspan of nearly two metres. They catch fish by plunge-diving from great heights with wings folded so that when they pierce the surface of the water their profile is as slim as a needle. They catch their prey and guzzle it down, often on their way back up, re-emerging like bobbing corks.

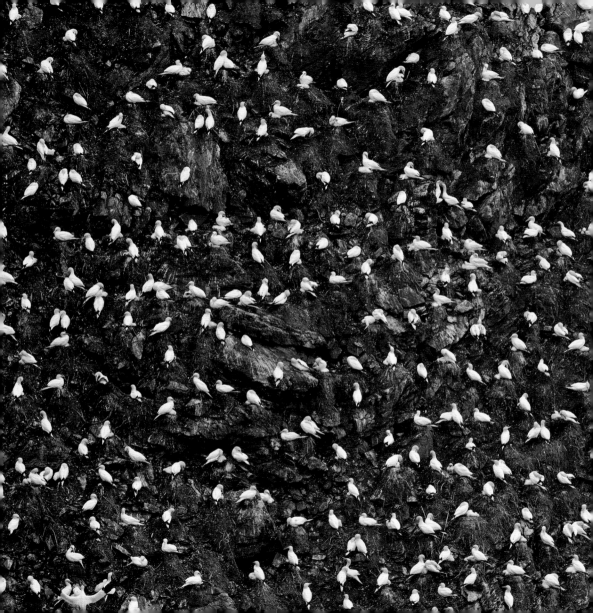

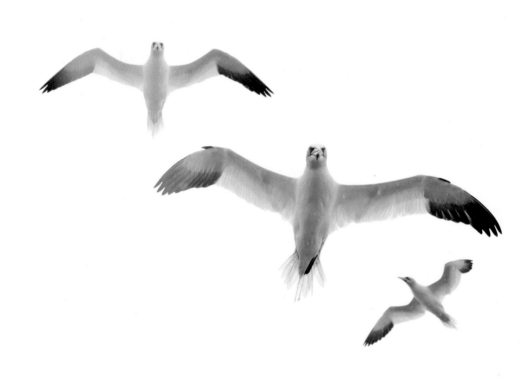

Gannets breed in large colonies, where they build nests side-by-side in the nooks and hollows of high sea cliffs.

If there are shoals of fish, or gannet-spotting boats that feed them fish, the birds come over to see if there is a meal to be had.

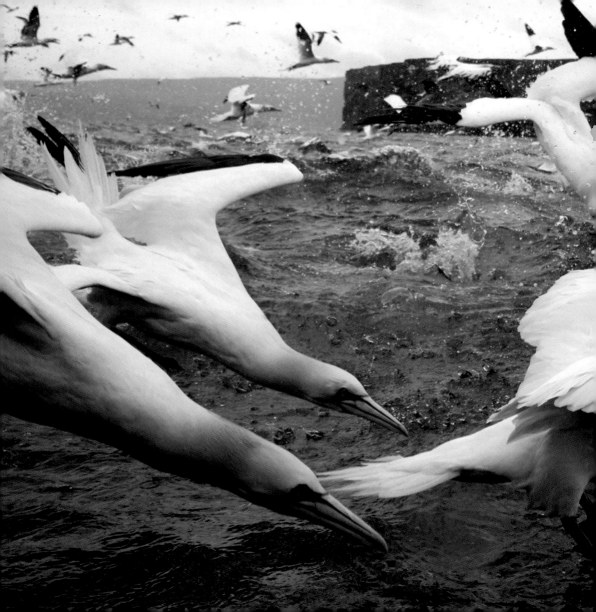

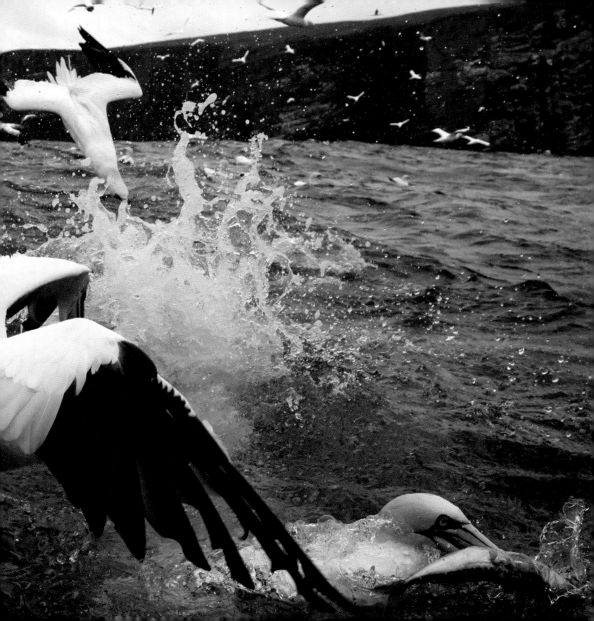

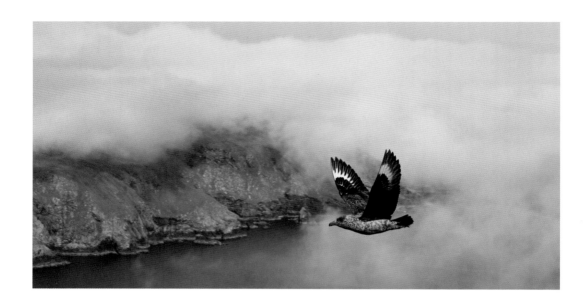

Great Skua

Stercorarius skua

Nowadays Shetland is home to about half of the world population of Great Skuas, and these big, fearless birds are impossible to miss during the breeding season. Known on the islands as 'Bonxies', they are quick to defend their nests against intruders, and can draw blood from an unsuspecting passer-by, especially one without any head gear, as they divebomb intruders in an attempt to chase them off.

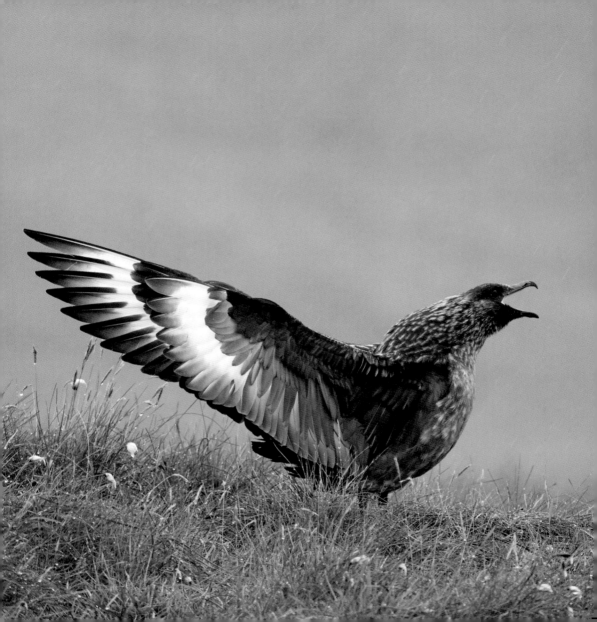

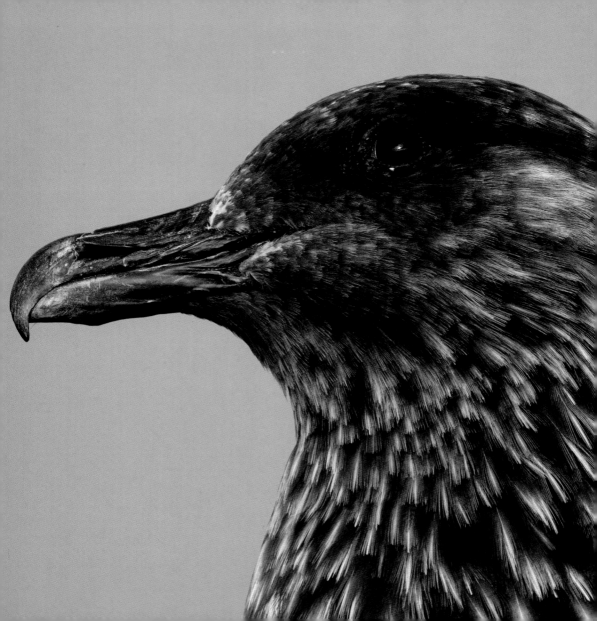

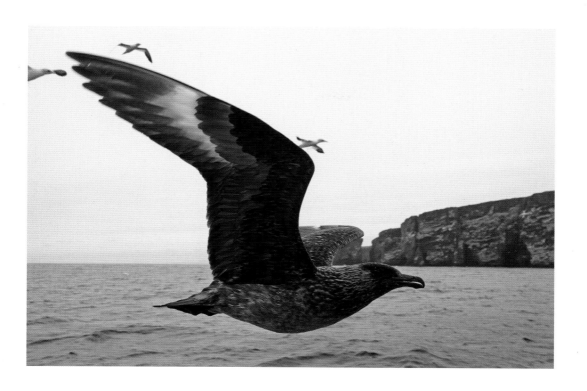

The diet of the Great Skua consists of fish that it either catches from the sea or robs from other seabirds. Sometimes certain populations specialize in preying on adult puffins, for example, or kittiwakes, and such behaviour can have a significant impact on the prey species' local populations.

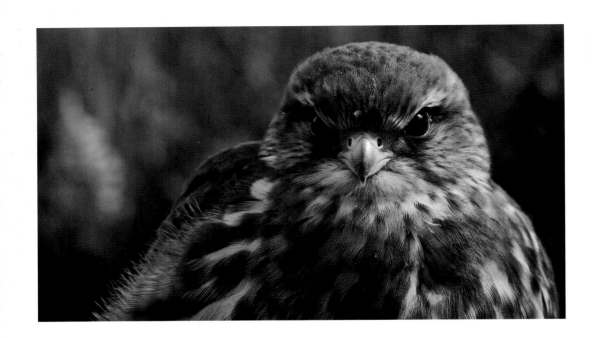

Merlin

Falco columbarius

The Merlin is Europe's smallest bird of prey, being little larger than a blackbird, but despite its small size it is an extremely efficient hunter of small birds such as Meadow Pipits (*Anthus pratensis*).

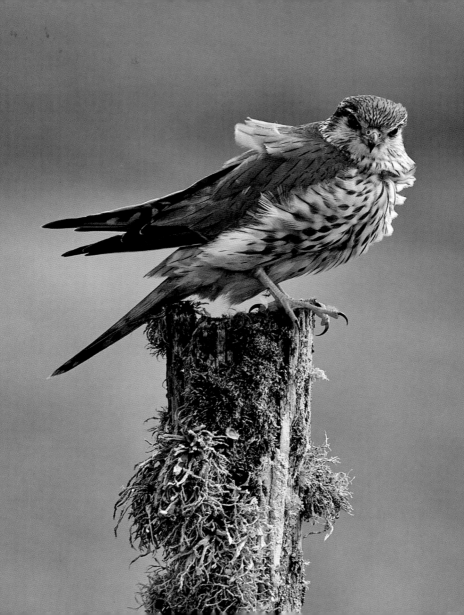

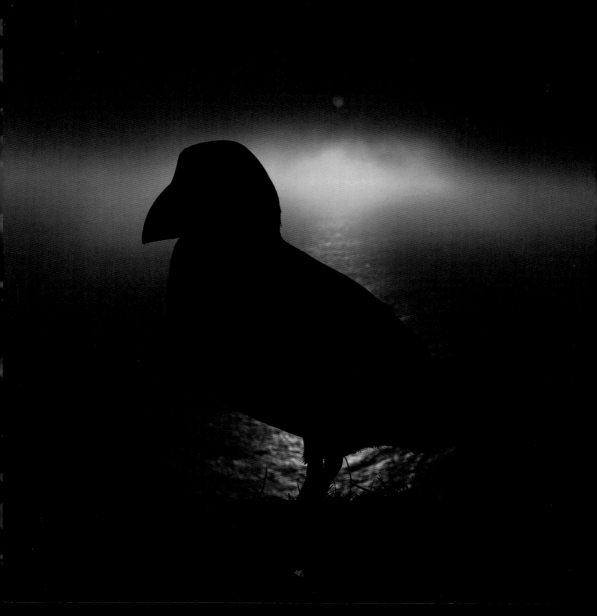

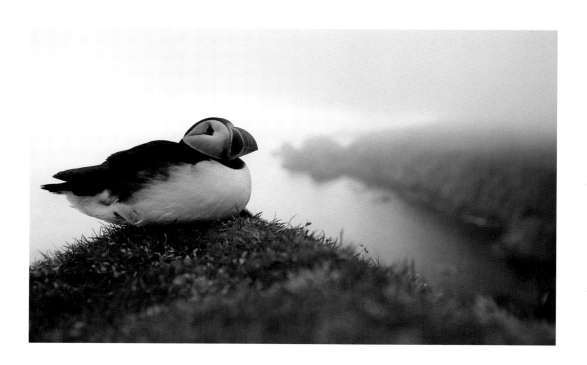

Atlantic Puffin

Fratercula arctica

The word 'iconic' is tailor-made for the puffin. Around 50,000 pairs breed in Shetland, and the Hermaness National Nature Reserve on Unst is probably the best place to see and photograph, and admire, this bird. The light-filled nights in early July, coupled with the mists and fogs which are typical of Shetland, are ideal for creating that something extra in puffin photography.

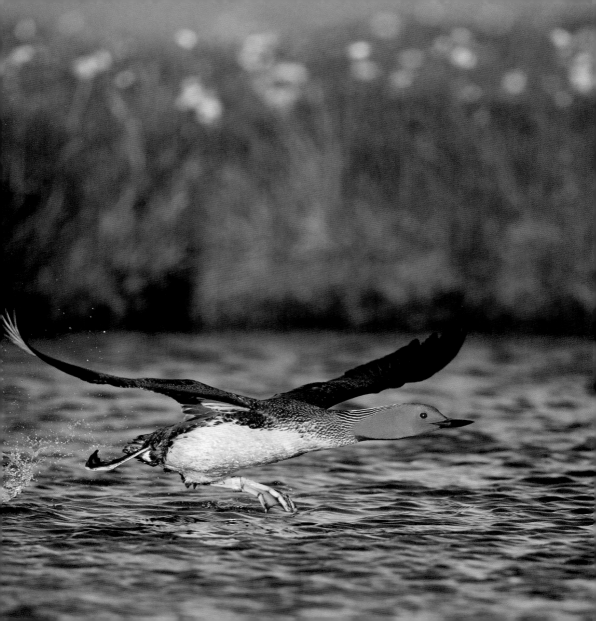

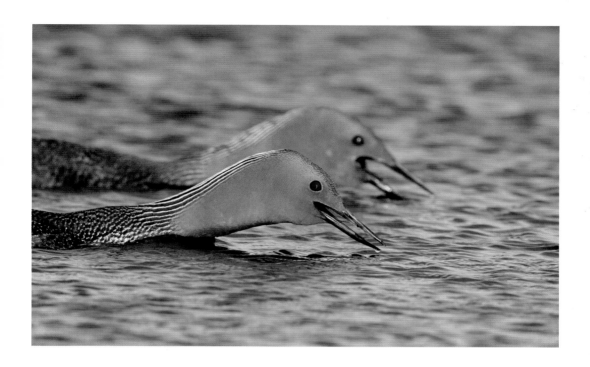

Red-throated Diver

Gavia stellata

These beautiful divers nest on small, fishless ponds in boggy wetland areas. Every couple of hours, one of the parents makes a longish take-off along the surface of the water. It flies to the sea to hunt, and returns, often within an hour, with a fish in its bill. When the young are small, it's a wonder that they don't choke to death when tackling such a relatively large fish and swallowing it whole.

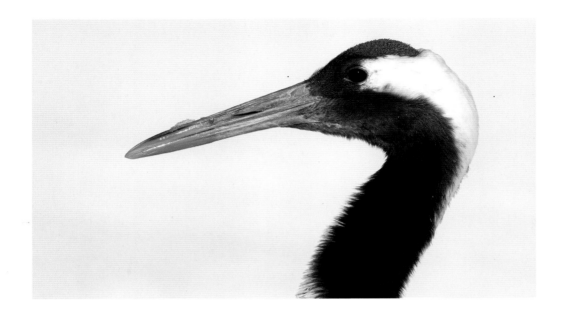

Red-crowned Crane

Grus japonensis

Hokkaidō is the most northerly of Japan's main islands, and its natural environment is different from the rest of the country. Hokkaidō shares some similarities with the nature and wildlife in the northern areas of eastern Russia, and it is the most south-easterly outpost in the ranges of many northern species.

Hokkaidō is known in particular for the Red-crowned Crane, which also goes by the names Japanese Crane and Manchurian Crane, and which has great symbolic value both in Japan and elsewhere in Asia, where it features in art and folklore. Known as tanchōzuru in Japanese, the crane is a symbol of happiness and longevity in Japanese culture.

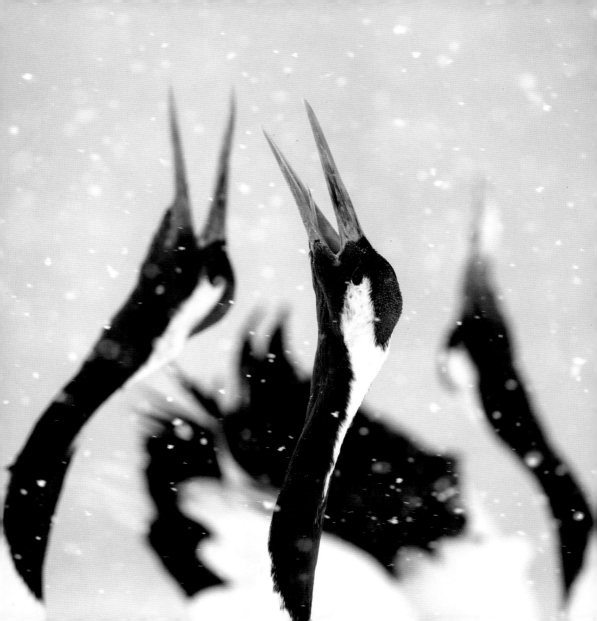

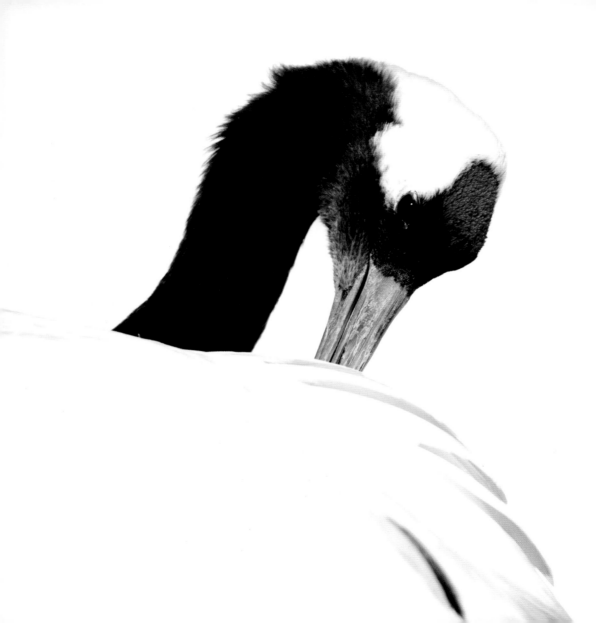

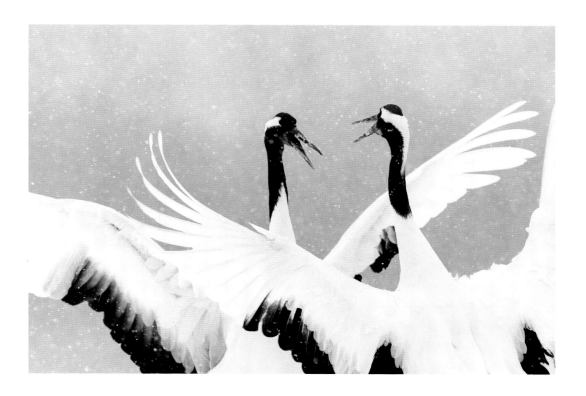

Despite being so revered, or perhaps partly because of it, the Red-crowned Crane was hunted close to extinction in the early 20th century, and its plight was further deepened by the loss of breeding grounds when bogs and marshes were turned into agricultural land. At its lowest point, only 20 pairs were left in Hokkaidō.

Due to conservation work and winter feeding by local people, Hokkaidō now has a population of 1,300 pairs. The recovery of the Red-crowned Crane is a true conservation success story.

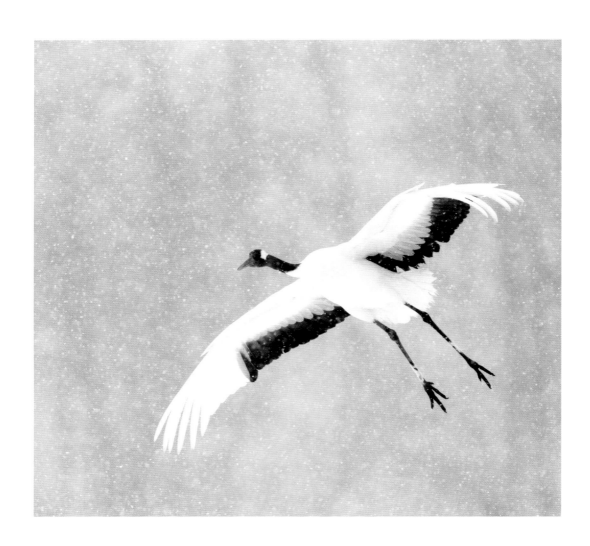

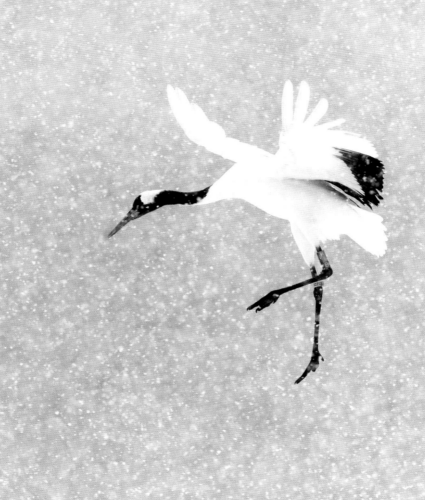

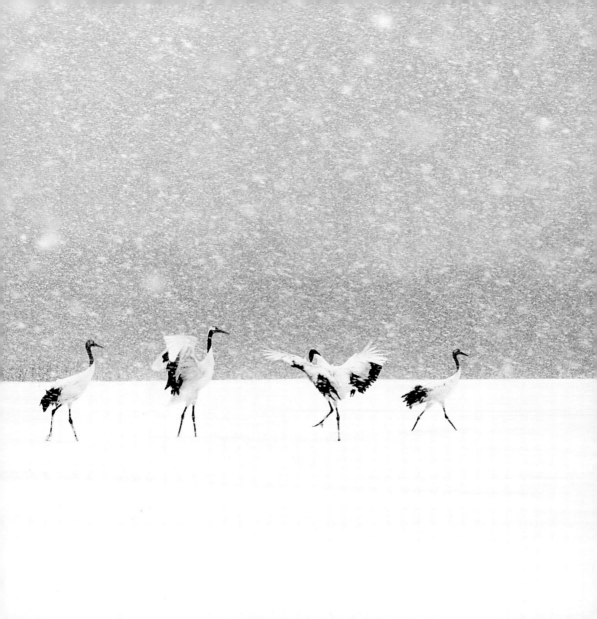

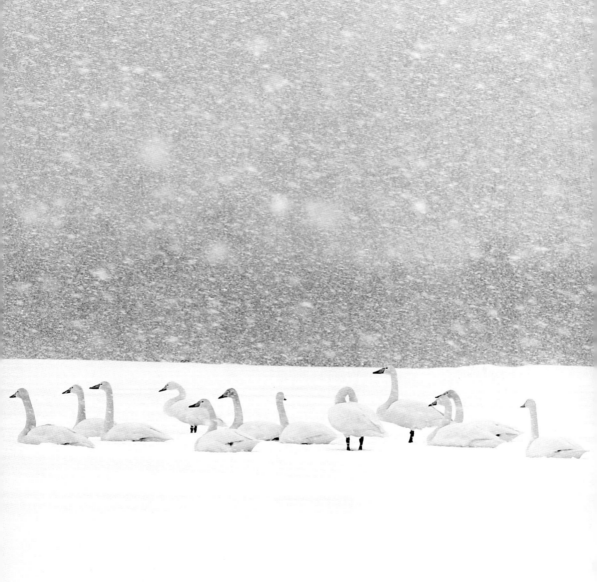

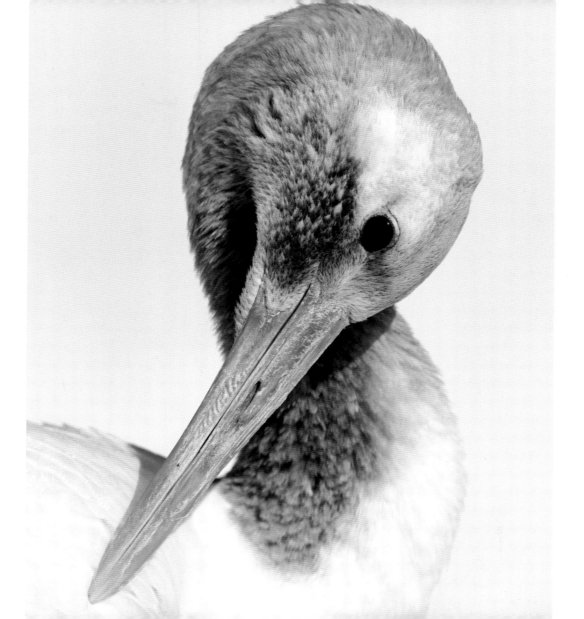

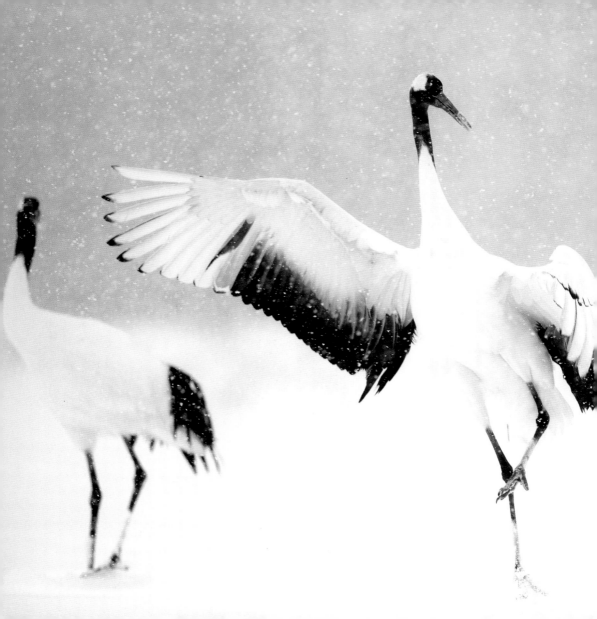

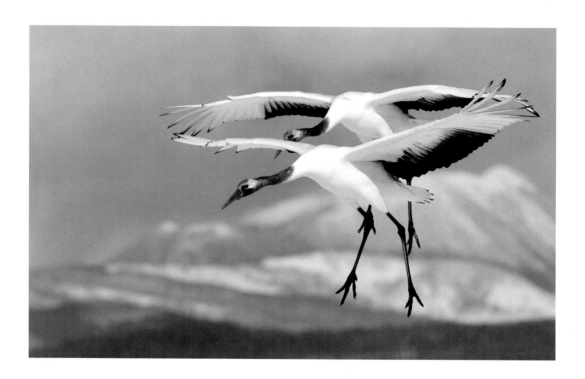

In winter, the Red-crowned Cranes visit feeding stations almost daily to feast on corn and fish. There can be dozens of birds present consistently at the most popular locations, even if small groups come and go all the time. Wings that span almost 2.5 metres carry the crane through air with slow, majestic beats.

It is a long-lived species, and also takes quite a long time to reach adulthood. In winter, the previous summer's young have a pale brown colouration on their head and neck, with no red.

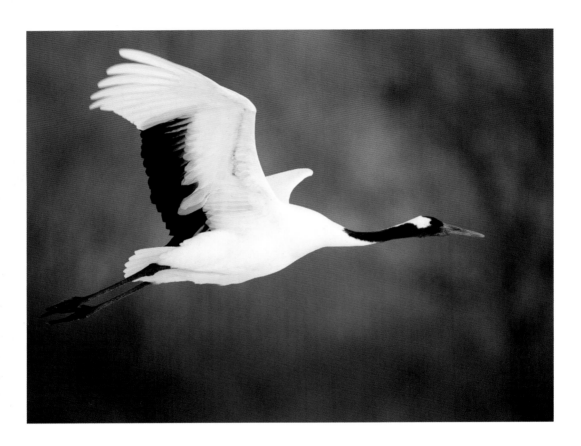

Red-crowned Cranes begin courtship rituals as early as February. Display behaviour includes elaborate dancing, jumping and very vocal duets that resemble the sound of a trumpet.

The last of the cranes leave well after sunset, and luck permitting they can be captured against the moon as it rises from behind the mountains.

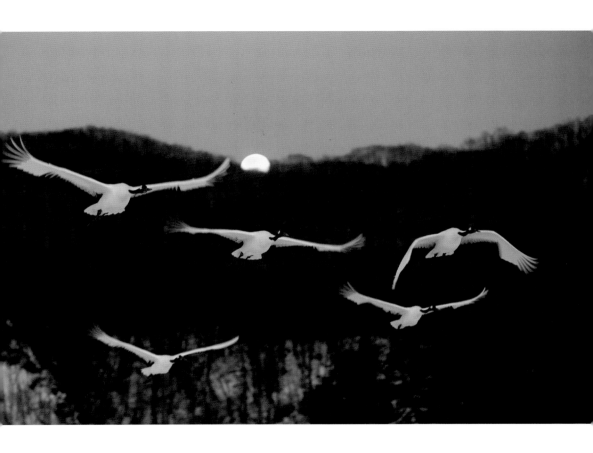

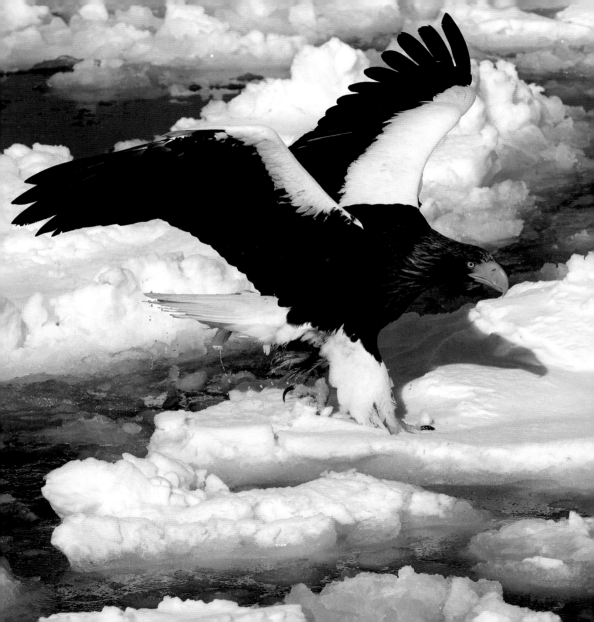

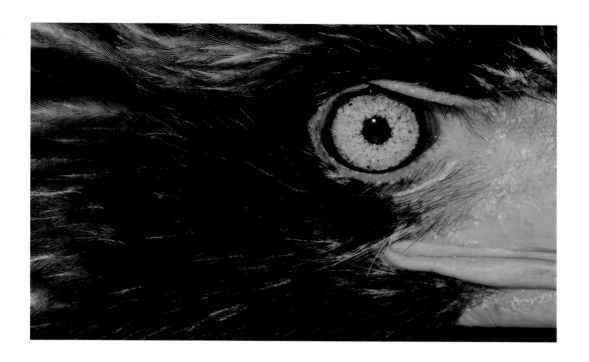

Steller's Sea Eagle

Haliaeetus pelagicus

Hokkaidō's avian attractions also include the magnificent Steller's Sea Eagle and the elegant Whooper Swan, both of which pull in birders and photographers like a magnet.

Outside a small north-eastern fishing town called Rausu, out on the pack ice in the Nemuro Strait in the Sea of Okhotsk, the locsal fishermen have been feeding the Steller's Sea Eagles and White-tailed Eagles for quite a some time.

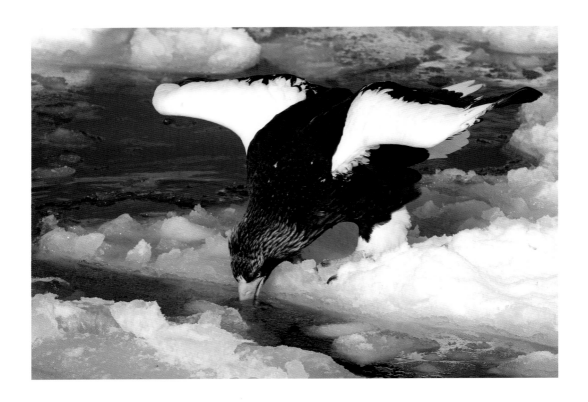

Every morning in the pack ice season, several boats packed with photographers and wildlife enthusiasts leave Rausu harbour before sunrise and head off along the coast. Upon reaching their destination, they are greeted by Steller's Sea Eagles, and the smaller White-tailed Eagles, sitting on the ice waiting for breakfast to be served. When the feeding starts and the eagles are up in the air, coming to get their share of the offerings, pushing and shoving each other a little, and flying against the beautiful backdrop of mountains, it is like Christmas for a photographer.

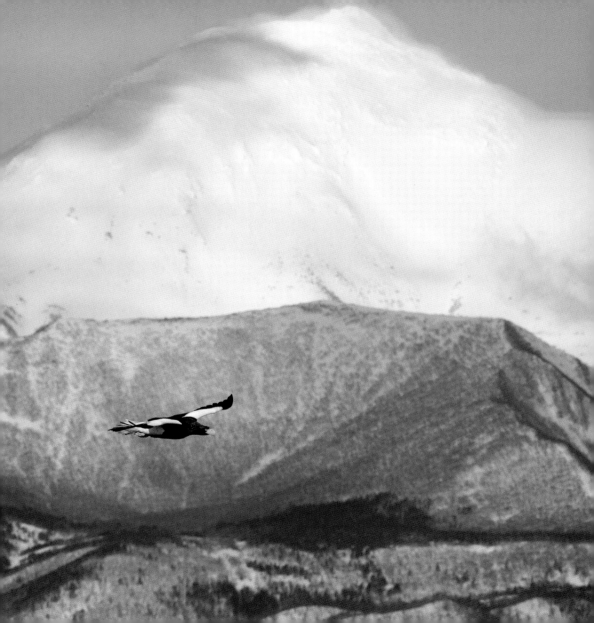

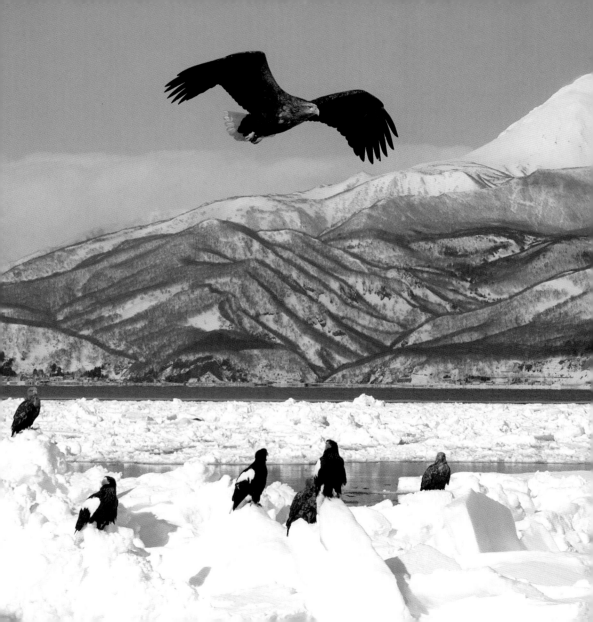

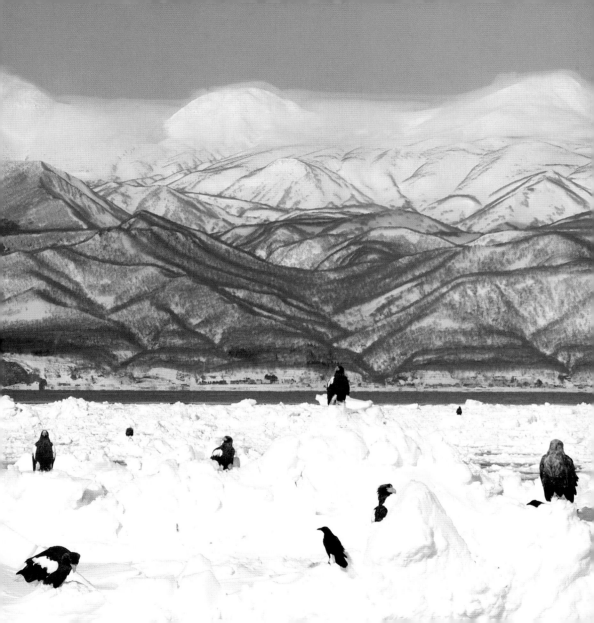

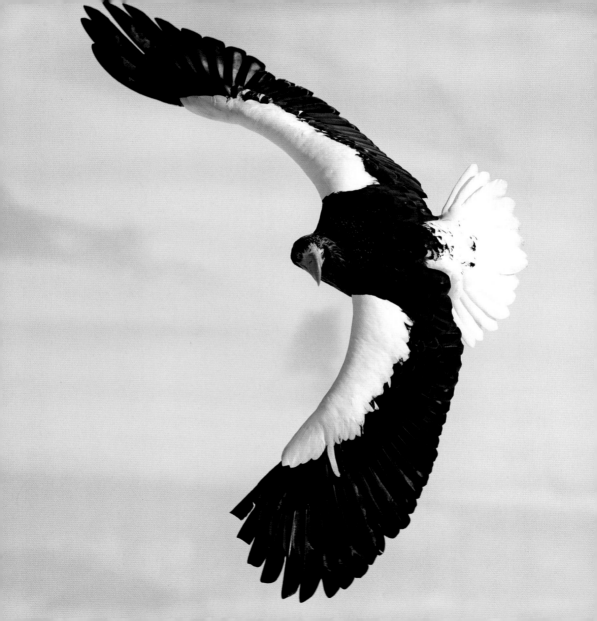

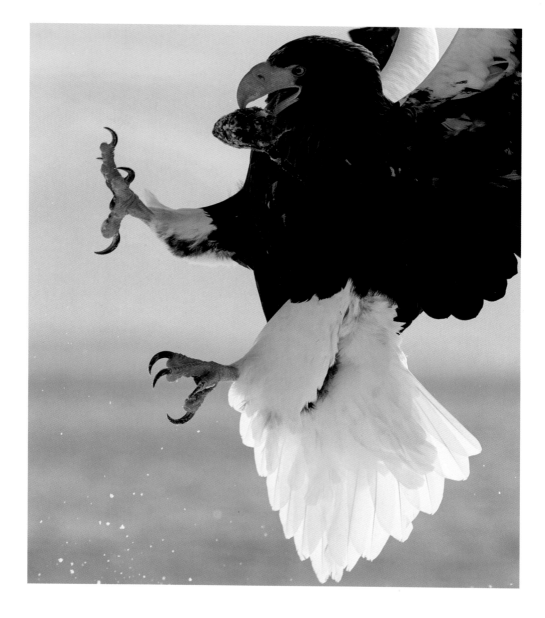

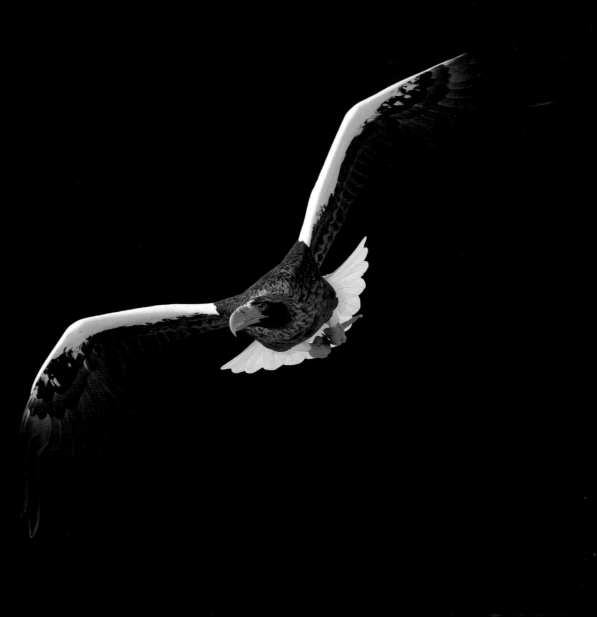

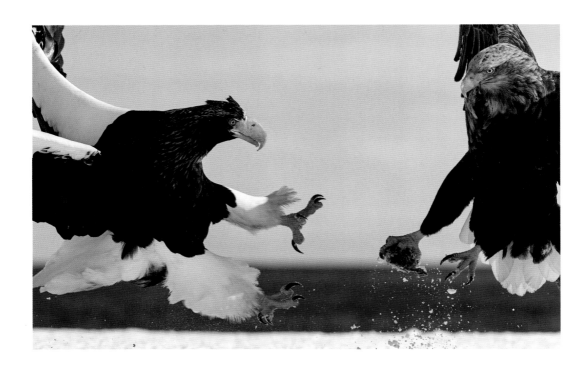

Being more used to seeing the White-tailed Eagle, which one has learned to think of as a big bird, it comes as a surprise to realise just how big the Steller's Sea Eagle actually is, making the White-tailed look small! Being bigger and stronger, the Steller's Sea Eagles find it easy to steal fish from the White-taileds.

The Steller's Sea Eagle has a more flamboyant colouring: a massive bright orange bill and a smart-looking black-and-white pattern in the plumage.

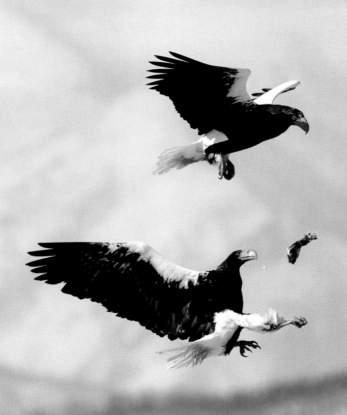

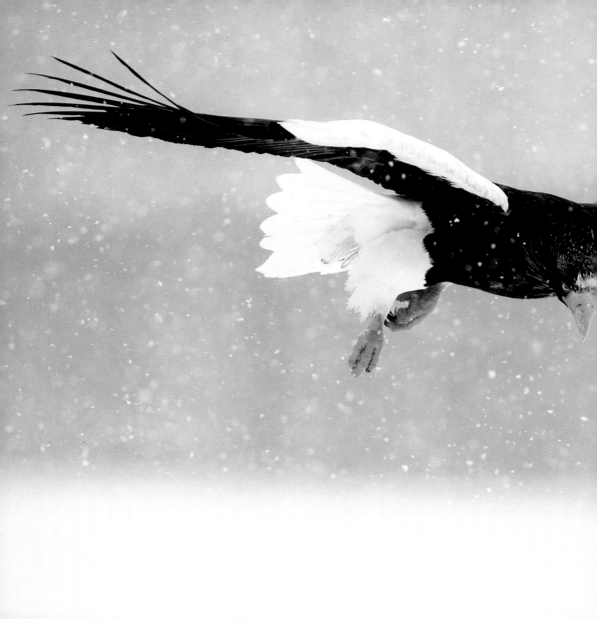

White-tailed Eagle

Haliaeetus albicilla

In Europe the White-tailed Eagle is generally very skittish. The species is not easy to photograph at close range, while on the ground or perched in a tree, unless a hide is used. Out at sea in Hokkaidō, they come to within five metres of the boat to catch fish, which provides great opportunities for taking super close-ups, as well as for using shorter lenses for wide landscape shots.

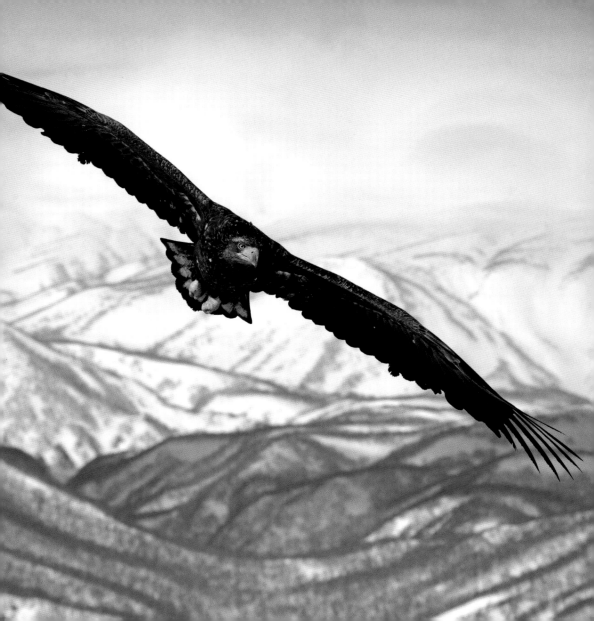

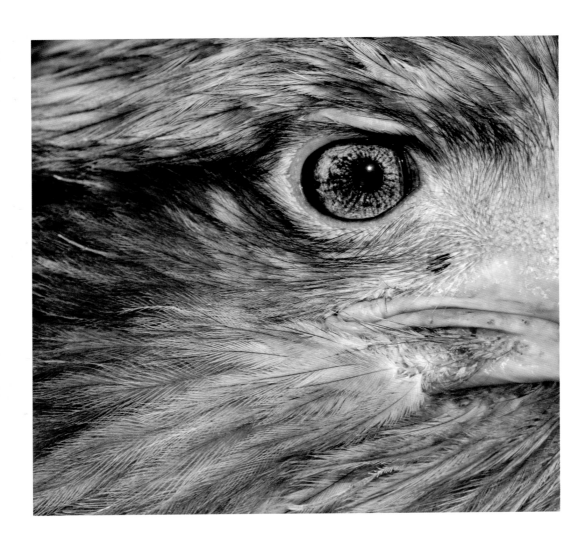

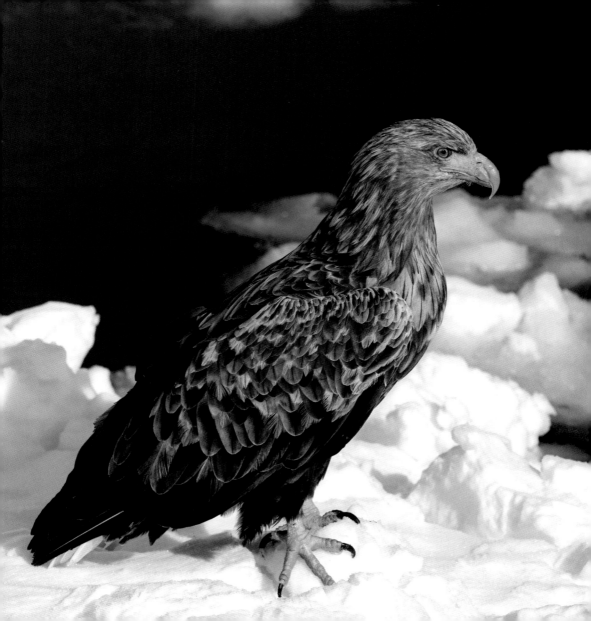

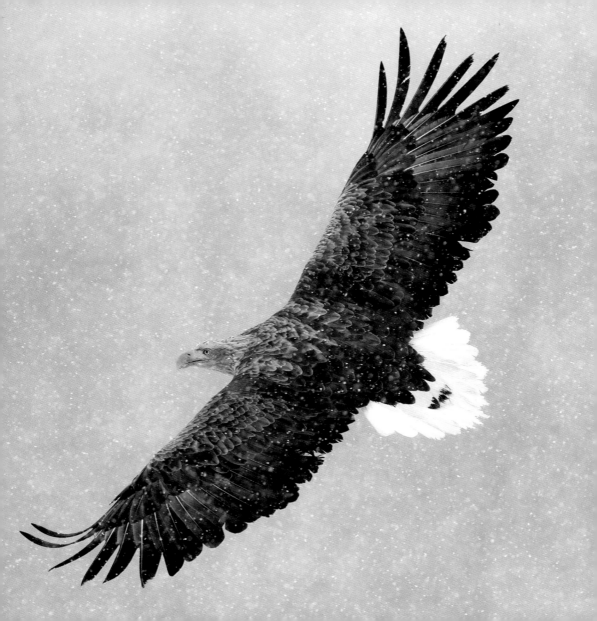

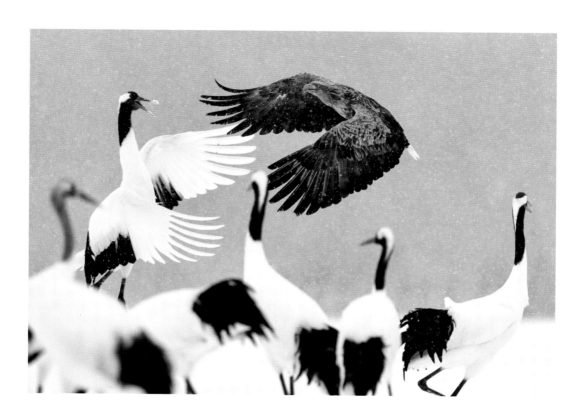

The White-tailed Eagles have also found their way to the Akan International Crane Centre, where during winter food is provided for the cranes every day at the same time. Arriving in good time, some White-tailed Eagles and Black Kites gather to circle above the feeding site. When the food arrives, they make daring dives into the melee to try to get their share.

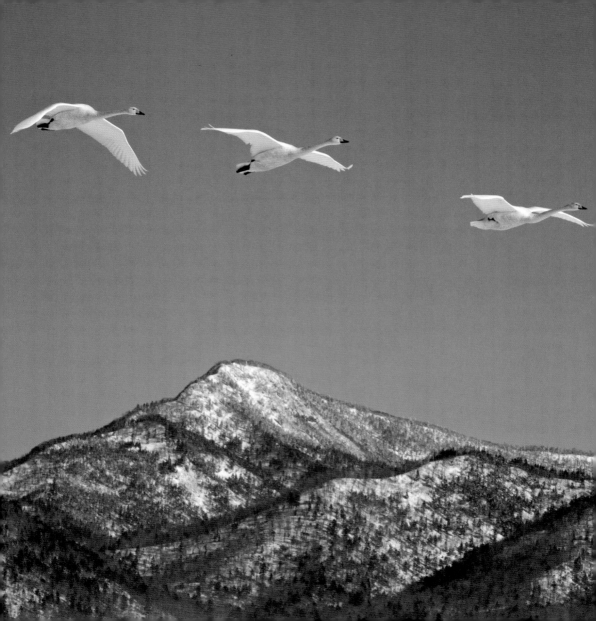

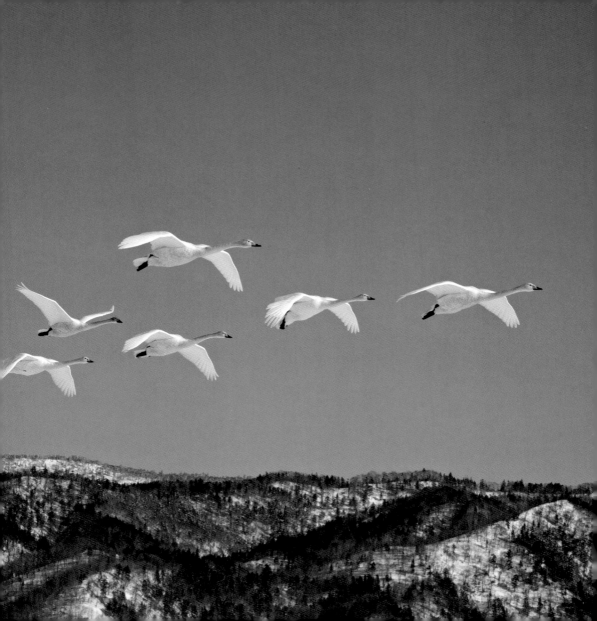

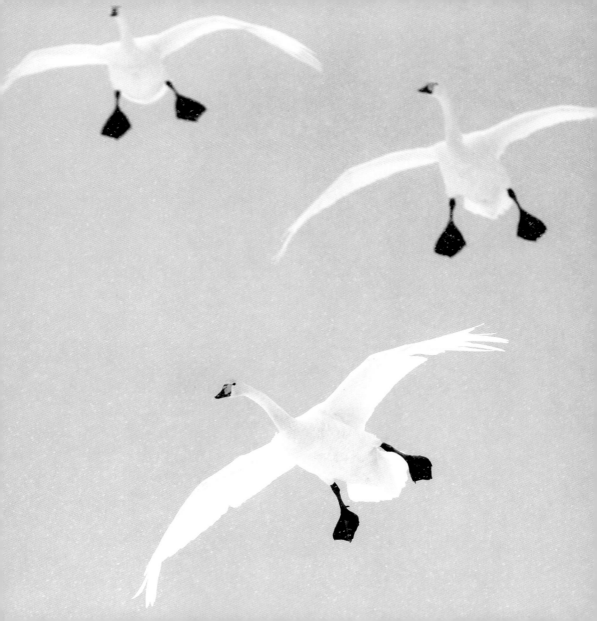

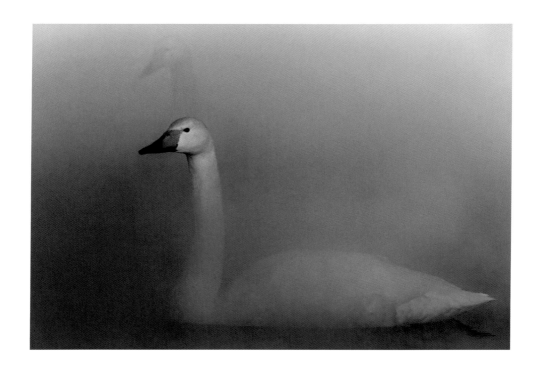

Whooper Swan

Cygnus cygnus

Hokkaidō is a volcanic region with hot springs in many places enabling the water to stay open even in extreme cold weather. This allows Whooper Swans to winter in Hokkaidō. The birds are fed throughout winter along the lake shores, and they have also learned to take advantage of the food supply at the Red-crowned Crane feeding sites.

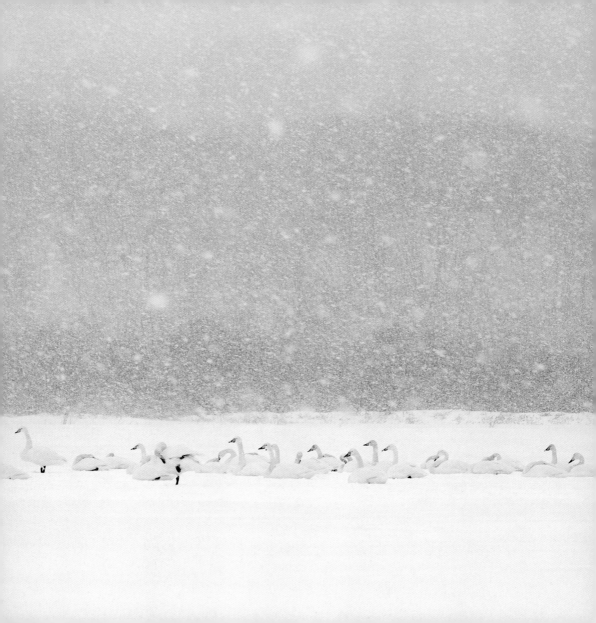

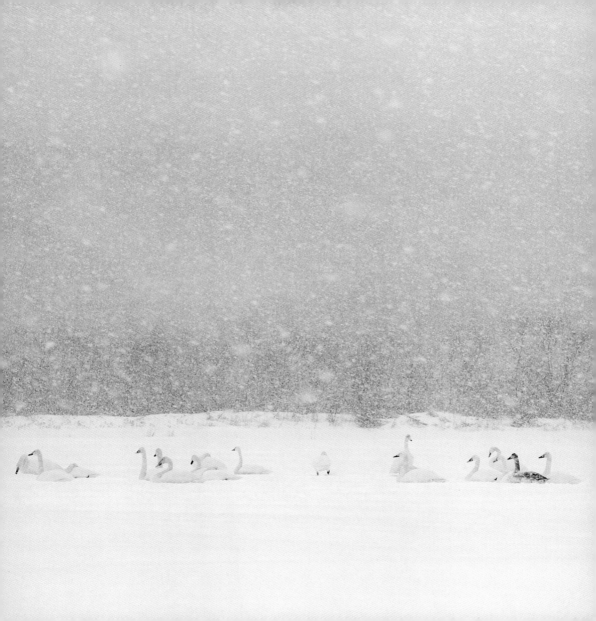

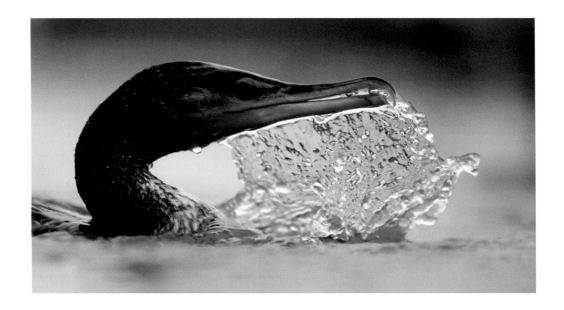

Great Cormorant

Phalacrocorax carbo

These winter pictures were taken in the Kiskunsági National Park, in southern Hungary, in an area that is a mixture of wetland with old fish farms, woodlands and puszta, or plains. In winter the fish ponds, both redundant and those in use, are home to large numbers of waterbirds, including herons, ducks and cormorants.

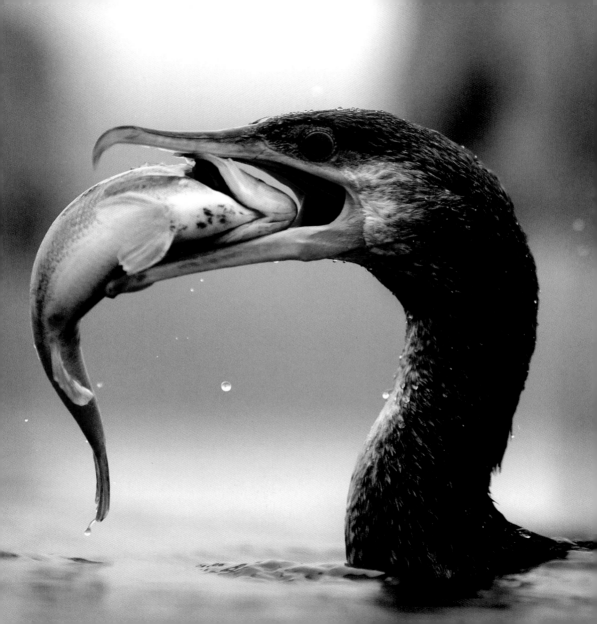

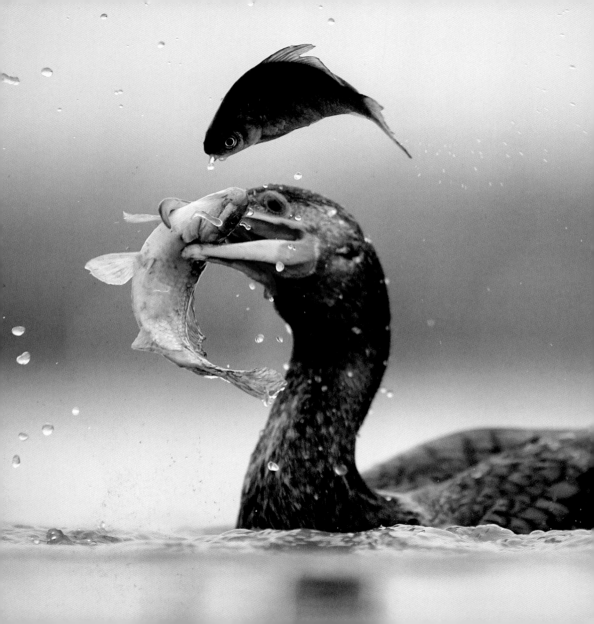

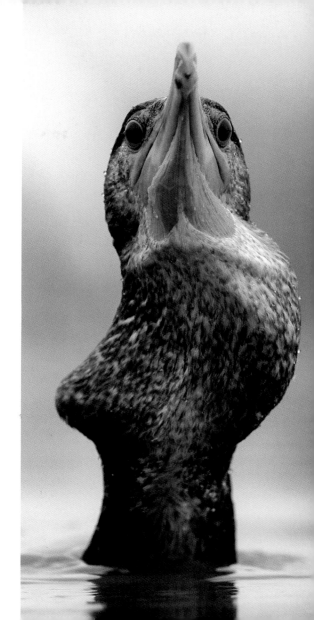

Great Cormorants feed on fish. Some people mistakenly believe that they will empty a wetland of fish, while others claim that they destroy the islands upon which they breed with their acidic faeces, so as a consequence cormorants are heavily persecuted by humans in many places.

Cormorants are understandably cautious, making it necessary to use a hide when photographing them at close range. They are very skillful at fishing, and catch their prey by diving underwater, resurfacing to swallow the fish, which can be surprisingly large.

GREAT CORMORANT

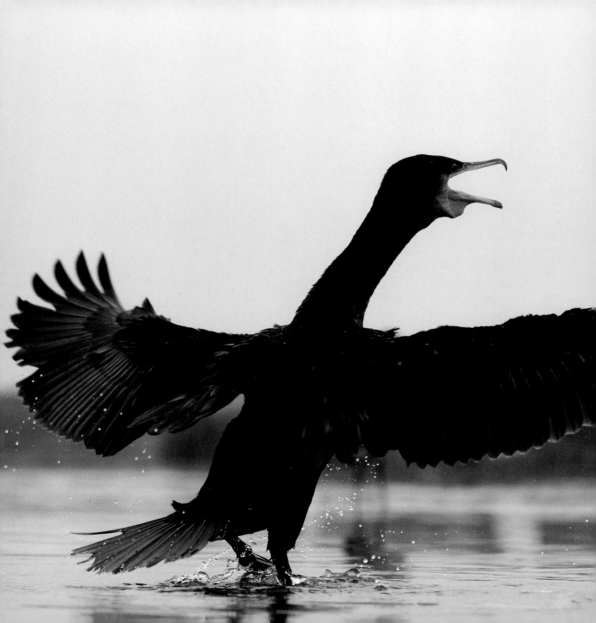

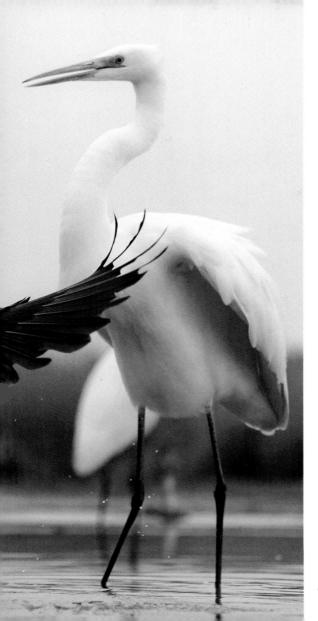

For such a skittish bird, the Great Cormorant
is amazingly brave when defending its catch or
fishing territory against the much bigger Great
White Egret (*Ardea alba*).

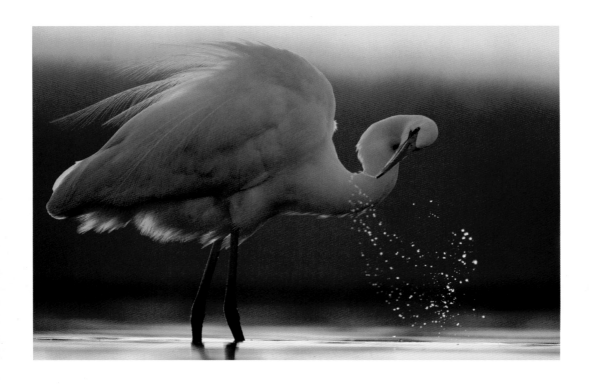

Great White Egret

Ardea alba

The Great White Egret stands a metre tall, but in its all-white feather coat it exudes an air of grace and harmonious proportions. Preying mainly upon fish and frogs it stands patiently by the water, as still as a statue, until it strikes as fast as lightning, its sharp bill a deadly weapon. A good spot with ample fish attracts a lot birds, and therefore there is often a great deal of scuffling, chasing and jousting among them.

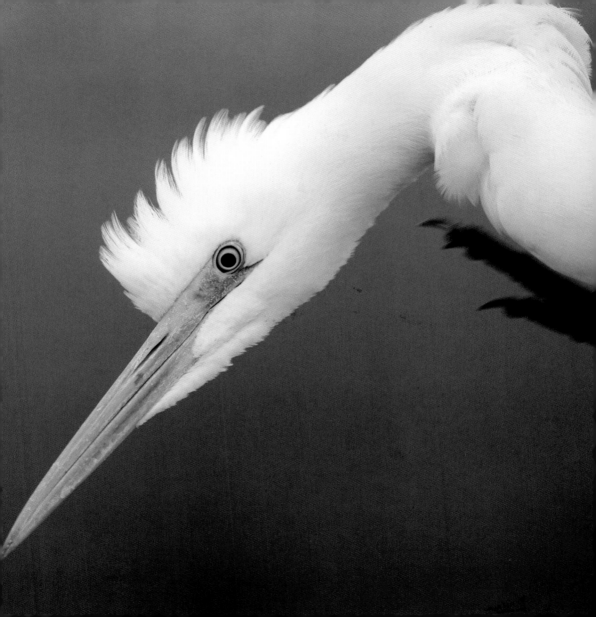

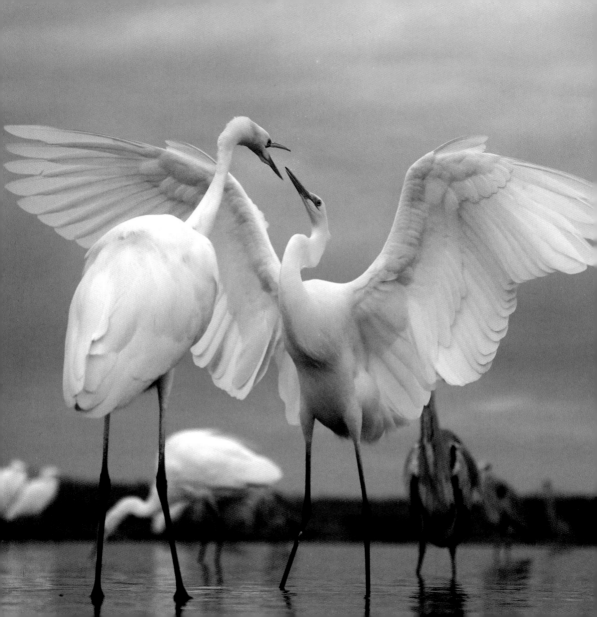

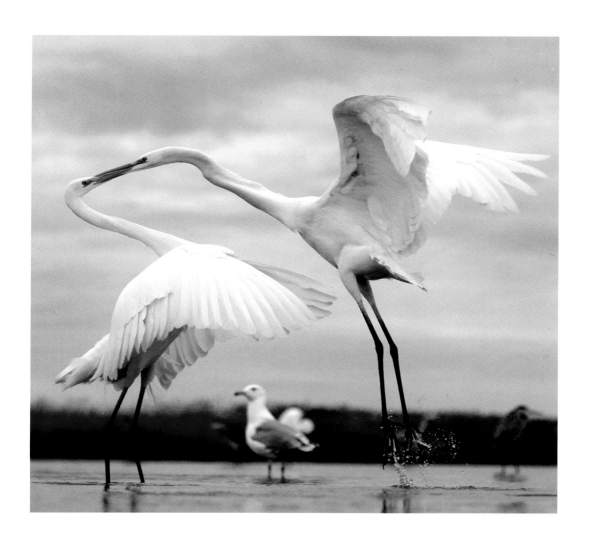

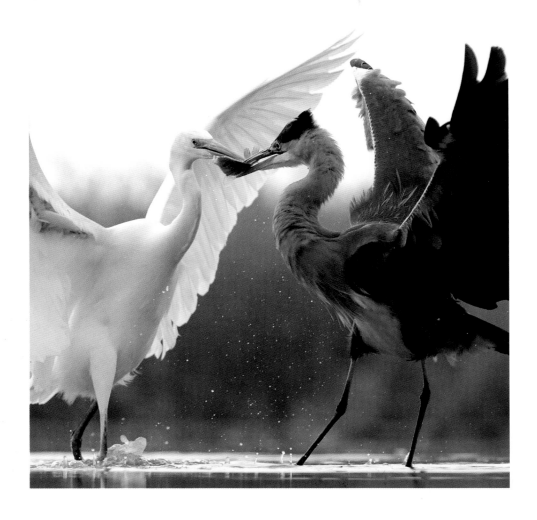

On average, the Great White Egret is slightly bigger than the Grey Heron (*Ardea cinerea*), yet it seems to regularly lose out in fights over fish. In this case, both birds lost out.

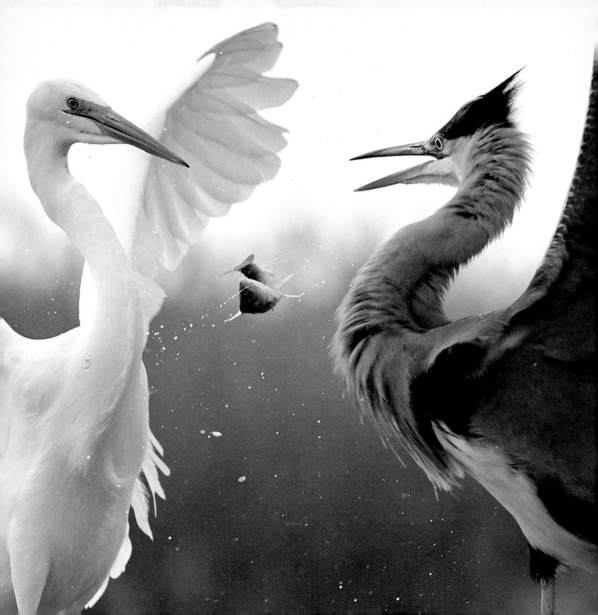

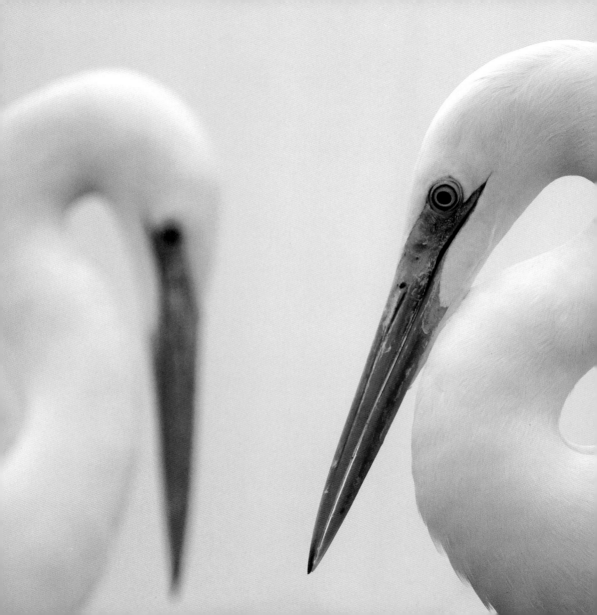

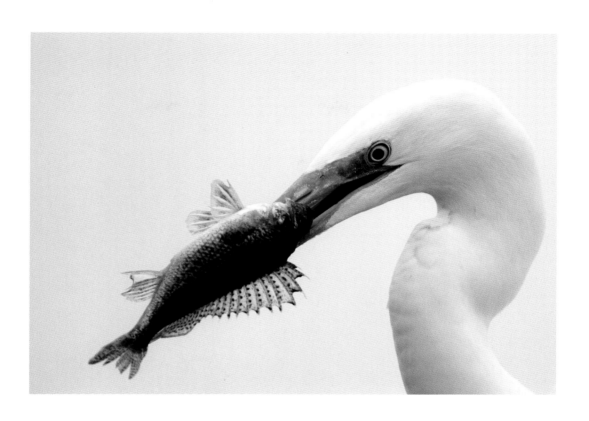

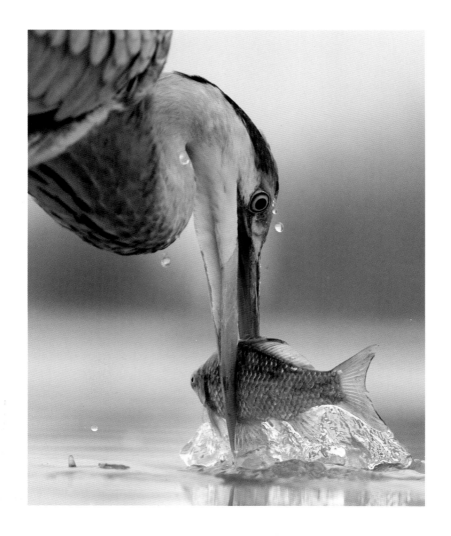

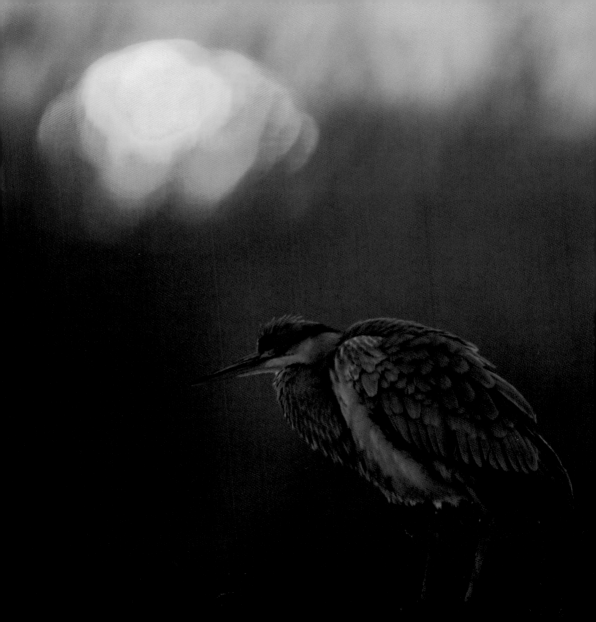

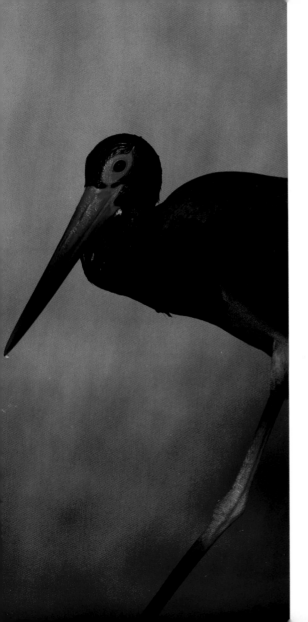

Black Stork

Ciconia nigra

Standing over a metre high, this timid bird cannot be photographed up close without the use of a hide. Views from close range reveal the beautiful iridescent greens, blues and purples in the adult's plumage, but what is truly beautiful is the vivid red colour on the bill and around the eyes. The stork moves with dignity as it wades in the shallow water by the shore, in search of prey such as frogs, large insects and fish.

BLACK STORK

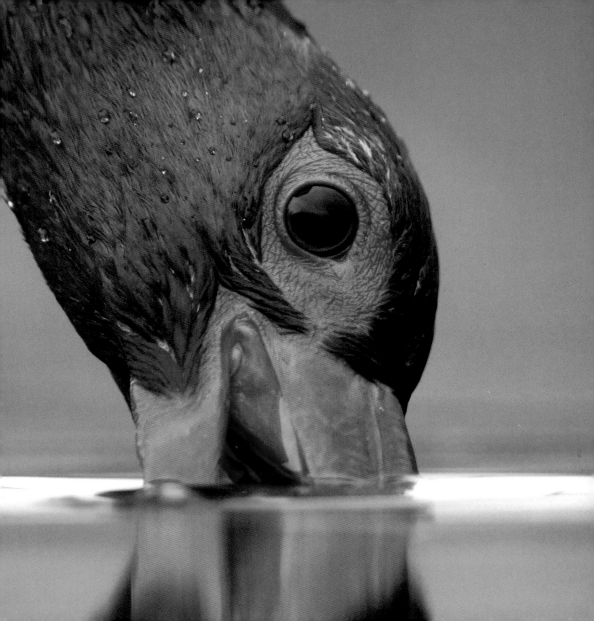

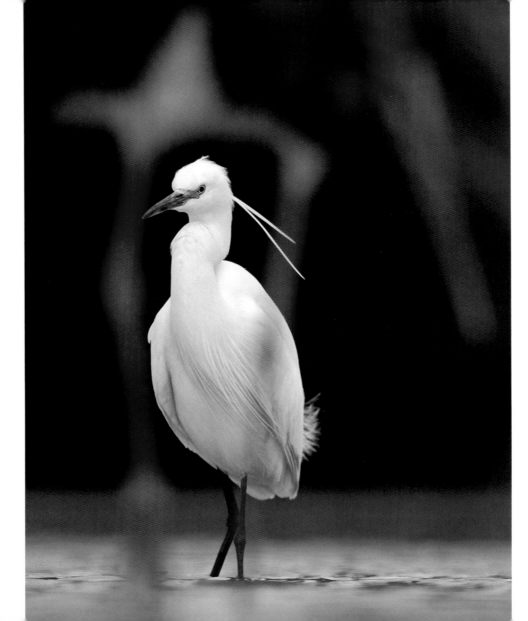

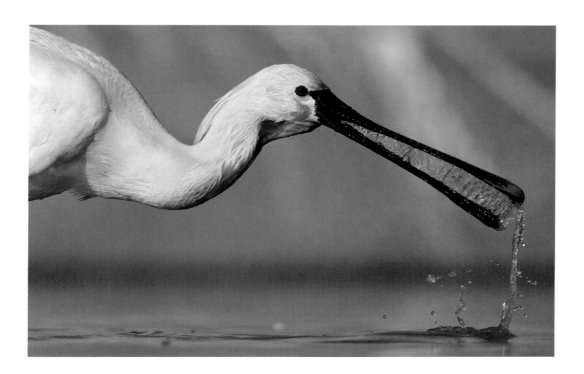

Little Egret

Egretta garzetta

Like a smaller version of the much bigger Great White
Egret. Its small size stands out in this photo, where it has
been captured through the long red legs of the larger
Black Stork.

Eurasian Spoonbill

Platalea leucorodia

Whereas egrets and herons stab at their prey with sharp
pointed bills, the spoonbill sweeps its broad-edged beak
through the water, sifting for food.

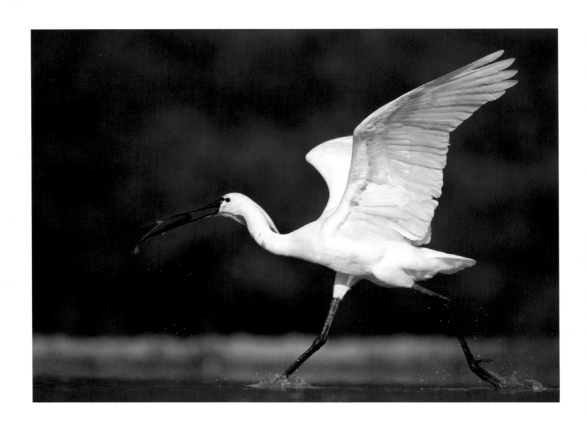

The remarkable long, flat spatulate bill is swung in big arcs from side-to-side as the bird wades through water foraging for food, such as fish, frogs and other small aquatic creatures. Grey Herons especially are quick to steal the catches of other birds, and the spoonbill often has to evade attack and escape to calmer waters before it can swallow its prey.

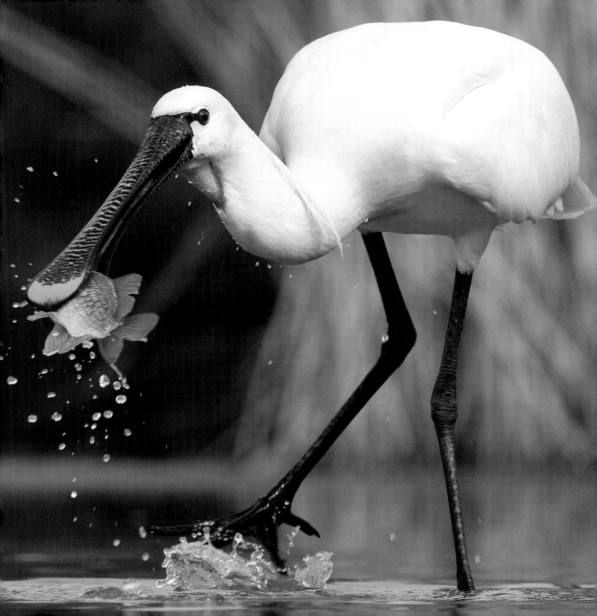

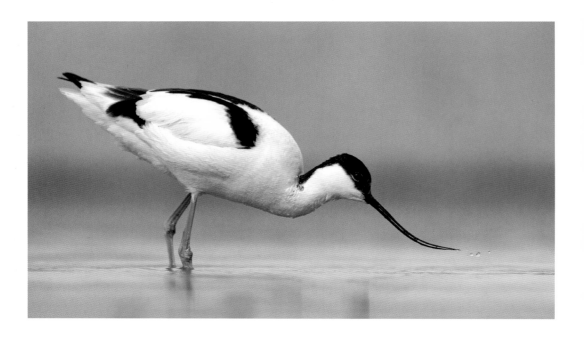

Pied Avocet

Recurvirostra avosetta

Spring sees the arrival of many new species in the
wetland areas of the puszta, including a variety of
herons and waders. The streamlined and elegant
avocet has a striking feature: its upturned bill,
which it keeps just about open as it stalks aquatic
invertebrates.

Common Blackbird

Turdus merula

The forests and the open puszta are busy with many
interesting songbirds. Blackbirds like to bathe on a
hot day, spraying water everywhere.

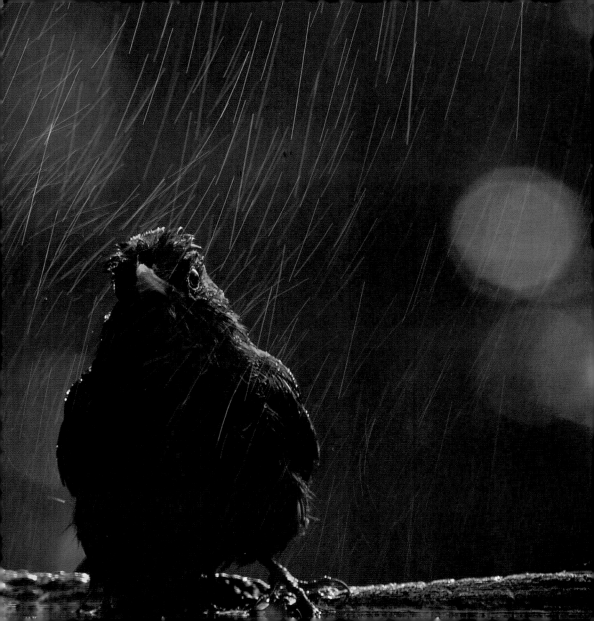

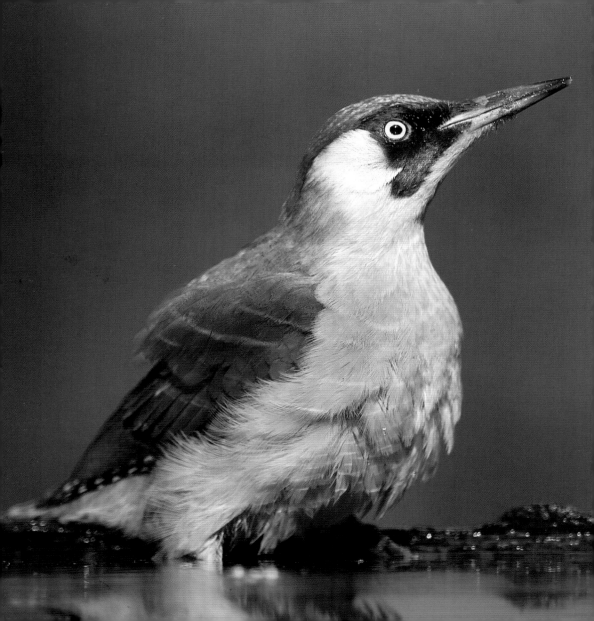

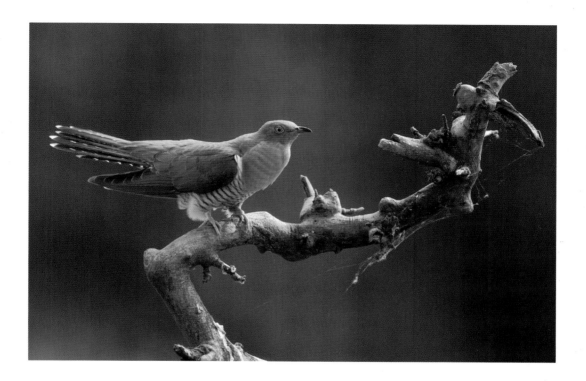

Green Woodpecker

Picus viridis

The best chance to photograph this handsome but rather elusive bird away from its nest is at a suitable drinking and bathing site, which the same bird can frequent every other day or so.

Common Cuckoo

Cuculus canorus

It doesn't take long for small birds to spot a cuckoo and begin harassing it; they detest it for its habit of laying eggs in their nests. The hatchling cuckoo then rather brutally pushes the original eggs out of the nest.

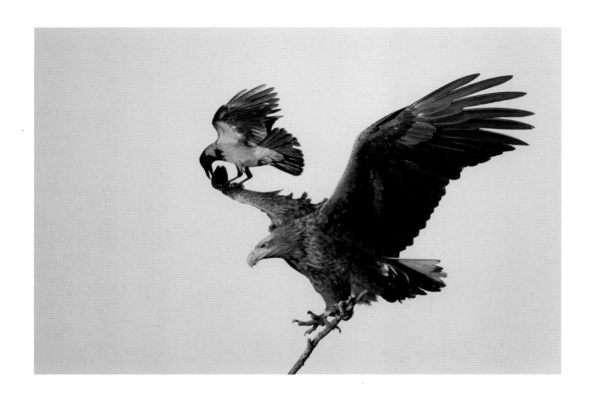

Hooded Crow and White-tailed Eagle

Corvus cornix **and** *Haliaeetus albicilla*

These fearless corvids are often seen mobbing much larger predators such as eagles.

Common Kingfisher

Alcedo atthis

This colourful, much-loved beauty is a proficient hunter of fish in ponds and rivers.

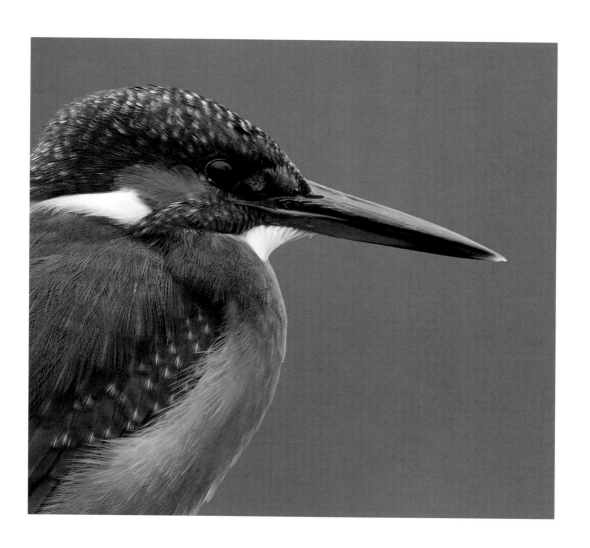

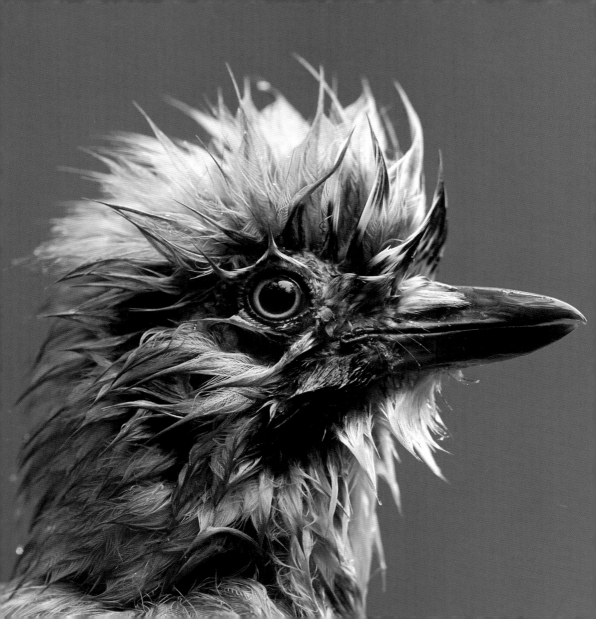

Eurasian Jay

Garrulus glandarius

A jay's post-bath look with punk hairdo.

Hawfinch

Coccothraustes coccothraustes

For a small bird, the Hawfinch is uncharacteristically elusive and timid. A hide is necessary in order to see it up close.

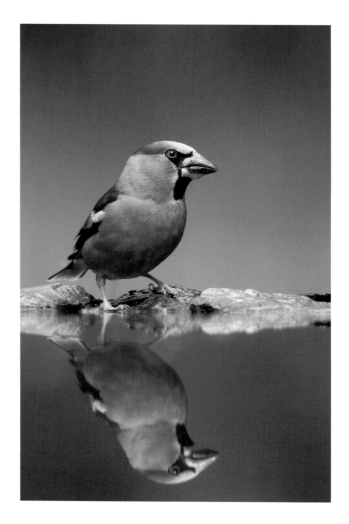

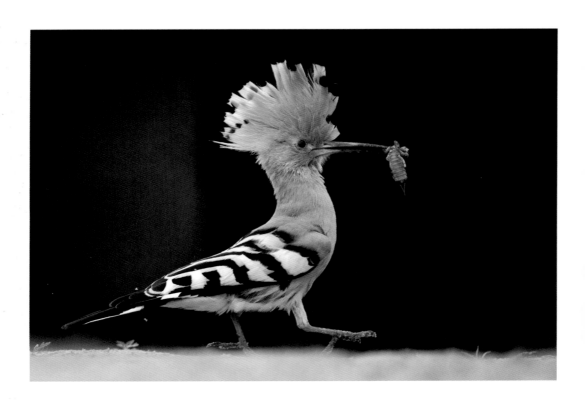

Hoopoe

Upupa epops

When excited, and also immediately after landing, the Hoopoe raises the feathers in its crest. In the image above an adult is bringing food for its chicks. In the picture opposite the time for mating is not always right for both parties.

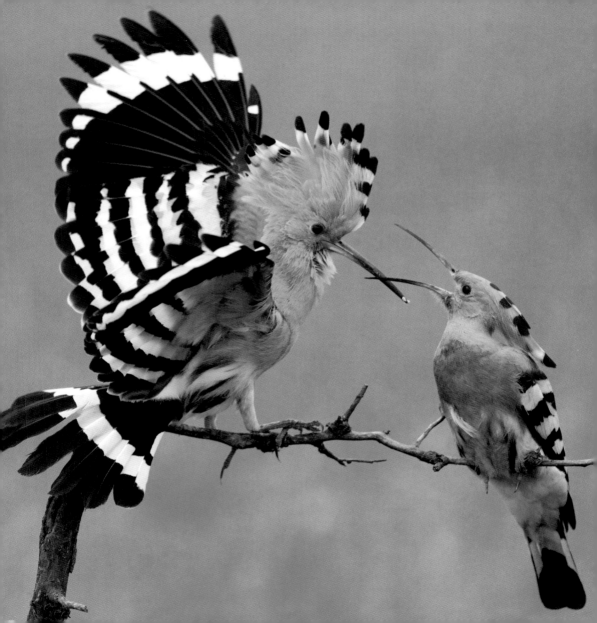

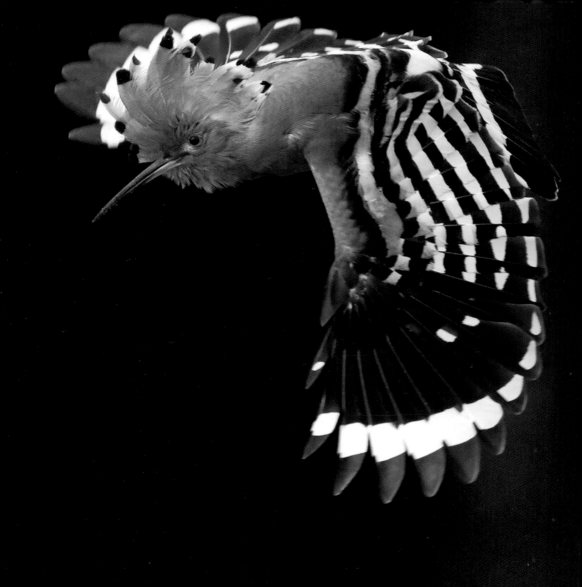

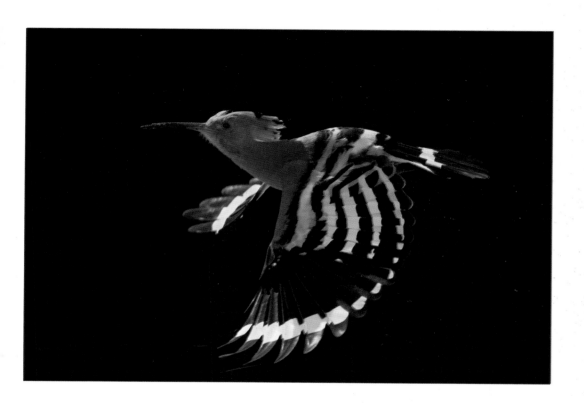

The Hoopoe's flight pattern is unpredictable and undulating, and it often flies close to ground, making it a very challenging subject to photograph!

In flight the black and white stripes on the wings become much more noticeable.

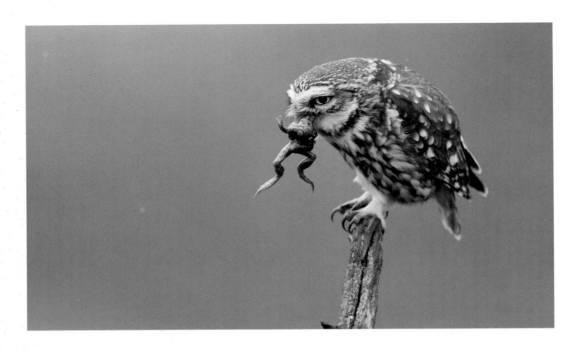

Little Owl

Athene noctua

We think of owls as creatures of the night but the Little Owl can often be seen hunting in the daytime. This one had caught a frog – a relatively rare prey item.

Little Egret

Egretta garzetta

In full breeding plumage, the Little Egret has elegant plumes on the back of its head, as well as on its back and chest, while the lores turn violet. This species can be distinguished from the Great White Egret by size and by its yellow feet, which contrast with the black legs.

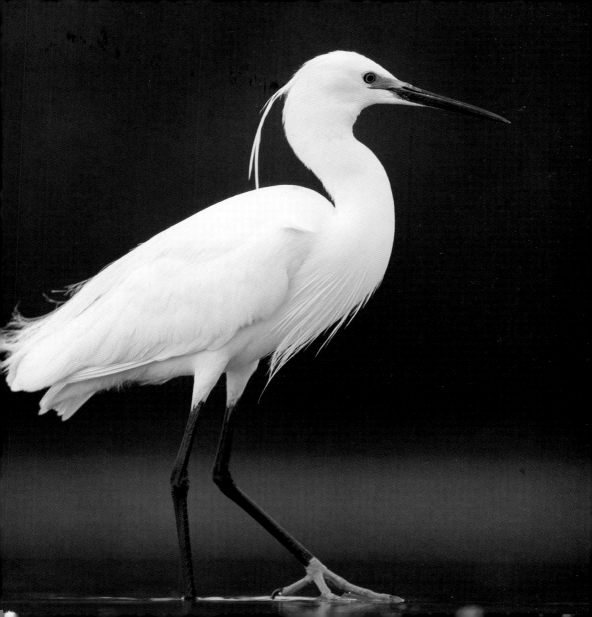

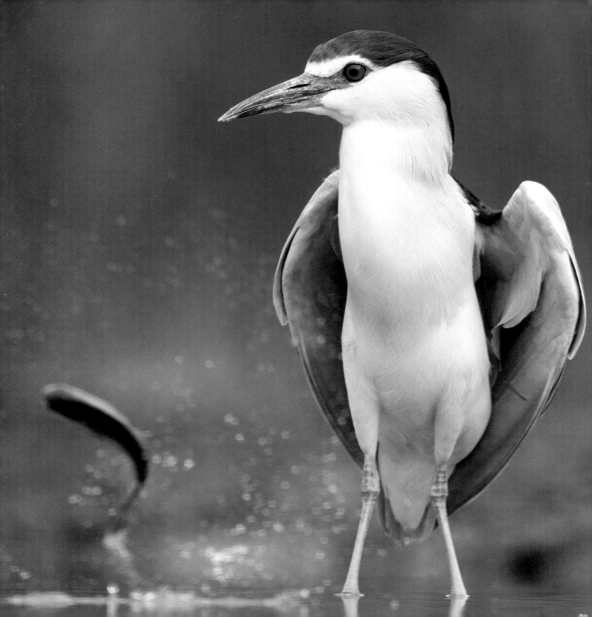

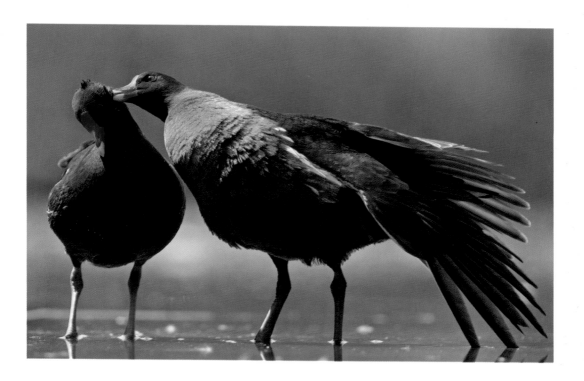

Black-crowned Night Heron

Nycticorax nycticorax

As its name suggests, and also its large eye, the night heron is mainly a nocturnal bird, although it is not unusual for it to venture out and hunt in the daytime as well.

Common Moorhen

Gallinula chloropus

Many birds, such as the moorhen pair in the picture, engage in mutual grooming, where the partners groom the other's hard-to-reach areas.

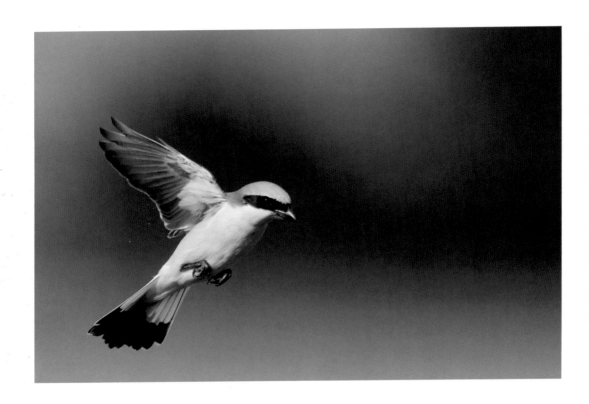

Red-backed Shrike

Lanius collurio

This small bird preys upon beetles and other insects, often pouncing from a vantage point such as a branch, telephone line, or fence post. When it spots its target, it launches into hot pursuit and catches its prey. It can also hover, as shown in the picture, searching for prey so that it can strike directly from flight.

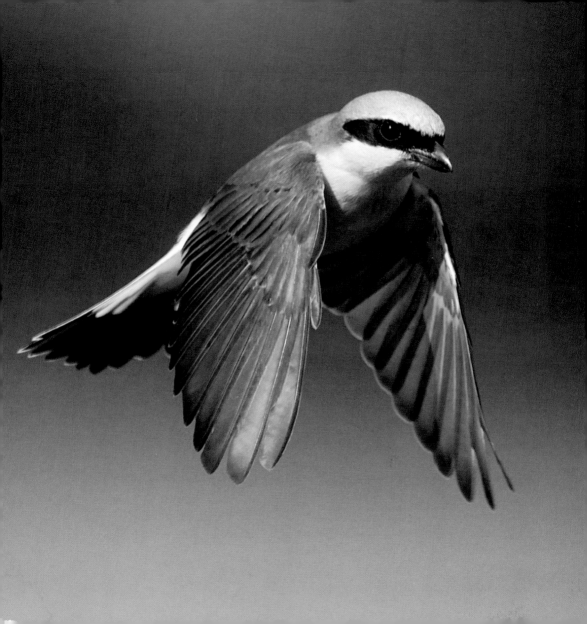

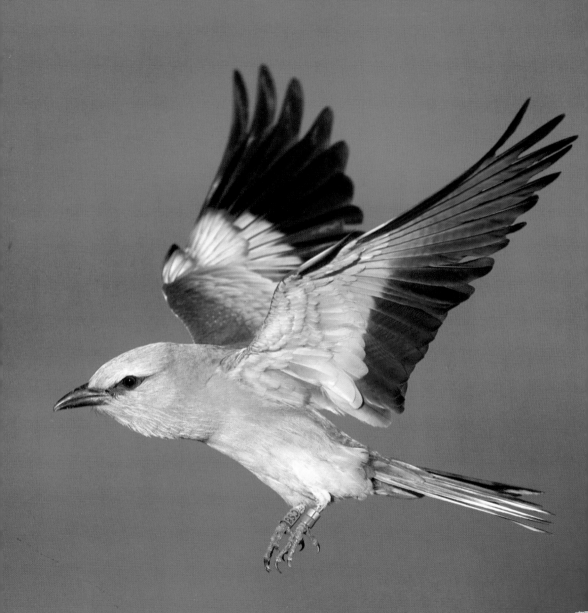

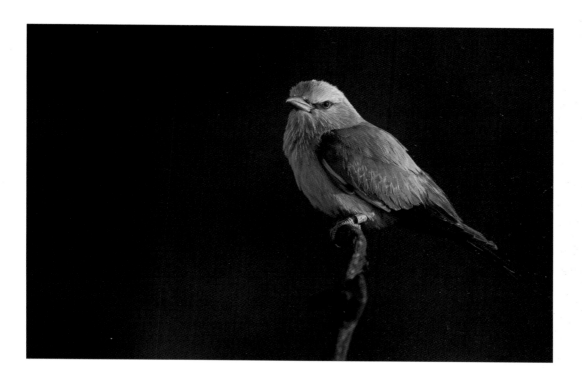

European Roller

Coracias garrulus

One of the most charismatic birds found in the puzsta. The beautiful metallic blue shine of its plumage is best seen when the bird is in flight.

Rollers nest in tree holes and in nest boxes. They are versatile hunters, preying on insects, lizards, snakes and small rodents.

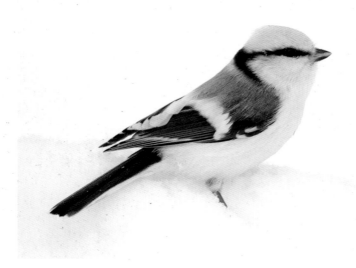

Azure Tit

Cyanistes cyanus

In this final section we return to Finland with a selection of my favourite pictures from recent years. Even though it is fittingly sporting the colours of the Finnish flag, the Azure Tit is a rare visitor from the south-east.

Black-throated Diver

Gavia arctica

This beautiful waterbird is, on the one hand, quite primitive-looking, like something from pre-historic times, yet at the same time it is exquisitely stylish.

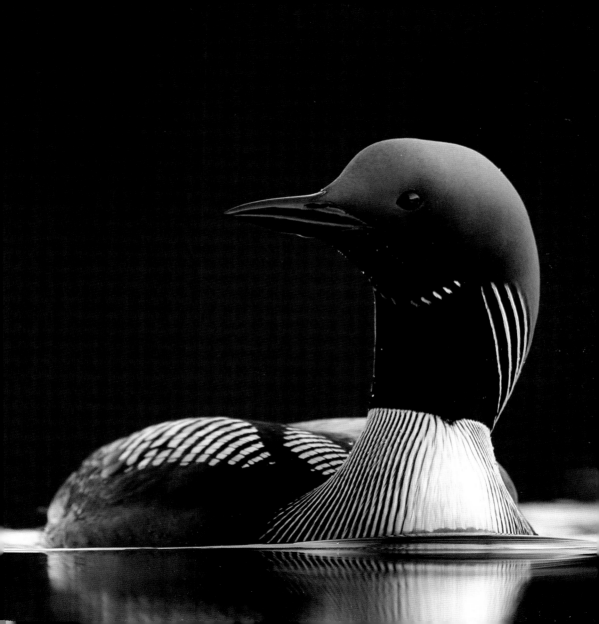

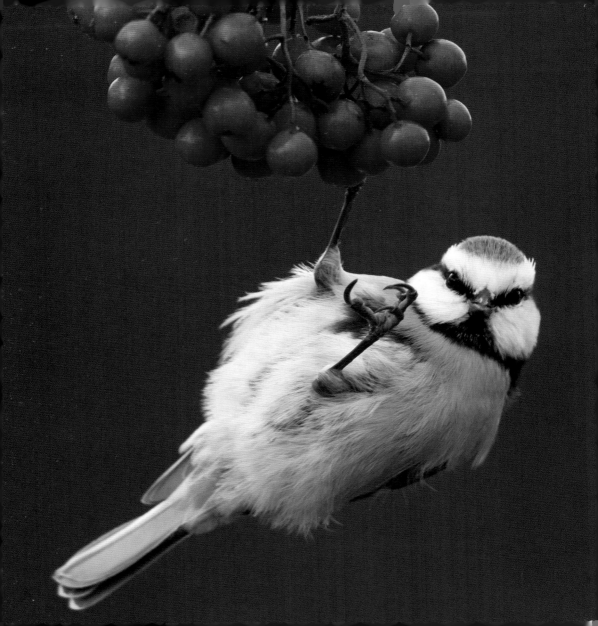

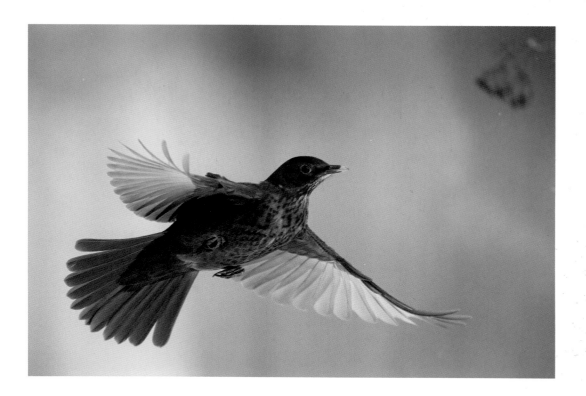

Blue Tit

Cyanistes caeruleus

Generally insectivorous in the summer and a
seed-eater in the winter, the Blue Tit occasionally
feasts on rowan berries.

Common Blackbird

Turdus merula

When the rowan crop is especially plentiful, thrushes
and waxwings winter in Finland in large numbers,
staying until the berries are finished.

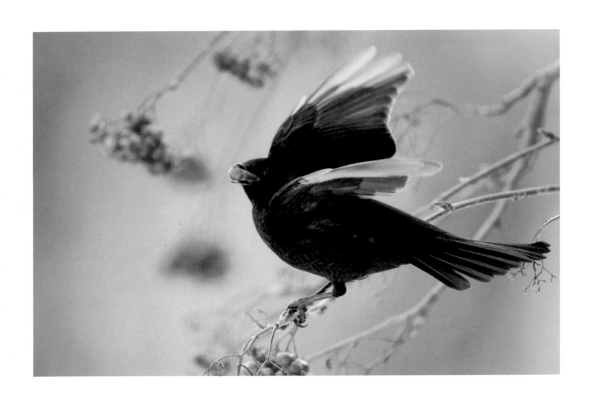

Like other thrushes, the blackbird eats the berries either perching on a branch or hanging from it. When the last of the branches have been gleaned, they pick the berries in flight, hovering at the thin branch-tips.

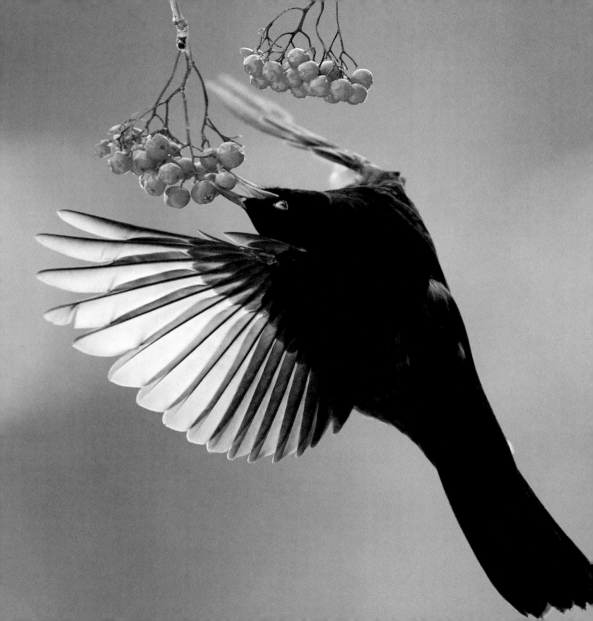

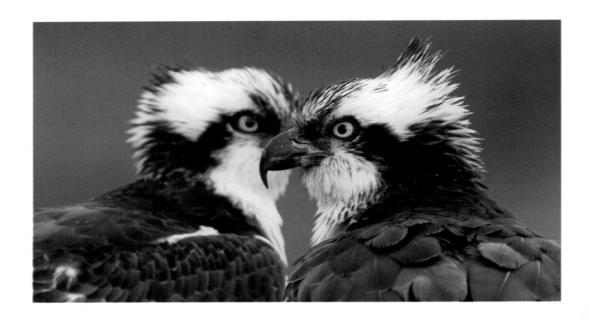

Osprey

Pandion haliaetus

Quite often I have a picture in mind of the type of photo I want to take before setting out, but just as often, a good opportunity presents itself by surprise. The moment this pair of Ospreys settled in this position, where they created a mirror image of each other, was unexpected but most inspirational to the photographer.

Common Chaffinch

Fringilla coelebs

Despite the technological advances in camera and lens equipment in the past 10 years, it's still really difficult to capture a small bird in flight. It takes many attempts and countless repetitions, but eventually there is enough material to choose from and get one good result, which is ample reward.

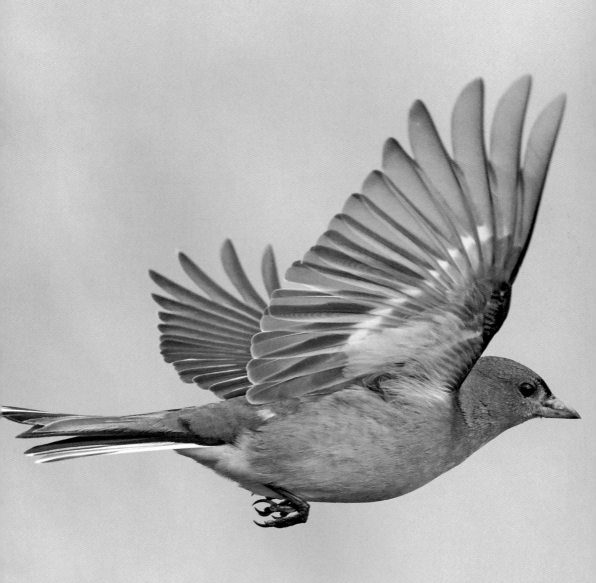

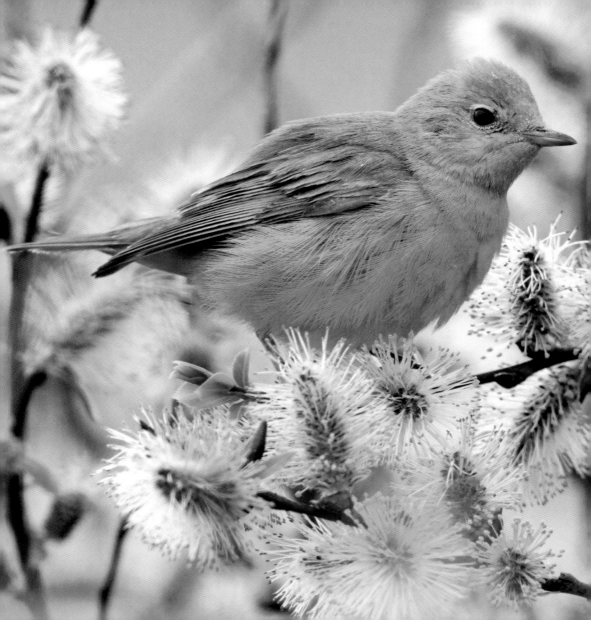

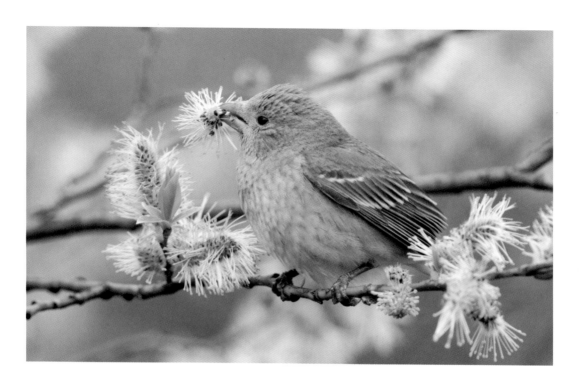

Garden Warbler

Sylvia borin

Common Rosefinch

Carpodacus erythrinus

Most of the songbirds that migrate to Africa or southern Asia for the winter don't return to Finland before early May. At that time the willows blossom, which attracts insects, which in turn attracts birds to feed on the insects. Many birds also like the juicy blossoms. Darting busily inside a willow amongst the blossoming buds the birds develop an odd yellow coat as their feathers collect pollen.

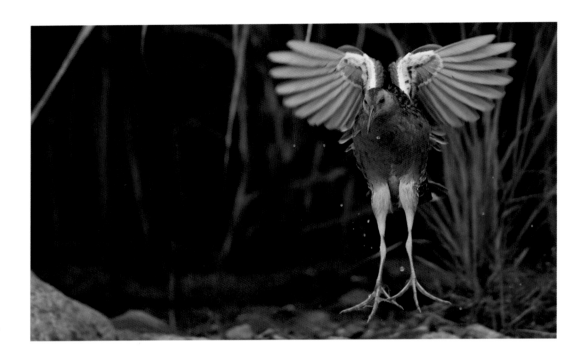

Water Rail

Rallus aquaticus

These birds lead secretive lives inside reedbeds, although occasionally they will emerge into the outside world. For several days in a row this individual came out to bathe in a small puddle along an open stretch of shore. It was incredibly skittish, bordering on paranoid, startled by its own shadow and constantly flying back to the safety of the reeds.

Lesser Spotted Woodpecker

Dendrocopos minor

In the autumn, this tiny woodpecker can be seen tapping on thistles, reeds and bulrushes while foraging for insects.

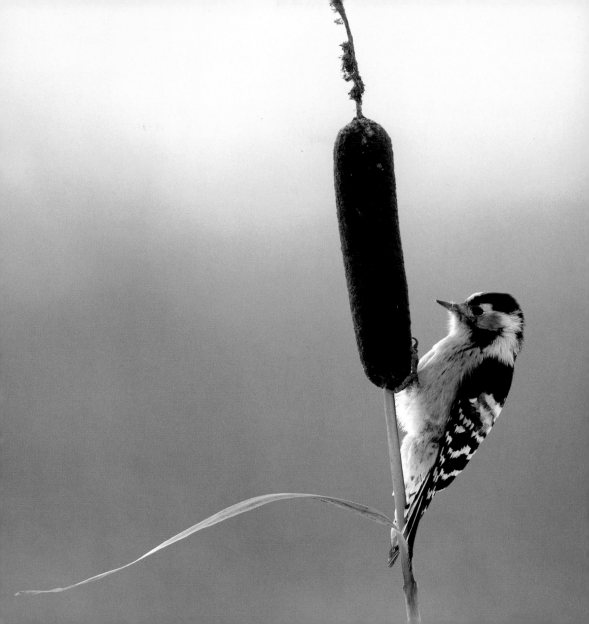

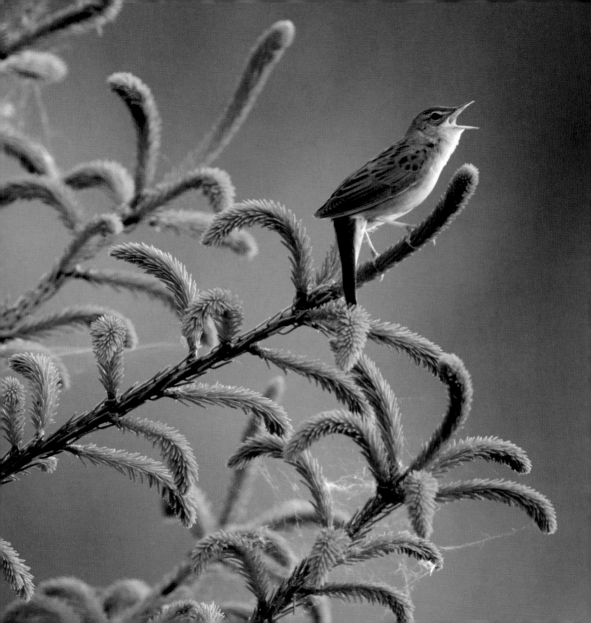

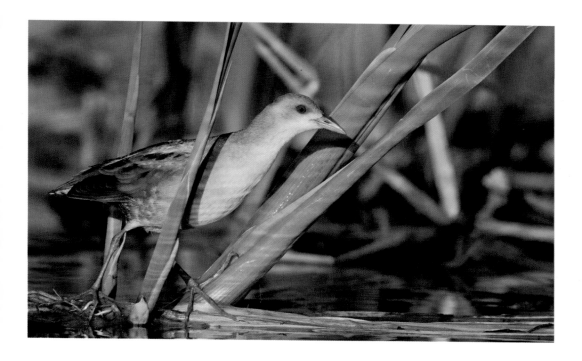

Common Grasshopper Warbler

Locustella naevia

Grasshopper warblers are usually masters of the art of concealment, singing at night and from the cover of vegetation. However, sometimes in the light northern summer nights, the occasional bird ventures out to sing in the open.

Little Crake

Porzana parva

These small birds are relatively easy to hear as they sing in the evening and at night. They are usually hidden in the vegetation, but with luck can be glimpsed as they weave through the grasses and reeds looking for food.

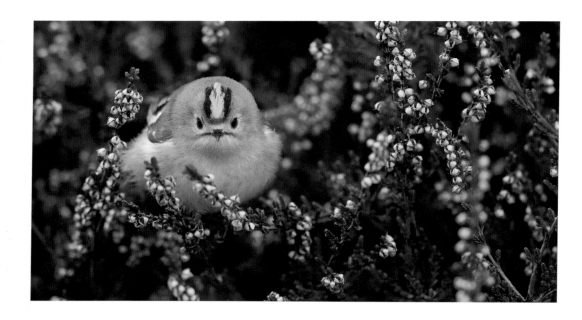

Goldcrest

Regulus regulus

The Finnish coastline is broken into thousands of
islands. The outermost islands, between Finland
and Sweden, often teem with migrating birds during
September and October. One of the most common
is the Goldcrest, which forages for insects in heather,
juniper and other low-growing shrubs on these
rocky, mostly treeless islands.

Eurasian Dotterel

Charadrius morinellus

Up in the Arctic hills in Lapland it's not uncommon
for the temperature to dip below zero even on a
summer's night. After a couple of cold nights, the
blueberry leaves start to resemble their autumn
versions, and a resting dotterel blends in well with
this background.

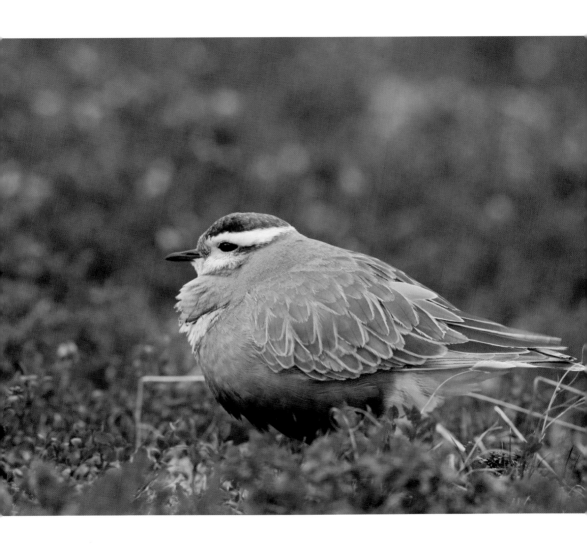

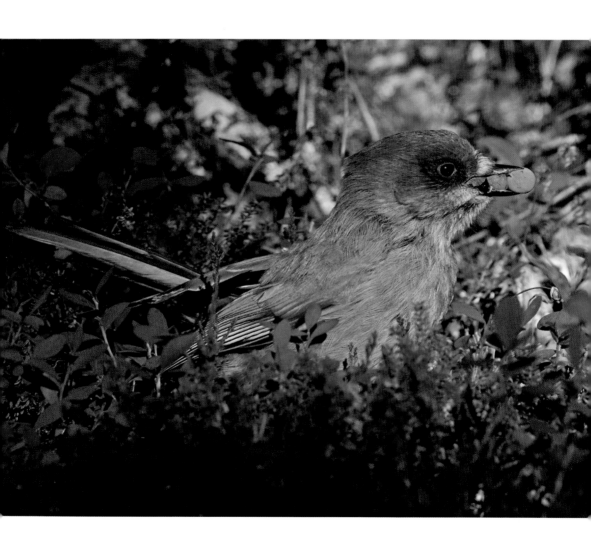

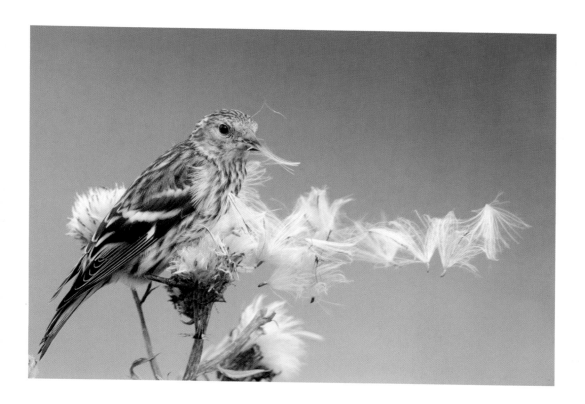

Siberian Jay

Perisoreus infaustus

These fearless little corvids make excellent subjects for photography, and in this image the bog bilberries in the bird's bill give added colour and interest.

Eurasian Siskin

Spinus spinus

Seeds coming loose from the thistle latch onto each other and form a delightful seed chain blowing in the wind.

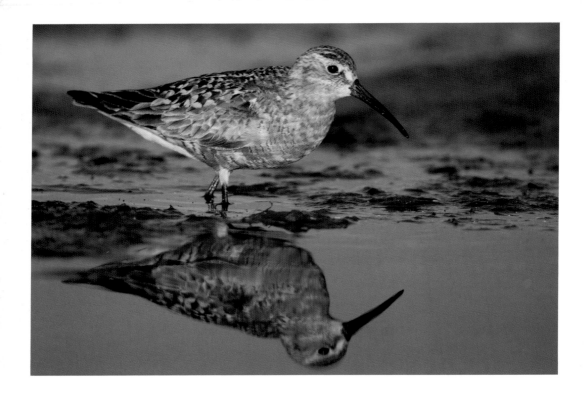

Curlew Sandpiper

Calidris ferruginea

Wind conditions play an important role in
photography, either working for you or against you.
Here a moulting adult Curlew Sandpiper stands in
attractive late evening light, in calm water with not a
ripple of wind that could ruin a perfect reflection.

Sand Martin

Riparia riparia

In this case the strong headwind worked in favour
of the photographer, causing the martin to struggle
and fly slower as it was hunting over the water,
and making an otherwise almost impossible object
trackable with the camera.

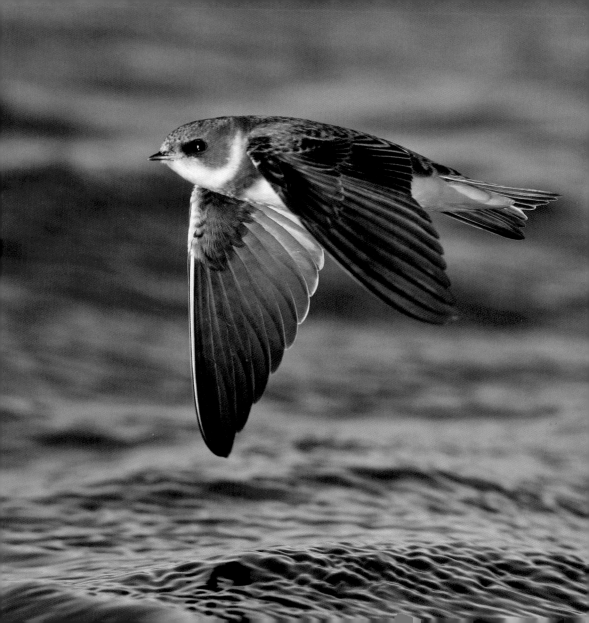

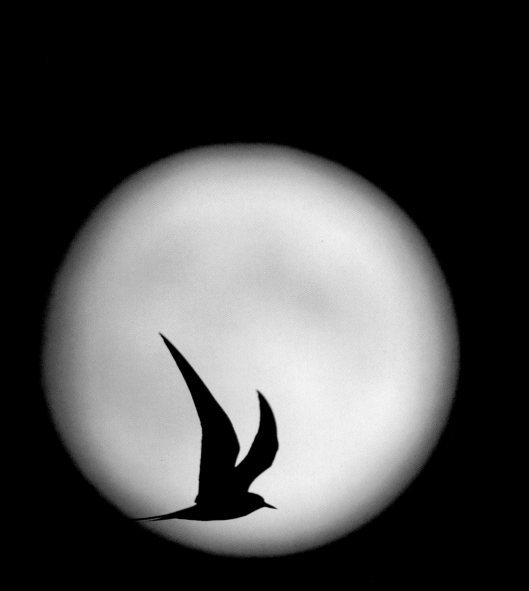

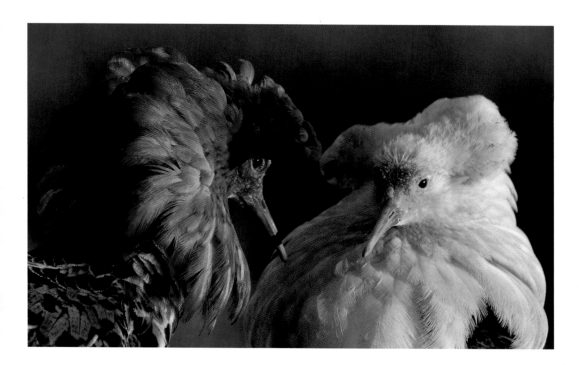

Arctic Tern

Sterna paradisaea

To take this picture, I needed the moon to be at
a suitable height, quite low, lots of Arctic Terns
flying, again at a suitable height, a couple of
evenings to waste, and an ounce of luck.

Ruff

Philomachus pugnax

Every male in breeding plumage has a unique pattern
and feathering around its head and chest. Ruffs have a
special group display, where they try to out-do each other
in the size and finery of their breeding plumage: if neither
surrenders, a fight determines who is the mightier.

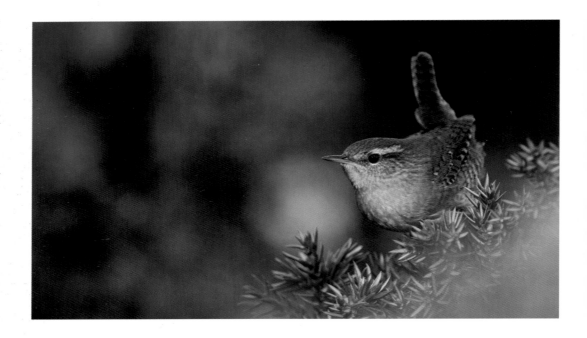

Eurasian Wren

Troglodytes troglodytes

This tiny bird usually betrays its presence with
its characteristic rattling, churring call. It likes
to stay inside junipers but every once in a while
comes out to perch on top of the bush, with tail
cocked, to observe its surroundings, before quickly
disappearing into the next bush.

Wood Sandpiper

Tringa glareola

If food is plentiful, these sandpipers can stop for a
bit longer before continuing on their migration, and
each claims a short stretch of shore as a territory.
Defending one's spot can cause fierce fights among
the birds, even when there is plenty of room and
food for all.

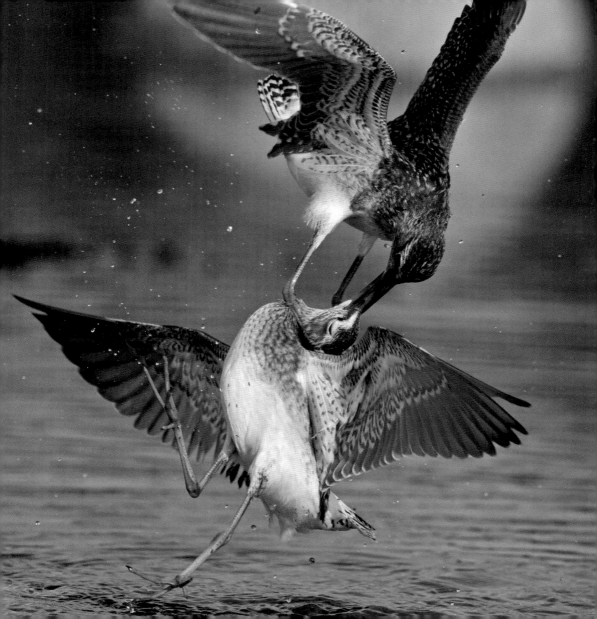

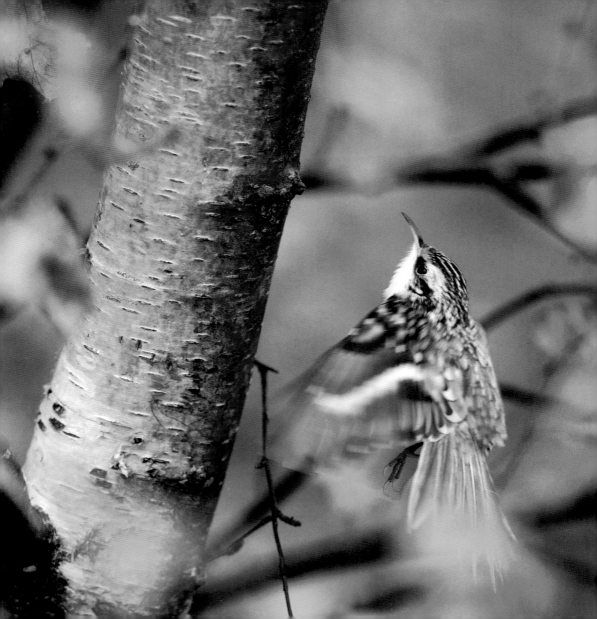

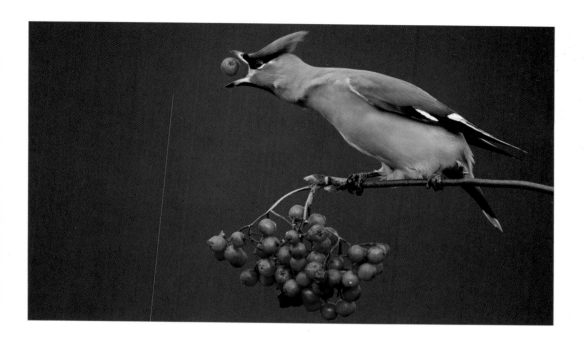

Common Treecreeper

Certhia familiaris

A treecreeper resembles a mouse more than a bird as it climbs a tree looking for food. Its plumage serves it well in the forest, being similar in colour to bark and enabling the bird to hide in plain sight.

Bohemian Waxwing

Bombycilla garrulus

A waxwing carefully snaps a berry from the cluster using its bill. Sometimes it misses the rounded food item, but quickly retrieves it. When berry numbers start to dwindle, there can be several birds hanging on the same branch. As long as there is food, the extreme cold is not a problem, not even low temperatures such as the −35°C in the image on page 373.

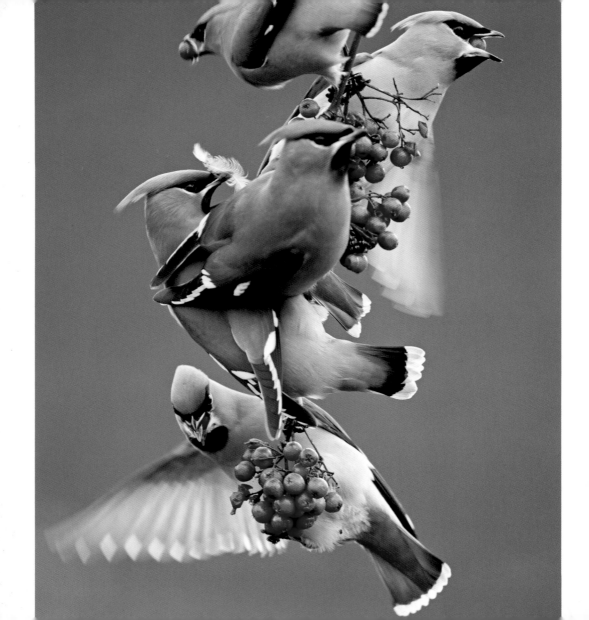

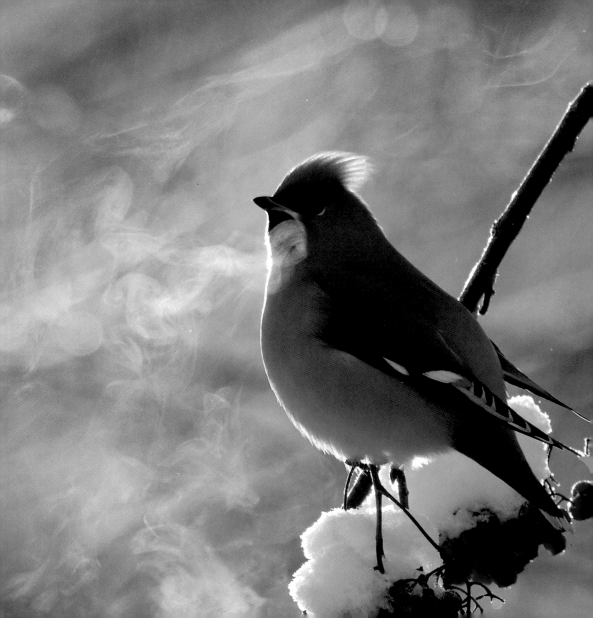

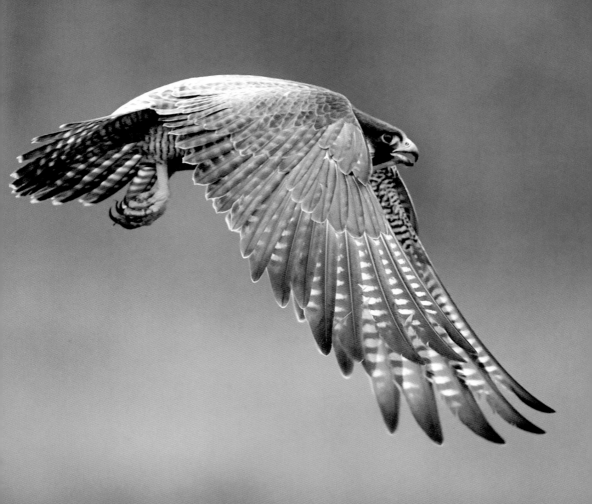

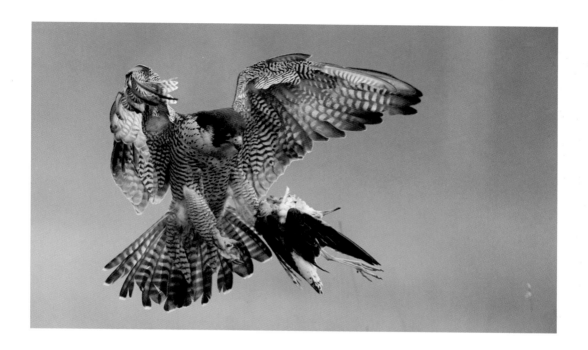

Peregrine Falcon

Falco peregrinus

In Finland this large falcon breeds mostly on large, wet and hard-to-access open bogs.

In the 1960s and 1970s environmental toxins nearly wiped out the entire population, but now Finland has about 300 pairs and rising.

European Robin

Erithacus rubecula

I fed this bird some worms and woodlice and in a couple of days we were at ease with each other. The robin allowed me to climb a tree close to where it was perching and photograph it freely.

[OVERLEAF]

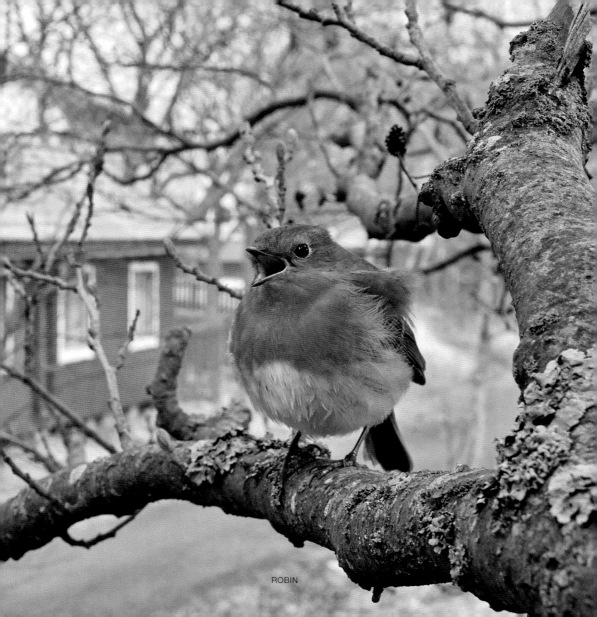

ROBIN

Image details

Images listed by page number. All photographs are taken with a Canon EOS camera and Canon lenses.

1 Grey Heron, 1D X, 200–400mm + 1.4X (560mm), f9, 1/250s, ISO 2500, May 2016.
2–3 Red-crowned Crane, 1D X, 600mm, f5, 1/250s, ISO 1000, February 2014.
4 Great Cormorant, 1D X, 500mm + 1.4X, f5.6, 1/3200s, ISO 3200, September 2012.
6 Common Raven, 1D X, 500mm + 1.4X, f7.1, 1/2000s, ISO 2000, March 2013.
8 Ural Owl, 1D Mark IV, 800mm + 1.4X, f10, 1/50s, ISO 200 February 2012.
9 Ural Owl, 5DS R, 600mm + 2X, f8, 1/1000s, ISO 2000, February 2016.
10 Eurasian Pygmy Owl, 1D X, 500mm, f9, 1/25s, ISO 1000, January 2013.
11 Eurasian Pygmy Owl, 1D X Mark II, 600mm, f5, 1/200s, ISO 1600, February 2016.
12 Eurasian Pygmy Owl, 1D X, 400mm, f3.5, 1/400s, ISO 5000, February 2016.
13 Eurasian Pygmy Owl, 1D X Mark II, 400mm, f11, 1/4000s, ISO 12800, February 2016.
14 Eurasian Pygmy Owl, 1D X Mark II, 400mm, f8, 1/5000s, ISO 12800, February 2016.
15 Eurasian Pygmy Owl, 1D X Mark II, 600mm, f8, 1/320s, ISO 2500, February 2016.
16 Northern Hawk Owl, 1D X, 400mm, f5, 1/4000s, ISO 5000, February 2016.
17 Northern Hawk Owl, 1D X, 70–200mm (200mm), f2.8, 1/4000s, ISO 6400, February 2016.
18 Northern Hawk Owl, 1D X Mark II, 400mm, f7.1, 1/5000s, ISO 6400, February 2016.
19 Northern Hawk Owl, 1D X, 600mm + 2X, f8, 1/250s, ISO 1250, February 2016.
20 Northern Hawk Owl, 1D X, 400mm, f5.6, 1/5000s, ISO 5000, February 2016.
21 Northern Hawk Owl, 1D X Mark II, 400mm, f11, 1/5000s ISO 5000, February 2016.
22 Snowy Owl, 1D X, 70–200mm (200mm), f5.6, 1/3200s, ISO 3200, February 2016.
23 Snowy Owl, 5DS R, 600mm + 1.4X, f14, 1/1250s, ISO 500, February 2016.
24 Snowy Owl, 5DS R, 600mm + 2X, f16, 1/800s, ISO 500, February 2016.
25 Snowy Owl, 1D X, 600mm, f6.3, 1/3200s, ISO 500, February 2016.
26 Snowy Owl, 1D X, 600mm + 1.4X, f5.6, 1/160s, ISO 2000, February 2016.
27 Snowy Owl, 1D X, 600mm + 2X, f10, 1/2000s, ISO 800, February 2016.

28–29 Snowy Owl, 1D X, 600mm, f11, 1/500s, ISO 2000, February 2016.
30 above Snowy Owl, 1D X, 600mm, f13, 1/4000s, ISO 3200, February 2016.
30 below Snowy Owl, 1D X, 600mm, f11, 1/4000s, ISO 3200 February 2016.
31 Snowy Owl, 1D X, 70–200mm + 1.4X (280mm), f10, 1/4000s, ISO 2000, February 2016.
32–33 Snowy Owl, 1D X, 600mm, f6.3, 1/4000s, ISO 3200, February 2016.
34 Snowy Owl, 1D X, 600mm + 2X, f13, 1/200s, ISO 250, February 2016.
35 Snowy Owl, 5DS R, 600mm + 2X, f10, 1/1000s, ISO 1250, February 2016.
36–37 Snowy Owl, 1D X, 70–200mm + 1.4X (280mm), f9, 1/4000s, ISO 2000, February 2016.
38 Great Grey Owl, 1D X, 400mm, f5, 1/200s, ISO 1600, March 2015.
39 Great Grey Owl, 1D X, 400mm, f5, 1/2500s, ISO 2500, March 2015.
40 Great Grey Owl, 1D X, 400mm, f4.5, 1/3200s, ISO 2500, March 2015.
41 Great Grey Owl, 1D X, 400mm, f2.8, 1/3200s, ISO 2000, March 2015.
42–43 Great Grey Owl, 1D X, 24–70mm (70mm), f5.6, 1/2000s, ISO 3200, March 2015.
44 Great Grey Owl, 1D X, 600mm + 2X, f20, 1/200s, ISO 2000, February 2015.
45 Great Grey Owl, B&W, 1D X, 400mm, f11, 1/2500s, ISO 2500, March 2015.
46–47 Great Grey Owl, B&W, 1D X, 400mm, f11, 1/2500s, ISO 2500, March 2015.
48–49 Great Grey Owl, 1D X, 400mm, f4, 1/2500s, ISO 3200, March 2015.
50 Great Grey Owl, 1D X, 200–400mm + 1.4X (560mm), f5.6, 1/250s, ISO 1600, June 2015.
51 Great Grey Owl, 1D X, 400mm, f2.8, 1/1250s, ISO 2000, June 2015.
52 Rock Ptarmigan, 1D X, 500mm, f4, 1/200s, ISO 640, June 2014.
53 Rock Ptarmigan, 1D Mark II, 300mm, f4, 1/500s, ISO 100, June 2004.
54 Rock Ptarmigan, 1D X, 400mm, f4, 1/3200s, ISO 2500, September 2014.
55 Rock Ptarmigan, 1D X, 70–200mm (200mm), f6.3, 1/800s, ISO 1250, June 2014.
56–57 Rock Ptarmigan, 1D X, 200–400mm + 1.4X (560mm), f9, 1/125s, ISO 2000, September 2014.

58–59 Rock Ptarmigan, 1D X, 600mm + 1.4X, f8, 1/500s, ISO 800, April 2013.
60–61 Rock Ptarmigan, 1D X, 600mm, f20, 1/125s, ISO 125, February 2015.
62 Rock Ptarmigan, 1D X, 70–200mm (200mm), f18, 1/400s, ISO 250, February 2015.
63 Rock Ptarmigan, 1D X, 600mm, f8, 1/5000s, ISO 1250, April 2013.
64 Rock Ptarmigan, 1D X, 600mm + 2X, f8, 1/2500s, ISO 500, April 2013.
65 Rock Ptarmigan, 1D X, 70–200mm (200mm), f5.6, 1/640s, ISO 1250, February 2015.
66 Rock Ptarmigan, 1D X, 600mm + 1.4X, f14, 1/400s, ISO 200, April 2013.
67 Rock Ptarmigan, 1D X, 600mm, f5.6, 1/4000s, ISO 1250, April 2014.
68–69 Black Grouse, 1D X, 400mm, f3.2, 1/2500s, ISO 3200, February 2014.
70 Black Grouse, 1D X, 70–200mm + 1.4X (280mm), f4, 1/250s, ISO 2500, January 2015.
71 Black Grouse, 1D X, 600mm + 2X, f8, 1/200s, ISO 2500, May 2014.
72–73 Black Grouse, 1D X, 200–400mm + 1.4X (560mm), f4, 1/2500s, ISO 3200, April 2014.
74 Black Grouse, 1D X, 600mm + 1.4X, f5.6, 1/2500s, ISO 800, March 2014.
75 Black Grouse, 1D X, 400mm, f5, 1/3200s, ISO 3200, April 2015.
76 Black Grouse, 1D X, 400mm, f6.3, 1/3200s, ISO 3200, April 2015.
77 Black Grouse, 1D X, 600mm, f5, 1/3200s, ISO 3200, April 2015.
78–79 Black Grouse, 1D X, 70–200mm (105mm), f5.6, 1/125s, ISO 500, May 2014.
80 Black Grouse, 1D X, 600mm + 1.4X, f10, 1/40s, ISO 3200, May 2014.
81 Black Grouse, 1D X, 600mm + 1.4X, f5.6, 1/500s, ISO 2000, May 2014.
82 Black Grouse, 1D X, 70–200mm + 1.4X (266mm), f5, 1/1600s, ISO 1600, June 2014.
83 Black Grouse, 1D X, 200–400mm + 2X (718mm), f10, 1/400s, ISO 1600, June 2014.
84 Willow Grouse, 1D X, 500mm, f14, 1/1000s, ISO 2000, September 2014.
85 Willow Grouse, 1D X, 500mm, f4, 1/3200s, ISO 4000, September 2014.

176 below King Eider, 1D X, 500mm, f7.1, 1/500s, ISO 1600, March 2013.

177 King Eider, 1D X, 500mm + 1.4X, f10, 1/2000s, ISO 1000, February 2013.

178 Long-tailed Duck, 1D X, 600mm, f4, 1/320s, ISO 4000 March, 2013.

179 Long-tailed Duck, 1D X, 600mm, f4, 1/1250s, ISO 1600, March 2013.

180 Long-tailed Duck, 1D X, 500mm + 1.4X, f5.6, 1/640s, ISO 2500, February 2013.

181 Long-tailed Duck, 1D X, 600mm, f4, 1/3200s, ISO 2000, March 2013.

182 Long-tailed Duck, 1D X, 600mm, f5, 1/640s, ISO 2000, March 2013.

183 Long-tailed Duck, 1D X, 600mm + 1.4X, f7.1, 1/2500s, ISO 1000, February 2013.

184–185 Long-tailed Duck, 1D X, 600mm, f4, 1/5000s, ISO 1250, March 2013.

186 Steller's Eider, 1D X, 500mm + 1.4X, f5.6, 1/500s, ISO 2500, February 2013.

187 Steller's Eider, 1D X, 500mm + 1.4X, f6.3, 1/2500s, ISO 800, March 2013.

188–189 Steller's Eider, 1D X, 500mm + 2X, f8, 1/2000s, ISO 1600, March 2013.

190–191 Steller's Eider, 1D X, 500mm + 1.4X, f8, 1/3200s, ISO 2000, March 2013.

192 Golden Eagle, 1D X, 400mm, f2.8, 1/3200s, ISO 2000, March 2016.

193 Golden Eagle, 1D X, 600mm + 2X, f14, 1/320s, ISO 1250, November 2013.

194–195 Golden Eagle and Black-billed Magpie, 1D X, 200–400mm (381mm), f4, 1/1000s, ISO 1600, March 2016.

196 Golden Eagle, 1D X, 400mm, f7.1, 1/3200s, ISO 800, March 2016.

197 Golden Eagle, 1D X, 200–400mm + 1.4X (560mm), f6.3, 1/3200, ISO 800, March 2016.

198 Golden Eagle and White-tailed Eagle, 1D X, 300mm, f2.8, 1/1250s, ISO 2000, January 2013.

199 Golden Eagle and White-tailed Eagle, 1D X, 300mm, f2.8, 1/1250s, ISO 2000, January 2013.

200 White-tailed Eagle, 1D X, 400mm, f2.8, 1/2000s, ISO 1600, November 2013.

201 White-tailed Eagle, M, 500mm + 2X, f8, 1/160s, ISO 800, January 2013.

202 White-tailed Eagle, 1D X, 400mm, f3.5, 1/3200s, ISO 1600, November 2013.

203 White-tailed Eagle, 1D X, 200–400mm, f13, 1/4000s, ISO 2500, October 2014.

204 White-tailed Eagle, 1D X, 400mm, f5, 1/2500s, ISO 2500, November 2013.

205 White-tailed Eagle, 1D X, 70–200mm (200mm), f2.8, 1/400s, ISO 5000, November 2013.

206–207 White-tailed Eagle, 1D X, 200–400mm + 1.4X (560mm), f5.6, 1/800s, ISO 3200, October 2014.

208 Great Snipe, 1D X, 400mm, f2.8, 1/1600s, ISO 6400, June 2013.

209 Great Snipe, 1D X, 600mm, f4, 1/1000s, ISO 2000, June 2013.

210–211 Great Snipe, 1D X, 70–200mm (135mm), f10, 1/50s, ISO 1600, June 2013.

212 Great Snipe, 1D X, 400mm + 2X, f5.6, 1/60s, ISO 3200, June 2013.

213 Great Snipe, 1D X, 600mm + 1.4X, f5.6, 1/800s, ISO 1250, June 2013.

214 Great Snipe, 1D X, 600mm, f4, 1/500s, ISO 1600, June 2013.

215 Great Snipe, 1D X, 600mm, f4, 1/1000s, ISO 1250, June 2013.

216 Great Snipe, 1D X, 400mm, f2.8, 1/1600s, ISO 5000, June 2013.

217 Great Snipe, 1D X, 400mm, f4, 1/80s, ISO 12800, June 2013.

218 Brünnich's Guillemot, 1Ds Mark III, 800mm + 1.4X, f18, 1/100s, ISO 500, April 2009.

219 Brünnich's Guillemot, 1D X, 600mm, f5, 1/3200s, ISO 1600, March 2013.

220 Glaucous Gull, 1D X, 500mm, f4, 1/2000s, ISO 2500, March 2016.

221 Great Black-backed Gull, 1D X, 500mm + 1.4X, f10, 1/2500s, ISO 1250, March 2013.

222 Common Guillemot, 1D X, 500mm, f4, 1/1600s, ISO 2000, March 2013.

223 Common Guillemot, 1D X, 600mm, f6.3, 1/3200s, ISO 1600, March 2013.

224–225 Common Guillemot, 1D X, 500mm, f16, 1/4s, ISO 100, March 2016.

226 Common Guillemot, 1D X, 600mm, f4, 1/4000s, ISO 1600, March 2013.

227 Common Guillemot, 1D X, 500mm, f4, 1/2000s, ISO 2500, March 2016.

228–229 Common Guillemot, 1D X, 70–200mm (102mm), f3.2, 1/1250s, ISO 1250, March 2013.

230 Gyr Falcon, 1D X, 500mm + 1.4x, f5.6, 1/1000s, ISO 2000, March 2013.

231 Gyr Falcon, 1D X, 500mm + 1.4x, f5.6, 1/2000s, ISO 1600, March 2013.

232 Herring Gull, 1D X, 600mm, f4, 1/3200s, ISO 1250, March 2013.

233 Herring Gull, 1D X, 500mm + 1.4X, f5.6, 1/2000s, ISO 2000, March 2013.

234–235 Black-legged Kittiwake, 1D X, 70–200mm (200mm), f4, 1/1250s, ISO 2500, March 2013.

236 Common Raven, 1D X, 600mm, f4, 1/2500s ISO 1600, March 2013.

237 Common Raven, 1D X, 500mm, f4, 1/1000s, ISO 1600, March 2013.

238 Razorbill, 1D X, 500mm, f11, 1/2500s, ISO 1250, April 2009.

239 Razorbill, 1D X, 500mm, f13, 1/2000s, ISO 1600, April 2009.

240 European Shag, 1D X, 500mm, f4, 1/1600s, ISO 1250, March 2016.

241 European Shag, 600mm, f4, 1/1250s, ISO 1600, March 2013.

242 European Shag, 1D X, 500mm, f7.1, 1/8000s, ISO 4000, March 2013.

243 European Shag, 1D X, 600mm + 2X, f8, 1/320s, ISO 800, March 2013.

244 Black Guillemot, 1D X, 200–400mm + 2X, (619mm), f9, 1/160s, ISO 1600, July 2014.

245 Black Guillemot, 1D X, 200–400mm + 1.4X (442mm), f8, 1/150s, ISO 640, July 2014.

246–247 Northern Gannet, 1D X, 24–70mm, (70mm), f13, 1/100s, ISO 1600, July 2014.

248 Northern Gannet, 1D X, 500mm, f7.1, 1/5000s ISO 2000, July 2014.

249 Northern Gannet, 1D X, 24–70mm (70mm), f6.5, 1/2500s, ISO 2000, July 2014.

250 Northern Gannet, 1D X, 500mm, f7.1, 1/500s, ISO 500, July 2014.

251 Northern Gannet, 1D X, 24–70mm (70mm), f11, 1/1600s, ISO 2000, July 2014.

252–253 Northern Gannet, 1D X, 24–70mm (31mm), f10, 1/2500s, ISO 2000, July 2014.

254 Great Skua, 1D X, 70–200mm (70mm), f13, 1/1000s, ISO 800, July 2014.

255 Great Skua, 1D X, 500mm, f10, 1/320s, ISO 1600, July 2014.

256 Great Skua, 1D X, 500mm + 2X, f20, 1/160s, ISO 1600, July 2014.

257 Great Skua, 1D X, 24–70mm (24mm), f8, 1/1000s, ISO 2000, July 2014.

258 Merlin, 1D X, 500mm + 2X, f8, 1/800s, ISO 800, July 2014.

259 Merlin, 1D X, 200–400mm + 1.4X (560mm), f7.1, 1/1000s, ISO 1600, July 2014.

260 Atlantic Puffin, 1D X, 24–70mm (35mm), f20, 1/250s, ISO 200, July 2014.

261 Atlantic Puffin, 1D X, 24–70mm (24mm), f2.8, 1/250s, ISO 200, July 2014.

262 Red-throated Diver, 1D X, 500mm, f5, 1/3200s, ISO 2000, July 2014.

263 Red-throated Diver, 1D X, 500mm + 2X, f14, 1/800s, ISO 1250, July 2014.

264 Red-crowned Crane, 1D X, 600mm, f8, 1/2500s, ISO 500, February 2014.

265 Red-crowned Crane, 1D X, 600mm + 1.4X, f5.6, 1/1250s, ISO 1250, February 2014.

266 Red-crowned Crane, 1D X, 600mm, f4, 1/1600s, ISO 200, February 2014.

267 Red-crowned Crane, 1D X, 600mm, f5.6, 1/1600s, ISO 1250, February 2014.

268 Red-crowned Crane, 1D X, 600mm + 1.4X, f6.3, 1/1600s, ISO 1250, February 2014.

269 Red-crowned Crane, 1D X, 70–200mm (70mm), f5, 1/250s, ISO 200, February 2014.

270–271 Red-crowned Crane and Whooper Swan, 1D X, 600mm, f5, 1/1250s, ISO 1000, February 2014.

272 Red-crowned Crane, 1D X, 600mm + 2X, f10, 1/2000s, ISO 640, February 2014.

273 Red-crowned Crane, 1D X, 600mm + 2X, f10, 1/2000s, ISO 800, February 2014.

274 Red-crowned Crane, 1D X, 200–400mm (400mm), f4, 1/2000s, ISO 800, February 2014.

275 Red-crowned Crane, 1D X, 600mm, f11, 1/5000s, ISO 800, February 2014.

276 Red-crowned Crane, 1D X, 600mm, f4, 1/1000s, ISO 1600, February 2014.

277 Red-crowned Crane, 1D X, 70–200mm (70mm), f2.8, 1/160s, ISO 5000, February 2014.

278 Steller's Sea Eagle, 1D X, 70–200mm (200mm), f11, 1/3200s, ISO 800, February 2014.

279 Steller's Sea Eagle, 1D X, 600mm + 2X, f18, 1/640s, ISO 1000, February 2014.

280 Steller's Sea Eagle, 1D X, 70–200mm (200mm), f8, 1/3200s, ISO 800, February 2014.

281 Steller's Sea Eagle, 1D X, 200–400mm (300mm), f8, 1/4000s, ISO 500, February 2014.

282–283 Steller's Sea Eagle and White-tailed Eagle, 1D X, 70–200mm (70mm), f18, 1/2000s, ISO 800, February 2014.

284 Steller's Sea Eagle, 1D X, 200–400mm (262mm), f11, 1/3200s, ISO 1250, February 2014.

285 Steller's Sea Eagle, 1D X, 200–400mm (270mm), f6.3, 1/3200s, ISO 800, February 2014.

286–287 Steller's Sea Eagle, 1D X, 600mm + 1.4X, f6.3, 1/3200s, ISO 800, February 2014.

288 Steller's Sea Eagle and White-tailed Eagle, 1D X, 200–400mm (334mm), f9, 1/3200s, ISO 1250, February 2014.

289 Steller's Sea Eagle, 1D X, 200–400mm + 1.4X (560mm), f8, 1/2500s, ISO 500, January 2014.

290–291 Steller's Sea Eagle, 1D X, 600mm, f4.5, 1/3200s, ISO 1250, February 2014.

292–293 White-tailed Eagle, 1D X, 200–400mm (280mm), f20, 1/1000s, ISO 1000, February 2014.

294 White-tailed Eagle, 1D X, 600mm + 2X, f16, 1/800s, ISO 1000, February 2014.

295 White-tailed Eagle, 1D X, 200–400mm (250mm), f8, 1/3200s, ISO 800, February 2014.

296 White-tailed Eagle, 1D X, 600mm, f5.6, 1/2500s, ISO 2000, February 2014.

297 White-tailed Eagle and Red-crowned Crane, 1D X, 600mm, f5.6, 1/2500s, ISO 2000, February 2014.

298–299 Whooper Swan, 1D X, 70–200mm (95mm), f13, 1/2000s, ISO 800, February 2014.

300 Whooper Swan, 1D X, 600mm, f5, 1/1250s, ISO 800, February 2014.

301 Whooper Swan, 1D X, 200–400mm (329mm), f8, 1/400s, ISO 200, February 2014.

302–303 Whooper Swan, 1D X, 70–200mm (70mm), f5.6, 1/250s, ISO 200, February 2014.

304 Great Cormorant, 1D X, 70–20mm (200mm), f2.8, 1/4000s, ISO 3200, January 2014.

305 Great Cormorant, 1D X, 70–200mm (200mm), f2.8, 1/1600s, ISO 3200, January 2014.

306 Great Cormorant, 1D X, 70–200mm (200mm), f2.8, 1/1600s, ISO 3200, January 2014.

307 Great Cormorant, 1D X, 70–200mm (200mm), f4, 1/1250s, ISO 2500, January 2014.

308–309 Great Cormorant and Great White Egret, 1D X, 70–200mm (85mm), f3.2, 1/3200s, ISO 3200, January 2014.

310 Great White Egret, 1D X, 600mm, f4, 1/1600s, ISO 4000, January 2014.

311 Great White Egret, 1D X, 200–400mm + 1.4X (560mm), f5.6, 1/125s, ISO 1600, January 2014.

312 Great White Egret, 1D X, 70–200mm (70mm), f2.8, 1/1600s, ISO 3200, January 2014.

313 Great White Egret, 1D X, 70–200mm (85mm), f3.2, 1/2500s, ISO 3200, January 2014.

314 Great White Egret and Grey Heron, 1D X, 70–200mm (200mm), f4, 1/3200s, ISO 3200, January 2014.

315 Great White Egret and Grey Heron, 1D X, 70–200mm (200mm), f4, 1/3200s, ISO 3200, January 2014.

316 Great White Egret, 1D X, 70–200mm + 1.4X (280mm), f5.6, 1/2000s, ISO 3200, January 2014.

317 Great White Egret, 1D X, 200–400mm + 1.4X (519mm), f5.6, 1/500s, ISO 5000 January 2014.

318 Grey Heron, 1D X, 200–400mm (286mm), f4, 1/2000s, ISO 3200, January 2014.

319 Grey Heron, 1D X, 600 mm, f4, 1/250s, ISO 2000, January 2014.

320 Black Stork, 1D X, 400mm, f4, /1000s, ISO 1600, May 2016.

321 Black Stork, 1D X, 400mm + 2X, f5.6, 1/100s, ISO 2500, May 2016.

322 Little Egret and Black Stork legs, 1D X, 400mm, f3.5, 1/200, ISO 2000, May 2016.

323 Eurasian Spoonbill, 1D X, 200–400mm (400mm), f5.6, 1/4000s, ISO 1600, May 2016.

324 Eurasian Spoonbill, 1D X, 400mm, f3.5, 1/4000s, ISO 800, May 2016.

325 Eurasian Spoonbill, 1D X, 200–400mm (400mm), f11, 1/500s, ISO 1000, May 2016.

326 Pied Avocet, 1D X, 400mm, f6.3, 1/3200s, ISO 2000, May 2016.

327 Common Blackbird, 1D X, 400mm, f8, 1/30s, ISO 500, May 2016.

328 Green Woodpecker, 1D X, 400mm, f3.2, 1/1250s, ISO 1000, May 2016.

329 Common Cuckoo, 1D X, 400mm + 1.4X, f4, 1/1600s, ISO 2500, May 2016.

330 White tailed Eagle and Hooded Crow, 1D X, 200–400m + 1.4X (560mm), f5.6, 1/1000s, ISO 2500, January 2014.

331 Common Kingfisher, 1D X, 600mm + 2X, f16, 1/40s, ISO2000, January 2014.

332 Eurasian Jay, 1D X, 400mm, f4.5, 1/320s, ISO 1600, May 2016.

333 Hawfinch, 1D X, 200–400mm + 1.4X (560mm), f6.3, 1/160s, ISO 1600, May 2016.

334 Hoopoe, 1D X, 400mm, f3.5, 1/3200s, ISO 3200, May 2016.

335 Hoopoe, 1D X, 400mm, f5, 1/3200s, ISO 2000, May 2016.

336 Hoopoe, 1D X, 200–400mm (258mm), f5.6, 1/3200s, ISO 3200, May 2016.

337 Hoopoe, 1D X, 200–400mm (258mm), f5, 1/5312s, ISO 3200, May 2016.

338 Little Owl, 1D X, 400mm, f2.8, 1/3200s, ISO 6400, May 2016.

339 Little Egret, 1D X, 400mm, f2.8, 1/1000s, ISO 2500, May 2016.

340 Black-crowned Night Heron, 1D X, 400mm, f4, 1/3200s, ISO 1600, May 2016.

341 Common Moorhen, 1D X, 200–400mm (280mm), f5.6, 1/500s, ISO 1000, May 2016.

342 Red-backed Shrike, 1D X, 400mm + 1.4X, f6.3, 1/4000s, ISO 3200, May 2016.

343 Red-backed Shrike, 1D X, 400mm + 1.4X, f5.6, 1/4000s, ISO 3200, May 2016.

344 European Roller, 1D X, 400mm, f4, 1/4000s, ISO 1600, May 2016.

345 European Roller, 1D X, 400mm, f28, 1/640s, ISO 1000, May 2016.

346 Azure Tit, 1D X, 600mm + 1.4X, f5.6, 1/800s, ISO 3200, January 2016.

Index

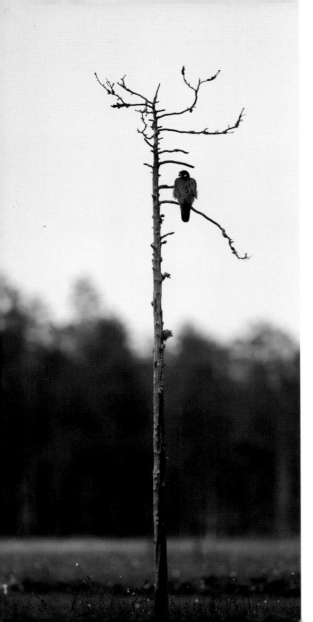

This edition published in 2018
by Reed New Holland Publishers Pty Ltd
First published in 2017
by Reed New Holland Publishers Pty Ltd
London • Sydney • Auckland

131–151 Great Titchfield Street, London WIW 5BB, UK
1/66 Gibbes Street, Chatswood, NSW 2067, Australia
5/39 Woodside Avenue, Northcote, Auckland 0627, New Zealand

newhollandpublishers.com

A record of this book is held at the British Library and the
National Library of Australia.

ISBN 9781925546262

Group Managing Director: Fiona Schultz
Publisher and Project Editor: Simon Papps
Designer: Andrew Davies
Translator: Minna Lindroth
Production Director: James Mills-Hicks
Printer: Toppan Leefung Printing Limited

10 9 8 7 6 5 4 3 2 1

Keep up with New Holland Publishers on Facebook
facebook.com/NewHollandPublishers

Front cover: Red-crowned Crane (*Grus japonensis*)
Back cover: White-tailed Eagle (*Haliaeetus albicilla*)
Page 1: Grey Heron (*Ardea cinerea*)
Pages 2–3: Red-crowned Cranes (*Grus japonensis*)
Page 4: Great Cormorants (*Phalacrocorax carbo*)
Page 6: Common Raven (*Corvus corax*)
Page 384: Peregrine Falcon (*Falco peregrinus*)

Acknowledgement
I've expressed my gratitude to many people for their help on my
travels and journeys to take pictures of birds, many of whom will
have the pleasure to help me again in future projects… A special
thank you for their much appreciated company and helping hand
in specific projects goes to Asami Akihiro, Daniel Cazo, Ole
Martin Dahle, Ville Heikkinen, Jame Helander, Eero Kemilä, Olli
Lamminsalo, Marc Latrémouille, Jarmo Manninen, Bence Máté,
Hannu Mänty, Brydon Thomason and Juhani Toivakka.